ARCTIC SOLITAIRE

ARCTIC SOLITAIRE

A BOAT, A BAY, AND THE QUEST FOR THE PERFECT BEAR

PAUL SOUDERS

MOUNTAINEERS
BOOKS

MOUNTAINEERS BOOKS is the nonprofit publishing division of The Mountaineers, an organization founded in 1906 and dedicated to the exploration, preservation, and enjoyment of outdoor and wilderness areas.

1001 SW Klickitat Way, Suite 201, Seattle, WA 98134
800.553.4453, www.mountaineersbooks.org

Printed in China
Distributed in the United Kingdom by Cordee, www.cordee.co.uk
21 20 19 18 1 2 3 4 5

Copyeditor: Alyssa Barrett
Design and layout: Kate Basart/Union Pageworks
Cartographer: Lohnes+Wright
All photographs by the author unless credited otherwise
Cover photograph: *Polar bear peering over iceberg, Repulse Bay, Nunavut*
Last page: *A polar bear swims near Hall Islands along Hudson Bay near the Arctic Circle.*

Library of Congress Cataloging-in-Publication data is on file for this title

Mountaineers Books titles may be purchased for corporate, educational, or other promotional sales, and our authors are available for a wide range of events. For information on special discounts or booking an author, contact our customer service at 800-553-4453 or mbooks@mountaineersbooks.org.

Printed on FSC®-certified materials

ISBN (paperback): 978-1-68051-104-8
ISBN (ebook): 978-1-68051-105-5

For Janet. You are the star that guides me home.

CONTENTS

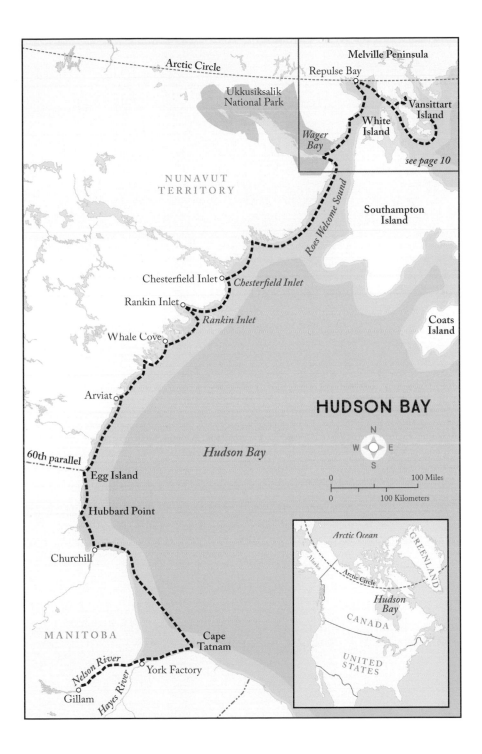

Arctic Circle

Melville Peninsula

Repulse Bay

Ukkusiksalik
National Park

*Wager
Bay*

White
Island

Vansittart
Island

see page 10

NUNAVUT
TERRITORY

Southampton
Island

Roes Welcome Sound

Chesterfield Inlet *Chesterfield Inlet*

Rankin Inlet

Rankin Inlet

Coats
Island

Whale Cove

Arviat

HUDSON BAY

N
W · E
S

Hudson Bay

60th parallel

Egg Island

Hubbard Point

0 100 Miles

0 100 Kilometers

Churchill

MANITOBA

Cape
Tatnam

Nelson River

York Factory

Gillam

Hayes River

Arctic Ocean

GREENLAND

Alaska

Arctic Circle

*Hudson
Bay*

CANADA

UNITED
STATES

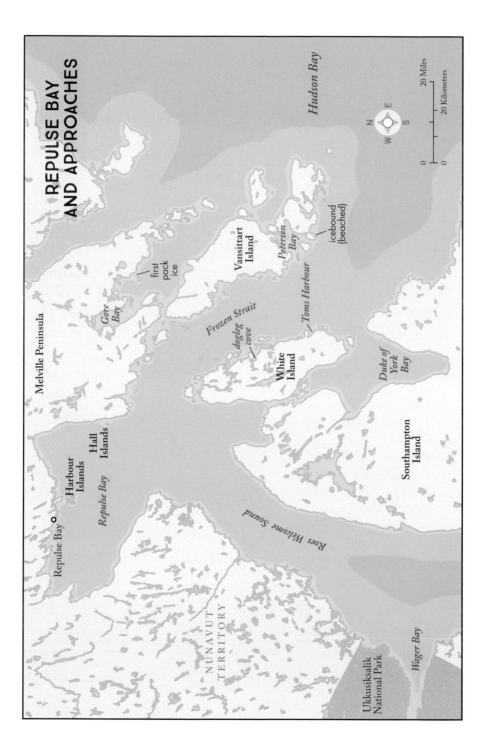

REPULSE BAY
AND APPROACHES

Hudson Bay

Melville Peninsula

Gore
Bay

first
pack
ice

Vansittart
Island

Petersen
Bay

icebound
(beached)

Frozen Strait

dogleg
cove

Toms Harbour

White
Island

Duke of
York
Bay

Repulse Bay

Harbour
Islands

Hall
Islands

Repulse Bay

Southampton
Island

Roes Welcome Sound

NUNAVUT
TERRITORY

Ukkusiksalik
National Park

Wager Bay

N
W E
S

20 Miles

20 Kilometers

0

0

AUTHOR'S NOTE

This book had its origins in the journals and notes I kept during four solo boat trips to Canada's Hudson Bay, in the summers between 2012 and 2015. These northern journeys began as a sort of lark: could I step out my front door and travel overland to the shores of a cold and mysterious sea, then head off by boat to see wild animals and have some adventures? I never thought to ask whether any of this was possible, advisable, or even strictly legal. I went north to photograph polar bears, and at each day's end, I scribbled down, in long hand, my experiences as a photographer and accident-prone boater. It is, at its heart, a personal recounting of my impressions and memories from travels during which I was often tired and afraid and very much alone. Time and distance have faded memory, but I have done my best to retain the accuracy of events, locations, and conversations.

In the absence of any training in the biology or behavior of wild animals, I relied instead upon my own limited observations, and I make no claim to expert knowledge now. While there were days when I must have tried their patience, I made every attempt to avoid stressing polar bears or other animals that already lived in a challenging environment.

My descriptions of the small Inuit communities along Hudson Bay's western coast are those of a preoccupied traveler passing through far too quickly. In these pages, I have tried to hold onto the flavor of my brief visits and those first, sometimes gritty or unfair impressions. I arrived unannounced and uninvited in these towns and was greeted, with only rare exception, with kindness and hospitality.

A note on distances: I use American statute miles when describing distances on land. Out on the water, however, I refer to nautical miles: 1 nautical mile is equal to 1.15 statute miles or 1.85 kilometers. It sounds arbitrary, but in fact it makes for an elegant way of seeing the world. You begin by dividing the earth's globe north to south into the 180 degrees of a semicircle. Each of those degrees of latitude is divided again into 60 minutes, and each of those minutes, 1/60 of a degree, equals one nautical mile, or roughly 6,000 feet.

Confused? That makes two of us. The upshot was that when I looked at the lines of latitude on my nautical charts, I could quickly see that it was 60 nautical miles, or a long day's travel, to move across one degree of latitude south to north and back again.

Anyone reading these words with a working knowledge of seamanship or boat mechanics will laugh or wince, as I do now, at my foolishness and ineptitude. Think of this not as a how-to manual so much as a cautionary tale.

THE ICE BEAR

All the easy pictures have been taken. But I'm here to tell you there are still some stupid and crazy ones left out there.

I was heading north with at least one of them in mind; I was looking for the polar bear of my dreams. Not a zoo bear, not some hanging-around-the-town-dump bear, and certainly not a Tundra Buggy tourist bear. I was searching for a polar bear living unafraid and standing unchallenged at the very top of the food chain. I planned to photograph that bear living, hunting, and swimming among the melting Arctic sea ice.

My plan to accomplish this was, to put it charitably, a little vague. I imagined that if I gathered up enough survival and camera gear, found a way to haul it halfway across the continent to the end of the road in Canada's north woods, and loaded it all onto a train bound for the shores of Hudson Bay . . . then somehow or other I would be able to go out and find that polar bear. I'm not always big on details.

Working as a professional wildlife photographer, I have always liked doing things the hard way, slapping together my own solo expeditions and then figuring it all out along the way. Is it because I'm difficult and stubborn and cheap? Well, yes. But I've also found that the lessons learned through painful experience are the ones that tend to stick. Spend twenty-seven hours digging a Land Cruiser out of swamp muck with nothing but your bare hands and a small cooking pot and I wager you, too, will remember a shovel next time.

For years, I had been making noise about going to Canada's Hudson Bay to photograph the polar bears there. Churchill, Manitoba, is a tumbledown slice of small-town Canada inexplicably plopped down along the Bay's shore where the vast northern forests give way to Arctic tundra. It lies smack in the middle of approximately nowhere, and no road connects it to the outside world. There's just a long, narrow-gauge railroad leading to the smash-mouth hockey capital of Winnipeg, some six hundred miles south. If you continue a mere 220 miles farther, you can warm your frostbitten toes on the tropical shores of Fargo, North Dakota.

It takes less than two hours to reach Churchill by jet from Winnipeg. It's that or devote two long days going by slow train, if it's running. Churchill has grown world famous for its polar bears. Each autumn, hundreds of them, grown lean and hungry during the long summer months, gather along the Bay's western coast and wait for the freezing ice to thicken sufficiently to allow their return to the business of tracking, hunting, and eating seals. Visitors can step off the plane and, with the application of several thousand dollars, hop onto the nearest oversized, overstuffed, and overpriced Tundra Buggy, where they'll join a gaggle of other photographers and tourists, and trundle off to see dozens of polar bears in an afternoon.

But where's the fun in that?

Try to imagine crossing the Serengeti Plains of East Africa one hundred or even fifty years ago. To have been among the first to visit and photograph penguin-filled islands off Antarctica. To have stood alone among grizzly bears feasting upon Alaska's spawning salmon runs. As I look around the world, it seems we're left with nothing but ghosts, faded remnants of the wild lands and creatures that once defined our planet. I have spent the last two decades chasing shadows, caught up in a frantic scramble to create a record of those last remnants of wildness before they, too, vanish.

Sure, you can still go to some of these places, but you'd best be ready for plenty of human companionship and adult supervision. Remote wilderness destinations that once required committed professional expeditions to see and film now beckon invitingly from the pages of glossy vacation catalogs, promising gourmet cooking, free Wi-Fi, and a hot stone massage at dusty day's end. All to join two dozen other enthusiasts who will, often as not,

stand shoulder to shoulder with tripod legs entwined and shoot the same perfectly lovely, utterly identical photographs.

Making great pictures once required years of training and practice and, I liked to tell myself, no small measure of genius. New digital technology and modern autofocus lenses have rendered technically flawless images routine, ubiquitous, even kind of boring. Now, it feels like each day brings a new and seemingly endless stream of pretty pictures. But how many of them actually have anything new to say?

I'm no fan of any of this. I never saw much point in venturing out into the wilderness to be alternately bossed around and cosseted by guides who were younger, smarter, and better looking than me. I still fancy myself tough enough to travel hard across most any wilderness. Besides, sleeping in the dirt and eating dismal camp food makes good practice for the day my wife, Janet, grows weary of these antics and changes the locks.

I have long dreamed of finding my own private Arctic bastion, unpeopled but well-stocked with polar bears. Since Northern winters are long and dark and bracingly cold, and what reading I'd done promised death by frostbite, scurvy, or starvation, I reckoned that a summer visit might be a more prudent starting point. I'd dip my toes into the shallow end of the survival pool. Polar bears winter on the Arctic icefields. Come summer, the midnight sun returns and nearly all of that ice melts away. Shouldn't it be possible to take a small boat and visit the bears during those months as the ice disappears and the bears head for shore?

In the end, I found myself reluctantly following that well-worn tourist trail leading to Churchill after all. I couldn't afford my own private Tundra Buggy, so if I wanted to go it alone some creativity was required. I decided to go BYOB—Bring Your Own Boat.

Starting with the purchase of an inflatable boat barely ten feet long and a small ten-horsepower outboard motor, I assembled a mountain of gear in my garage. I packed up layer upon layer of long underwear and weather-proof sailing gear, goggles and gloves, hats and boots. I stuffed cases with photographic and underwater equipment. I gathered camping and survival gear, a stove and weeks' worth of dried camp food, satellite phones and beacons, and enough bear-banger noisemaking shells to hold my own Fourth

of July fireworks show. Tree-hugging, liberal pretensions notwithstanding, I took a drive from my quiet Seattle neighborhood out past the Silver Dollar Casino and the adjacent Moneytree Payday Loans storefront, to Discount Gun Sales. There, after a scant background check and no training at all, I procured a Remington Model 870 Special Purpose Marine Magnum pump-action shotgun. I gingerly cradled the gleaming stainless steel twelve-gauge in my hands like it might explode at any moment. The gun, together with a box of matching twelve-gauge slugs, wicked thumb-sized pieces of lead, was to be my last desperate line of defense in case it all went terribly wrong. And if I did wake one night to discover my leg clamped in some polar bear's jaws, whether I would shoot the offending bear or myself remained an open question.

I set off in my overloaded SUV, speeding east across half a continent's worth of interstate highways. After four days' travel I arrived at the pavement's end, looking not unlike a homeless, survivalist hoarder. There, in Thompson, Manitoba, I swatted at black flies while piling everything onto the train heading north across the wilderness. When I finally decamped in Churchill, the calendar said it was late June, but all the same I was greeted with the cold, hard slap of rain whipping in off the pack ice. It was just me and that mountain of gear piled up on the platform as the train pulled slowly south.

A late thaw had left the shoreline jumbled with ice, great pans of it heaved up against the shore, a solid line of white disappearing into the fog. I had imagined myself camping in the Arctic wilderness, listening to the call of loons from my toasty sleeping bag. Here in the real world, I booked a room at the Polar Inn and overloaded a taxi to haul my crap the three blocks from train station to hotel front door. The management greeted me, my gear, and the trail of mud I tracked through the lobby with an air of bemused disbelief. Still, they lent me a pickup truck to carry the heaviest bits down to shore and I quickly set to work inflating my laughably puny boat with a too-small hand pump, puffing and muttering darkly against the chill wind. In the absence of a proper small boat harbor, I tied my dinghy to a big chunk of metal sticking out of the gravel beach and hoped for the best.

The truth was that I had no idea how any of this could end well. Small boat, big water, and aggrieved polar bears; it sounded like the recipe for grisly

headline news. Other than a few local operators running tourists out for a cold swim with the beluga whales, there wasn't much boat traffic on this stretch of Hudson Bay. The coastline was utterly flat and offered no protection from the storms that howled in off the land. The Bay itself might be better described as a vast inland sea, six hundred miles long and up to four hundred miles across. When the wind blew, there wasn't a tree or hill in half a thousand miles to stop it.

I quickly discovered that Hudson Bay wielded a monstrous range of tides, the water dropping as much as thirty feet from high tide to low ebb. A quagmire of mudflats and slime-slick rocks circled the shore when the tide went out, creating a half-mile slog over which I had to haul my eighty-pound motor, then the seventy-five-pound boat, and all of those cases of heavy gear.

As soon as the wind dropped that first evening, I ventured out onto the water, nervously picking my way through the ice, scouring the horizon for some hint of a polar bear. It turned out to be really hard to find a solitary polar bear in an ocean full of ice—who knew? I spent hours staring at the floes, days motoring hundreds of miles through the melting pack. As I wound my way through the shifting maze, I stopped frequently, climbed up onto any high spot I could find on the ice, then slowly scanned the horizon with binoculars for the white-on-white outline of a bear. Venturing farther and farther from shore, I would stay out until the midnight sun dipped below the horizon, leaving me to navigate home by GPS and the distant, twinkling lights of town.

After two weeks of toe-numbing cold, summer suddenly arrived on the heels of a dark line of thunderstorms. Clouds of biting black flies and mosquitoes descended as temperatures spiked into the nineties. At least I had something new to complain about. A strange haze—smoke from distant forest fires—filled the sky, drifting in with the record heat. Once the storms blew through, I set out from shore again, and spent an hour motoring hard to reach the melting ice. In the orange half-light, every lump and hummock looked like a bear. Hours passed. From a crumbled snow-covered ridge, I looked, and then looked again, and—to my astonishment—saw movement. A half mile away, a young bear woke and quickly shambled from the ice off toward water.

Polar bears are creatures of the sea. Classified as marine mammals, they spend most of their lives on the ice or in the ocean. It's only during the lengthening summer thaw that they spend appreciable time on land. When surprised, a bear's first reaction is often to head to the safety of water. Sliding ass-first off my own iceberg, I hopped into my boat and set off, struggling to keep the bear in sight.

Though possessed of a fearsome reputation, most bears will often as not avoid human contact when they can. Bears near town are hazed with noisemakers and beanbag shotgun shells. The overcurious are darted with tranquilizers and may spend months caged by local wildlife officials until freeze-up. Repeat offenders are not infrequently shot dead. Of course, should you find yourself alone in the wilderness, your attention wandering, and you stumble upon a polar bear feeling particularly unfastidious, you may find yourself among the hunted. Most bears will steer a wide berth, but this one, a young female judging by her size and build, gradually calmed and began to grow curious as I slowly trailed her. We were soon moving through the water in tandem, separated by a hundred yards, then fifty, then—holy shit, that bear was really close.

I dumped my camera gear out of its waterproof cases and shot her with the works. Telephoto lens. Wide-angle lens. Underwater pictures with a housing and fisheye lens. I held the outboard's throttle and steered the boat with one hand while shooting with the other. I even mounted one camera onto a six-foot boom and then awkwardly tried to swing it closer to her, but succeeded only in dunking the contraption into salt water, killing the camera, lens, and trigger.

Undeterred, I dug out a spare camera and began chewing the insulation off a copper wire to jury-rig a replacement shutter cord. As the bear swam beneath an iceberg, I managed to drift the boat in closer and hang the boom beside a hole in the ice. She rose to breathe and I began shooting, blindly pressing the shutter cable and hoping that something, anything, might be in focus. She submerged for a moment, then surfaced again for one more breath before disappearing beneath the ice.

The midnight sun hung like a dying star in the hazy orange sky. The bear reappeared and paddled slowly toward the sunset on a sea glowing like

molten metal. I followed at a distance, utterly transfixed, listening to her steady breathing and watching as her powerful front paws stroked through cold ocean. Stillness fell upon the water. There was no land in sight. I was alone at sea with a polar bear. The moment felt like I had been given a perfect jewel, something precious to hold onto for the rest of my days. I could have followed that bear for hours through the short half-lit summer dusk. But I cut the engine and let the boat drift. I watched in silence as she swam away, a slow vanishing.

I sat for a long while, the scene burning into memory. But I was still more than thirty miles from shore, and darkness was gathering. I pulled the outboard's starter cord, felt the motor catch, and steered my boat toward shore.

On the southbound train a week later, I sorted through the photographs on my laptop. There was my bear, walking across the ice, swimming and diving. Suddenly, there it was: one magical image that I'd never seen before, nor imagined, not even in dreams. In it, the polar bear floats beneath the surface, staring back up at my camera, surrounded by ice and empty sea, lit by the burnished, hazy sun. I laughed out loud, then started parading up and down through the passenger cars like some lunatic, showing the picture to a trainload of complete strangers.

I was hooked. I knew I had to come back and tell the story of this wild, lonesome, and dangerous place. More than anything, I was obsessed with finding more photographs that might again capture and illuminate and somehow hold on to the spirit of the ice bear.

Following pages: Submerged polar bear beneath melting sea ice, thirty miles north of Churchill, Manitoba

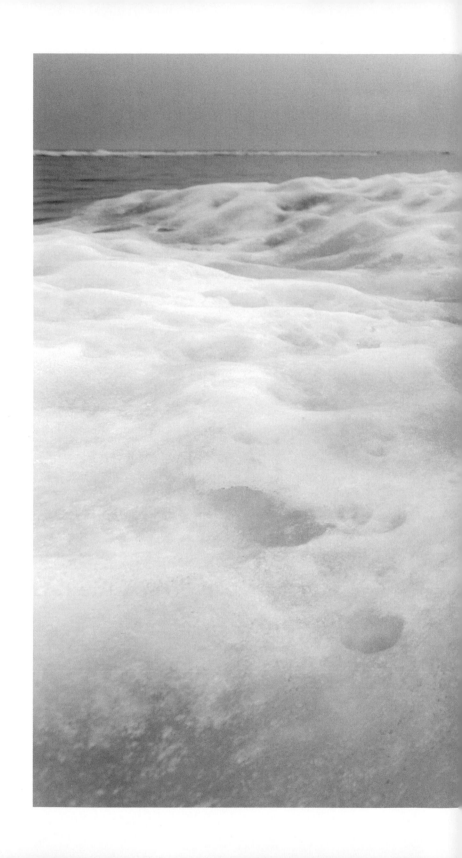

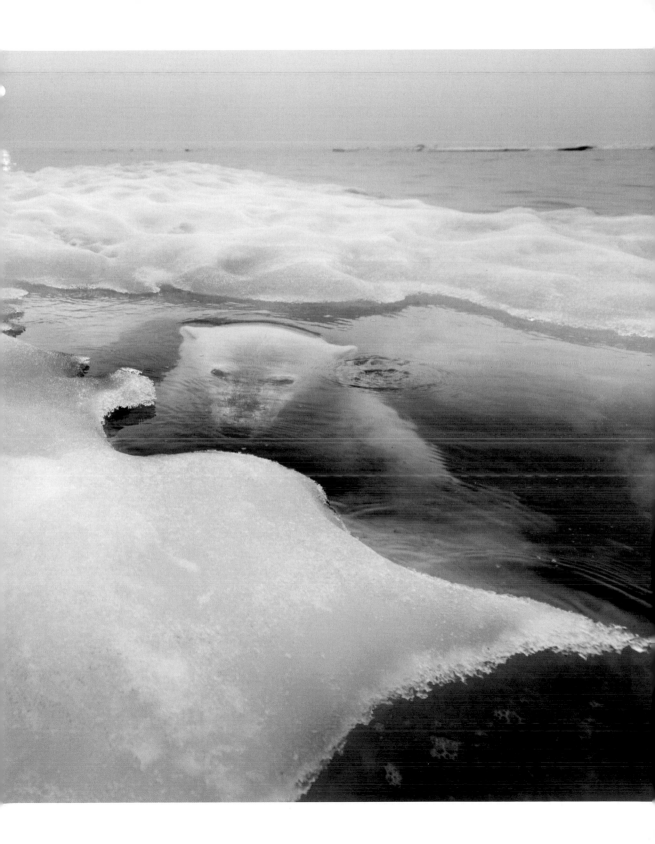

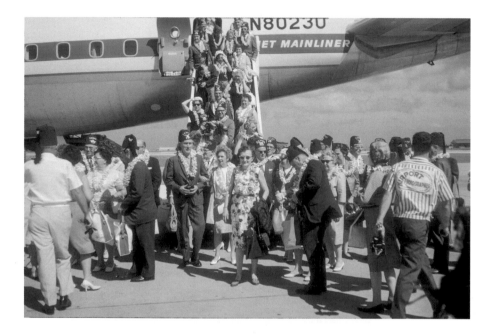

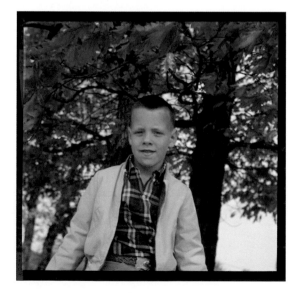

CHAPTER 2

BEGINNINGS

My people were not, by nature, an adventurous lot. If it weren't for some religious unpleasantness back in the old country, my Mennonite forebears might have happily stayed put in the rolling farmlands outside Zurich, milking their fat and contented cows. Instead, in 1727, they found themselves with one-way passage to America's distant shores. They must have liked what they saw when they stepped off the boat in Philadelphia. For the next two centuries, they never ventured farther than a long day's buggy ride from the docks. My grandparents, however, were made from different stock.

Though my grandfather spent his days counting money and shuffling numbers at the local bank, his true love was photography. He also liked to buy my grandmother naughty 1950s-era mail-order lingerie. Decades after he passed, I went through boxes of old family film and discovered that he also had a penchant for combining those two passions—the results of which I cannot unsee no matter how hard I try.

During the postwar boom years, they joined my grandfather's Masonic Lodge buddies and began traveling on package tours to Hawaii and Mexico

Top: Irma Zug and Zembo Shrine Masonic Lodge tour group, Honolulu Airport, circa 1964 *(photo by Paul D. Zug)*
Bottom: Paul Souders at age six, Pennsylvania, 1967 *(photo by Irma R. Zug)*

and the Caribbean. My grandfather's love for faraway places and photography grew, and so did his camera collection. He owned a small Speed Graphic, a Voigtländer, a Rolleiflex, and an early Nikon camera that still sits on a shelf in my office.

They'd already bought the tickets for their next big trip when doctors found the cancer. He died just before Christmas, a year shy of when he was set to retire, so much of the world left unseen.

My grandmother could have curled up and died inside, and I'm sure she did a little. But she went back to work at her nursing job, and kept right on traveling, without him, on those same package tours. One of my earliest and strangest memories is arriving at the Harrisburg airport to greet her and watching a look of genuine horror cross the grown-up faces around me as my sixty-something grandmother sashayed across the tarmac in a miniskirt and white go-go boots.

I'll say this for Grandma, she didn't give a shit what other people thought.

Whether it was up the Nile, down the Amazon, across Europe, or around Africa, she carried that clunky old Nikon camera on all her trips. When she returned, the family gathered in a darkened room to watch the world she'd seen unfold in slide after blurry slide. Elephants in the Serengeti, the Pyramids at Giza, Machu Picchu, Saint Peter's Basilica in Rome: my grandmother saw it all. I sat there fidgeting through her slideshows, desperate to get back to watching TV. But even then I asked myself, if my grandma traveled to the far corners of the earth, what could ever stop me?

Well, money for one. My mother worked as a registered nurse; my father was a union welder. With four kids, extra cash was rare. But I was my parents' first boy and was named after my grandfather. I always imagined that gave me a special place in my grandmother's heart, and I wasn't above wheedling presents from her as a child—or for a long time after. Everything from a ball glove and a new bike to bail money when I landed in the county lockup in the wake of some larcenous college hijinks. When I was eleven years old, she bought me my first camera: a simple plastic Kodak Instamatic that took twelve square pictures on black plastic cartridges of 126-roll film. I ran out into the winter gloom and took a dozen pictures of the skeletal oak trees around our house, then looked around for more film to waste. I was never

much for delayed gratification, and it felt like a slow death having to wait a week or more for my masterpieces to come back from the photo lab.

Mercifully, those early snapshots were long ago consigned to a landfill out past the interstate. But I can still remember that feeling that I could stop time, put a frame around the world, and hold it in my grubby little hands, one image at a time.

All the same, I never set out to be a nature photographer.

I grew up between a trailer park and a chicken farm. Where I'm from, nature was mostly poison ivy, junk cars, and broken glass. That Kodak Instamatic led me to a budding journalism career: by day, I took snapshots for the high-school paper and yearbook, then rushed home and turned our sole bathroom into a makeshift darkroom. Under a glowing red light, I developed rolls of black-and-white film, then printed my shaky masterpieces one by one. The camera gave me all the license I needed to jump any fence, cross any line, and push my luck well past its breaking point. I fancied myself the next great war photographer—even if the first day of deer-hunting season was the closest combat I would ever see in rural Pennsylvania. I have always had a rich and varied interior life.

A hundred miles down the road at the University of Maryland, my career path took a short detour. I signed up for a major in astronomy. It took longer than it should have for me to figure out that astronomy is physics, and physics is math, and math is . . . hard. One fall morning, I emerged dazed and blinking from ninety uncomprehending minutes of freshman calculus, then took the long walk down to Administration and switched majors. The College of Journalism expected little in the way of academic heavy lifting. As long as I could bang out thirty words a minute on the department's ancient and clattering manual typewriters, I was in.

But, as my freshman year dragged expensively and unproductively into its fourth semester, I saw that academia and I needed a little time apart. I dropped out, skulked back home, and moved into my parents' basement. It was time to regroup. I took a summer job working alongside my father in the hometown carpet factory. The place specialized in making miles of carpet for the big American cars that were, at the time, still rolling off Detroit's assembly lines. In the 1980s, the factory employed nearly two thousand people and was a cornerstone of my small hometown's manufacturing economy.

Every workday morning for three decades, my dad walked through those factory gates and into its dank and cavernous halls. He crafted machinery and improvised repairs from the dye pits to the assembly lines to the machine shop. My father was part of that greatest generation of men who fought against pure evil in a global war, then dusted themselves off, put both the horror and the heroics behind them, and started families. Together with their young wives, they built lives and reared a crop of overindulged and ungrateful children. My dad could swim a mile through cold lake water, ride a motorcycle, catch a fish, shoot a deer, fix damn near anything using the tools at hand—and he didn't take shit off anybody. As far as I could tell, he was universally respected and admired. I still have a picture, taken sometime in the early 1960s, of him shaking the carpet factory owner's hand. The camera's glaring flash captured the moment as my father strode up to this third-generation suit. Standing straight backed and square shouldered, my father looks like he's the one who runs the place and that suit was just around to keep his chair warm.

I am my father's son, but I'm afraid the apple fell some distance from that particular tree.

My arrival at the factory contained all the troubled elements of 1980's America: industrial decay, adolescent alienation, and generational family drama. It was like living inside a Springsteen song. I was just another college failure with a smart mouth and nothing to contribute in the way of useful skills.

If a day passed without me causing him some manner of embarrassment or shame, it was only because I'd overslept and called in sick. But each day when the lunch whistle blew, my dad would invite me to join him in the welding shop to eat lunch. I'd sit on the workbench, making a big show of flipping through a day-old copy of the *New York Times*, admiring photos from Lebanon or Guatemala or Mozambique, and wishing I was there instead.

I didn't know much, but I knew I had no future on the factory floor. Settle down with one of the hometown cheerleaders, raise a brood, learn a trade, and make an honest living working with my hands? Fat fucking chance. For starters, even small-town cheerleaders had standards and they'd known me for bad news since seventh grade.

After a month or two, I started spending my spare time loitering around the newsroom at our hometown newspaper, the *Evening Sentinel*. All through high school I'd pestered the paper's long-suffering chief photographer, pedaling my bicycle over to the newsroom to breathlessly offer up rolls of badly exposed and poorly focused pictures from local football games and track meets. Now, I was one more overenthusiastic stringer, speeding through the parking lot amid squealing tires, then charging uninvited into the newsroom to breathlessly present poorly exposed and badly focused images of house fires and overturned cars.

Still, he must have seen something in me, if only a cheap source of labor and someone eager to take any crap assignment. I would shoot anything: school board meetings, Halloween parades, ribbon cuttings. I took my police scanner everywhere. I even took it to bed. And, in a memory long repressed, to my girlfriend's bed. Any promising bit of mayhem that squawked across the scanner would send me bounding off into the darkness.

I lived for hard news and loved the lawless feeling of hurtling down unlit country roads at batshit speeds, rolling up at a scene amid flashing cop lights and blaring sirens. Nikon in hand, it felt like the rules did not apply.

After eighteen months at the factory, I hadn't managed to save more than a week of take-home pay. All the same, it was a mercy the day I quit and returned to school. I had learned one thing for certain: it would take something other than honest labor to make my way in the world. My first day back on campus, I headed straight to the college paper's newsroom.

The paper published five days a week and offered no wage, just ten dollars per photo published, plus darkroom access and all the film you could steal. I was hooked. For two years those cinderblock newsroom walls were home, and the band of writers, photographers, and crackpots became my family, my fraternity, my world. I knew I should be going to my classes, but I spent nearly all my time shooting pictures instead. Hell, this was a chance to do the job that I was studying for anyway. I missed most of my lectures and barely skimmed the textbooks, doing just enough work to avoid getting booted off campus.

Word got around that one of the suburban daily newspapers was looking for a lab tech, someone to sit in the darkroom processing film, making prints,

and breathing poison, all for ten bucks an hour. I needed the money more than the sleep, so I jumped at the chance. When a full-time staff shooting job opened up six months later, my pursuit of higher learning reached its long-overdue conclusion.

I happily worked fifty and sixty hours a week for the princely sum of $15,000 a year. I was getting paid to take pictures. Truth be told, I'd have paid them, just to get my foot in the door. I started my first day on the job with dreams of journalistic glory. War, famine, and mayhem all sounded like one big adventure—even if our coverage area was limited to the cosseted and prosperous suburbs of Montgomery County, Maryland. There, at least, strict zoning covenants held war, famine, and anarchy largely at bay.

Some days, it felt like every photograph held a flattering mirror up to our community: a boy with his prize cow, the winning touchdown, the Fourth of July parade. Hard news—the stuff I was drawn to—was a darker matter. I continued trawling the police scanners in hope of finding some car wreck or house fire to get the adrenaline pumping. At the sound of the radio's emergency tones, I'd scribble down the address, then sprint toward the parking lot, cameras clattering, eyes agleam at the prospect of some fresh mayhem. Getting manhandled by cops, firefighters, or angry family members was sometimes part of the deal, and made the story's beer-fueled retelling after work all the better. When I look back on it, the act of eagerly photographing some poor soul's mangled car or burning home feels like monetizing the misfortune of others. If you think too hard about my small corner of the news business, it starts to sound like schadenfreude dressed up in a nice suit.

At the time, though, I didn't dwell too much on journalistic ethics or moral questions. I was too busy plotting to head overseas and find myself an affordable and picturesque war, then start taking some real pictures. Even in the pre-9/11 world of the 1980s, dozens of bushfire conflicts and civil wars scorched various corners of the Third World. I devoured stories and images created by my heroes, the war photographers who covered conflicts from Northern Ireland to East Timor, the Western Sahara to South Africa. They recorded the worst that humanity had on offer, and made it look compelling, artistic—even beautiful.

I got my chance, but only after I was canned from my day job. I'd like to say it was because my creative flame burned too brightly, or my artistic passions ran too wild. But the sad truth was that, in our small but professional newsroom, I behaved like a drunken frat boy at Mardi Gras. I crossed the paper's editor one time too many, and he wearily called me into his office. He conceded that I was a not-untalented photographer who one day, sometime in the distant future, might grow up to become a decent employee. Then he sent me packing. I cleaned out my locker, and crammed all the film and unattended equipment I could into my little hatchback. The rear axle was almost dragging under the weight of pilfered photo gear when I peeled rubber out of the parking lot one last time.

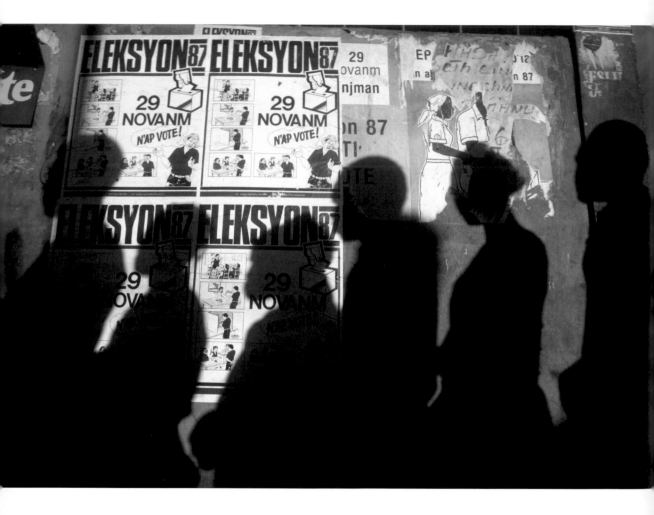

CHAPTER 3

ZONES OF CONFLICT

At the time, thankfully, Washington, DC, offered an abundance of freelance photography work, so only briefly did I have to subsist on unemployment checks, cheap beer, and self-pity.

I read about presidential elections scheduled in Haiti after dictator "Baby Doc" Duvalier's abrupt retirement to the French Riviera. Along with the promise of political mayhem and potential bloodshed, all within a cheap two-hour plane ride of Miami, there was a firm date for the events. Of course, I had no business in Haiti: no assignment, no prospective client, not even a valid press pass. I was just one more self-styled, self-appointed photojournalist with the zealous conviction that the world needed to see events through *my* eyes, *my* lens. I had a little room left on my credit cards, so I headed to the airport with a bag stuffed with forty rolls of Kodachrome, some cameras and lenses, and, looking back, a black hole where my soul was supposed to be.

Church bells rang as the sun rose on election day, November 29, 1987. Hundreds of men and women had lined up before dawn to cast their ballots

Voters' shadows on election day, Port-au-Prince, Haiti, 1987

in Haiti's first free elections in thirty years. The mood seemed determined and solemn. For a fleeting moment, I imagined I could capture the bravery and dignity of these people, who'd shrugged off a brutal dictatorship and now clung to hopes and dreams of a less blighted future.

But what the hell did I know? Before the sun had cleared the central cathedral's towers, gunfire echoed through the city. I was riding in some reporter's rented Toyota, crammed into the middle back seat between a couple other photographers. We were looking for the source of the shooting when an identical Toyota with government plates sped toward us. Just as it passed, four loud shots rang out and the three of us instinctively cowered, trying to duck into the same tiny space. The gunmen either had truly awful aim or, more likely, simply wanted to scare the hell out of a carload of *blancs*. The car sped down a side street and emerged a few blocks up the hill. We saw the shadow of a machine gun appear out the car window as they closed in on the line of voters outside a polling station. We watched as people scattered and bodies fell in the seconds before the sound of shots reached us.

We drove up and shot them, too, photographing the wounded and the terrified as they huddled behind church walls. We heard sustained gunfire not far away, and set off to follow that sirens' call. We sped all the way to Ecole Nationale Argentine Bellegarde, a small school that for this one day served as a polling station. It was more than three decades ago, but I can still see soldiers milling around the small courtyard, and the scattered fire trucks and ambulances. A man lay crumpled in the dust, blood running freely from a machete wound slashed deep into his skull. Did he turn over and reach up, or am I just imagining that now? I can still hear myself yelling—in English, of course—for someone to get a fucking ambulance.

There were bodies everywhere. I tried to keep track of how many, but I kept losing count. A young girl was curled up in a corner, head resting in her arms over a basket, almost like she was sleeping. A soldier walked past with a machine gun in one hand, and with the other picked her up by her hair. Her face was missing, shot away. In a large, open-air classroom, the dead lay scattered across the floor. There was so much blood.

This was everything I'd come for: the real deal. But my hands were shaky and my head buzzed with static. The ambulances drove off, and soon the

policemen and troops began to drift away. A strange quiet settled over the school. My crew was ready to head back, and maybe I had seen enough for one day, too. We left minutes before another wave of gunmen arrived to spray the courtyard with small arms fire, killing one cameraman and wounding several others.

For a day or two, we stood at the center of the world's attention. I was still young enough and dumb enough to believe we were going to shove this barbarism, this unreasoning violence, right in the world's face. The world looked up from breakfast, blinked, and had another slice of toast.

And that was that.

I made what little hay I could out of the trip, humble-bragging about "that time I got shot at," and showing my gruesome snaps to colleagues. A few days after returning home, I woke up before dawn in my dismal apartment. For a half-waking moment, the furniture was draped not with scattered luggage and dirty laundry but with the bodies of dead Haitian children, dozens of them. I stared numbly at the carnage, closed my eyes, and blinked slowly . . . once . . . twice . . . until they were gone.

I kept at it for the next year or so. I would shoot leftover assignments for the big DC newspaper bureaus until I saved enough to buy another plane ticket. Panama, back when that seemed like news. Israel, during one of its regular spasms of unrest. I maintained a smug exterior, but in truth I was circling the bowl, swirling toward both moral and financial bankruptcy, though only Citibank seemed to much notice or care.

In desperation, I started looking for another day job and I cast a wide net. I was willing to try just about any place that offered me a steady paycheck and a change of scene. A photo editor in far-off Alaska, in a move he grew to regret in the years to come, threw me a lifeline. The day after New Year's, I packed everything I owned into my Honda two-seater, cracked the windows to dissipate my hangover's fumes into one last slate-gray Baltimore dawn, and left behind everything and everyone I knew.

After six long days of driving, Anchorage, Alaska, greeted me with a record cold snap, toe-numbing even by local standards. It was twenty-seven degrees below zero, and my editor, a man of sly humor, thought it good sport

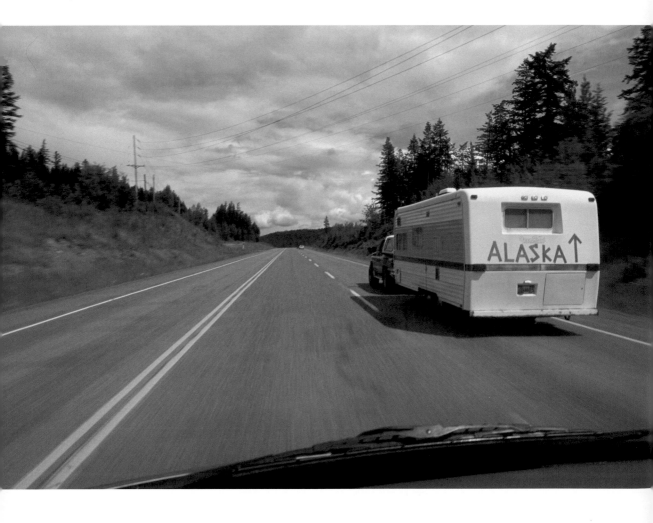

to pack me off to Fairbanks, where temperatures had plummeted to minus sixty. I wandered around town bundled up like the Michelin Man, wearing a brand-new, bright-red Eddie Bauer parka and military bunny boots. I felt like I'd been exiled to Neptune.

In the years I spent in Alaska, I had to photograph my share of the happy staples of any news photographer's day. On top of that, the Last Frontier offered its own endlessly inventive methods of self-harm to admire and record: snowmobile crashes, bush plane tragedies, and an endless array of firearms-related stupidity. But I could also wake up and find a moose on the front porch, and I watched bald eagles on my morning drive to work.

I still saw myself as a hard-news man, but over the span of a couple years I began to spend less time obsessively tracking the police scanner and more days out hiking in the Chugach Mountains that began at the city's edge. The silence I found there drowned out some of the noise in my head. In the wilderness, I saw light and form in different ways, and thought about other stories I might be able to tell. There was still pain and death and no small measure of cruelty in the natural world. But unlike all I'd witnessed in Haiti and elsewhere, I could see it wasn't for sport, and it wasn't for some man's profit or power or simple stupid meanness.

It dawned on me that, rather than tying my wagon to the sordid business of exposing the endless depths of human cruelty, I'd live longer and sleep better if I worked to record some of the beauty, wonder, and drama of the wild lands that surround us.

And on those rare occasions, nearly a quarter century later, when I need to quiet the journalistic demons from my past, I ask myself: what's the biggest story of our time? Isn't it man's ongoing and ever-quickening war upon nature? What if I photographed *that* battlefield? What if I shared the stories of *those* victims?

Northbound on Alaska Highway

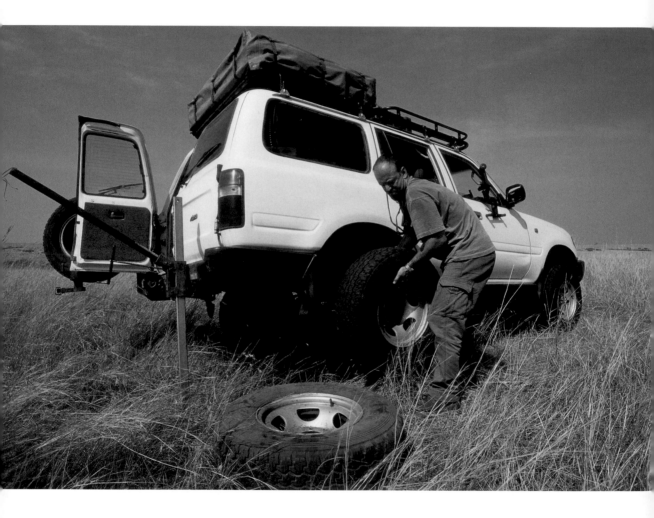

CHAPTER 4

TRANSITIONS

I left Alaska pretty much the way I'd arrived: barreling along the snow-covered highway with all my worldly possessions piled high inside the car. Bigger car, more stuff, but otherwise . . .

In my five years there, I had discovered a place where I seemed to belong. I had a job, a community of friends and colleagues, the stirrings of a normal life. And I was throwing it all away to bound off, again, into the unknown.

This time, I went to San Francisco to try working freelance again. Within seventy-two hours of arriving at my new home, I knew in the very core of my being that, in a lifetime defined by wrong turns and missed opportunities, this was the worst decision yet. I was in a big city with few friends, no clients, little work, and less money. Yet somehow, I stumbled into an assignment contract for Microsoft gazillionaire Bill Gates's new digital photography archive. It was a new concept at the time, and I believe the term "Digital Alexandria" was bandied about, without irony. Their goal was to collect images of everything in the world, through time. They even invented a new word for the company, Corbis, which I think is Latin for "bottomless money pit."

Flat tire on safari, Masai Mara Game Reserve, Kenya

My job description boiled down to "anonymous content provider," and they sent me off to Canada for four months with a fat per diem and a mission to travel across the country and photograph everything I saw, from Mounties in red serge and funny hats to Ontario steel mill workers. I drove from the lush green British Columbia rainforest more than four thousand miles to the distant Atlantic shores of Newfoundland, and then raced to their Seattle headquarters in time to crash the office Christmas party. My corporate masters, deciding my modest talents were best appreciated from a greater distance, shipped me off to Australia for another three months with only the barest hint of direction.

Jet lag and anxious uncertainty were cushioned only by a seemingly bottomless expense account and ready access to that night's hotel mini-bar. I'd call my editor (collect) in a panic, practically begging him for some guidance. I could imagine him sitting serenely cross-legged on some snow-covered mountaintop, ponytail blowing on the wind, imperturbable.

"What am I supposed to be shooting?"

Everything.

"Who are our clients? Who's going to buy this shit?"

Everyone.

Ommmmmmm . . .

Too soon, the river of cash dried up, but I knew there was no going back to the old newsroom grind. A dream gig shooting for *National Geographic* always hung in the horizon like some shimmering mirage—there can't be a photographer out there who hasn't imagined their pictures displayed on the magazine's yellow-bordered cover. Yet I never quite mustered the energy to chase down that dream; it seemed there was an impregnable wall barring access to those hallowed pages. I figured I'd die of old age before they would ever pay me to go on the trips I dreamed of. I was impatient and unwilling to devote endless hours to courting editors and pitching ideas. So, I never bothered asking. I cared only about the work, and it was so much easier to go out and spend my own money and just do it. I declared to myself, my folks, and my soon-to-be ex-girlfriend that I was now, officially, a nature photographer.

These self-financed trips started out simply enough. I bought a well-used VW camper van and disappeared for weeks at a stretch. I started with baby

steps, ticking off the photographic hot spots of the American West. I had just moved to Seattle, and Mount Rainier loomed right outside my apartment's kitchen window. Yosemite or Monument Valley were just a few days' drive down the interstate.

Looking back, I recognize that I didn't make a single picture that hadn't been done before. I studied the masters of my craft—everyone from Ansel Adams to Art Wolfe, Galen Rowell, and Frans Lanting—and I did everything I could to make my photographs look like theirs. I went to the same places, set up my tripod in the same spots, and shot mile after mile of old 35 mm slide film. For years my trip research, such as it was, consisted of buying the relevant Lonely Planet guide, booking a cheap online ticket, and taking a quick look through my stacks of old *National Geographic*s for any heroic images I might be able to replicate. The very nature of photographing iconic locations is the act of framing and recording scenes that have been shot over and over for decades, and there's a vanishingly small distance between "inspiration" and plagiarism. I'm ashamed to admit how often my toe slid over that line, unintentionally or not.

I made just enough money each month from royalties and the occasional magazine job to keep the lights on at home, fill up the gas tank, and keep moving. I saved enough for my first big plane ticket in 1998: a cheap round-trip steerage-class seat from Seattle through London and on to Cape Town, South Africa, where I rented a chartreuse VW subcompact and set off on safari. I didn't know a damn thing about Africa I hadn't seen on TV, but I wasn't about to let that stand in the way. I subsisted on a steady diet of lemon cookies, Simba brand potato chips, and a canned curry that looked, smelled, and (I imagine) tasted a lot like cat food. I soon discovered a new world of large and dangerous animals whose forbearance I sorely tested.

Back home, picture agencies were busy sending my images off to clients: magazine and book publishers, advertising agencies, and PR firms. I never had to personally meet or charm a single one of those editors and art directors. It seemed like the best kind of magic. All on their own, they paid perfectly good money to use my pictures, when they fit the bill, to illustrate stories and campaigns. Each month, royalty money flowed in, and I responded in the only way I knew how: I spent it, and fast.

My trips grew longer, more ambitious, and more expensive. I bought a beat-up Land Cruiser in South Africa and drove from Johannesburg, through the safari lands of Tanzania and Kenya, all the way to Uganda. I spent months photographing the wildlife and landscapes I encountered while camping rough in the bush. The calendar didn't have enough days for all the trips I wanted to do. Scouring the internet for cheap flights, I discovered Cathay Pacific offered a twenty-one-day air pass to anywhere they flew in Asia. I managed to visit twelve countries in those three weeks, touching down just long enough to get some local *bhat*, *dong*, or *rupees* at the airport ATM and race around to the most glaringly obvious highlights before catching a taxi back to the airport in time for my next flight.

With every Americana road trip or African safari or Antarctic boat charter, I imagined that I was pushing the photographic bar a little higher. But for the most part, I was just one more crappy wedding singer belting out cover versions of somebody else's greatest hits.

It was in Greenland, of all places, that I had my epiphany. Cold and remote, and stupendously expensive, the place was not yet on anybody's bucket list. I set off with no real notion of what I'd find. I traveled by boat and camped along the western coast, surrounded by dramatic fjords, glaciers, and icebergs like nothing I'd ever encountered. Hell, I hadn't even seen pictures of these places. I had no visual framework, no pre-existing iconic images to "interpret." Without other photographers' work to fall back on, I finally had to wake up and create images that were, for once, truly my own.

All of this was great fun, while it lasted. Making a living at photography, always a dubious proposition, has only grown harder in recent years. The advent of digital photography collapsed the distance between the professional photographer and the eager enthusiast. Advanced cameras made exposure and focus automatic. "Point and shoot" was once a pejorative for a crappy little camera; with the new digital equipment it became all the technical instruction anyone needed to call themselves a photographer.

At the same time, there has been an explosion in global travel. Places that once required insider knowledge, a pile of cash, and a full-blown expedition to reach are now overrun by swarms of tourists. From Machu

Picchu to the Serengeti, from Angkor Wat to Uluru, worlds that were first exposed on the pages of *National Geographic* are now trampled by hordes of smartphone-wielding, selfie-shooting vagabonds. Visiting America's national parks often as not feels like a tour of the country's most scenic and overcrowded parking lots. Even driving my old Land Cruiser through Africa was rarely the solitary affair I had hoped for. I once counted twenty-three trucks surrounding one luckless cheetah, and witnessed lion-inspired traffic jams that rivaled rush hour in Shanghai.

This is as good a time as any to confess it all: my shameless hypocrisy, my surpassing selfishness, my burgeoning misanthropy. I want gorgeous land-scapes and stunning wildlife and exotic travel, preferably without too much in the way of personal discomfort or heavy lifting, and I want it all to myself. I want it for the solitude that quiets the din in my head, for that clean break from all the distractions of home and modern living, and for a brief oppor-tunity to settle the hell down and get to work making pictures. I've blazed a weaving and erratic career trail, but if I had to describe my shtick, it's this: Go far. Go long. Go alone.

That original VW camper was a pretty good starting point for indepen-dent travel, offering the open road and a bit of wandering hippie street cred I otherwise lacked. My African truck was a fine next step, permitting months of wilderness travel, rooftop tenting, and off-road shenanigans. In between, over a decade of summers, I puttered around in woefully undersized, inflat-able dinghies across hundreds of miles of northern coastal waters. It made sense in so many ways; it was cheap, required no formal training, and yet was so dangerous and uncomfortable that no one was likely to follow. As a bonus, out on the water, I could go just about anywhere I damn well pleased.

It occurred to me that what I needed next—more than retirement savings, more than the comforts of home, or the love of a good woman—was a real boat.

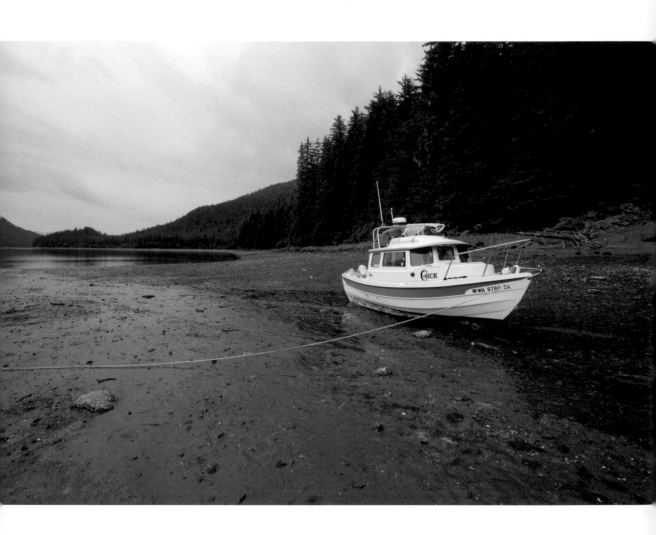

A HOLE IN THE WATER

This might be a good time to point out that I hate boats.

I hate the smell of them. I hate the cloying dampness, the sea-sickening bobbing-cork lurch, and the musty, cramped spaces. Then there's the unmistakable correlation between time on the high seas and violent psychological disorder. I'm hardly the first to observe that life at sea offers all the benefits of prison time—with arguably worse company and distinctly better odds of drowning

Yet even as my brain and my accountant shouted, No, no, no, my heart said, Oh hell yeah. It was time for a proper boat. I already had plenty of experience bashing around the waters of Alaska, Canada, and Greenland in small and often leaky Zodiac dinghies. These were not much more than blow-up rafts with an outboard motor bolted on the back. Light enough to carry as airplane luggage, once inflated, they could carry thirty gallons of fuel, weeks' worth of food, and all the camera gear I was willing to destroy. I covered thousands of miles of remote wilderness coastline in those boats, and felt like I was cheating death at every turn.

C-Sick aground at low tide, Windfall Harbor, Alaska

Picture the elegant simplicity of paddling a sea kayak across the still waters of some wondrous coastal fjord. Now imagine the exact opposite. Riding in a Zodiac can best be described as neck-snapping, molar-shattering torment. Every ripple, bump, and wave on the water is amplified up the length of your spinal column. There's no avoiding every drop of rain sent down from heaven nor the torrents of salt spray tossed up by the sea. Then, at the end of a long day's watery travels, there remained the prospect of locating a suitable campsite, wrestling a soggy tent into submission, rehydrating a bag of freeze-dried cardboard over a hissing camp stove, and settling in for another cozy night's sleep in the wet dirt, keeping one ear cocked for the sound of approaching bears.

For years, I jealously watched big cabin cruisers motoring up and down Alaska's Inside Passage as I squelched around the forest. From my dismal perch, I could watch proper yachting couples traveling in leather-upholstered splendor, sipping cocktails and preparing freshly caught salmon in their stainless steel galleys, before they settled down to eat by the warm glow of generator-powered lights. More than once, as I sat shivering in my dinghy, a stranger motored past and asked where my boat was. What could I say but, "You're looking at it"? If I sniffled and looked suitably pathetic, I could usually wheedle a cup of hot chocolate out of them.

Yet for all the months and miles I'd spent on the water, I didn't know much about proper boating that I hadn't picked up from Jacques Cousteau. On Sunday nights at seven thirty. I couldn't change a spark plug or tie a proper knot or fix a leak, and I was not above navigating with the torn-out pages of a road atlas. Still, I felt smarter than the kayaker I once passed in Alaska's Kenai Fjords who was using the cartoon map printed on some fish-and-chips joint's souvenir placemat.

After a decade of Zodiacs, the novelty had worn thin, even as my obsession with the North grew more fevered. I sometimes wonder how life would have turned out if my early reading hadn't inclined so heavily toward *Never Cry Wolf*, *Arctic Dreams*, and their frostbitten literary kin; if I had directed my creative passions more in the direction of swaying palms, warm breezes, and lissome tropical maidens wearing come-hither looks and not much else. If I'd pursued a life less *Call of the Wild* and more "Margaritaville." But I was

raised Lutheran, and the gray-bearded God of my youth expected us to be brave, work hard, and leave the sun-soaked beaches for more fun-loving folk.

When I found myself with some money to squander, I went out boat shopping. It was more dumb luck than rigorous research that led me to the C-Dory boats. Built just outside Seattle, these rugged fiberglass cabin cruisers were designed for weekend fishing trips around the sheltered waters of Puget Sound. They were small enough—eight-and-a-half feet wide, and twenty-two feet long—to haul on a trailer, but came equipped with a rudimentary bed, table, and kitchen. They reminded me of my old VW camper: simple and functional, but less inclined to leave me stranded with a dropped transmission in the middle of the New Mexico desert.

I bought the first boat I set eyes on. The owner, Pastor Kirby, had christened her "*C-Sick*"—that's Lutheran humor for you. He let me take her out for a white-knuckle test drive on Puget Sound. That I didn't sink the boat and drown us both I attribute to the power of his silent, fervent prayers. He carefully explained that she was in pristine condition, with low hours and two spotless Honda outboard engines. I half expected the good pastor to tell me he'd only driven her to church on Sundays. I was a fish on the hook; he barely had to reel me in. I paid full asking price, far more than she was worth, but you can't stop love.

The C-Dory seemed to me the personification of a Maine lobsterman's boat that had been softened by years of boring office work and life's heavy burdens—a mortgage, maybe some child support—but still tried to keep up with the old gang out on the water every weekend. Inside, her low forward cuddy cabin featured a cushioned V-berth, just big enough for two adults on intimate terms to sleep toe-to-toe beneath a fiberglass ceiling eighteen inches above their heads. The main cabin was taller, with more than six feet of headroom. It was a tight space all the same. I could stretch out my arms and touch the side walls, and it was three short steps—or two long ones when I was scared—from the simple gray-cushioned captain's chair to the cabin door, where I'd find whatever fresh trouble awaited me on the back deck.

Her builders had managed to fit all the necessities of shelter within this space: a combination two-burner stove and heater, and an eighteen-gallon freshwater tank that fed the stainless steel sink and faucet through a small

foot pump. The thirty-inch Formica table dropped down to fit between two simple bench seats and created an austere sleeping berth. She had a tiny icebox big enough for a couple six-packs under the captain's chair, plus more storage under the seats and beneath the galley sink. She came with a tiny, portable flush toilet crammed in behind a privacy curtain, that I replaced, in a fit of Luddite primitivism, with a simple five-gallon bucket.

At the helm, her original instruments were sparse but seemed to cover the essentials. a decade-old GPS with local charts, and a vintage fish-finder that measured depth as illustrated by crude, pixelated images of the fish purportedly swimming in the waters below. There was a marine band radio, a radar display that I neither understood nor trusted, some switches for the cabin and running lights, and a bigger switch to haul up the anchor. There was even a drink holder, sized to the exact dimensions of a beer can.

Pastor Kirby had outfitted the boat with a new canvas enclosure that turned the open rear cockpit into an extension of the cabin's modest living space. I dismissed this as mere frippery and promptly unbolted the thing. It sat neglected in my basement until I had endured a suitable number of cold, rain-drenched months in Alaska watching the open cockpit fill with water. When I finally relented and bolted the canvas back into place, *C-Sick*'s usable space was effectively doubled. Its clear plastic windows revealed all the scenic wonder with none of the steady trickle of ice water running down my neck.

Fully laden, the boat required a bare three feet of water to float—closer to two feet if I was quick enough to hit the hydraulic lift that pivoted her engine propellers up and away from danger. Modeled in part on old fishing dories, her bottom was nearly flat. Throttle open, *C-Sick* flew across flat water like a skipping stone, but when the wind kicked up, she transmitted and amplified every ripple and wave.

Pastor Kirby, always prudent, recommended running the engines around fifteen miles per hour or thirteen knots. I have always been more of a full-throttle guy, but as soon as I signed the papers, I recognized that this was a lot more boat than anything I'd had keys to before. I was now responsible for a young life, precious and fragile: *C-Sick*'s, at least, if not my own.

One of the many wonderful things about America is that you're free to buy any boat the bank is dumb enough to finance and, without a lick of training, head out onto the wide-open ocean to kill yourself and any other fool who steps aboard.

In an uncharacteristic moment of foresight, I signed up for a Power Boating for Complete Morons class down at the marina. I learned the basic rules of the sea, docking and navigation techniques, and some of the simpler forms of maritime suicide prevention. One lesson the course thoughtlessly omitted was how to back a fully laden trailer down a boat ramp while enduring the jeers and taunts of any nearby drunken fishermen. After fifty or sixty tries, I just about got the hang of it, but my palms turn sweaty every time I think back to those humiliating spectacles.

That first summer exploring the wild corners of the Alaska coastline, I quickly learned that boating exists in a gray zone between life as an unemployed grad school dropout and formally joining the ranks of the homeless. I might not bathe for a week. I crapped in a bucket, slept on a fold-out sofa, drank alone and to excess, and compulsively talked to myself—all while trying to avoid the watchful eye of law enforcement personnel. I finally began to understand why married men, grown weary of the responsibilities and comforts of their domestic routine, go fishing. I'll give you a hint: it's not about the fish.

Barreling along with the throttle open and both engines roaring, I covered nearly more than four thousand nautical miles that first summer. It turns out knowing fuck-all about boats is not the hindrance you might expect. When I dinged a propeller on the rocks, I figured out how to unbolt the mangled prop and slap on a new one while hanging over the transom, after only fifteen minutes of vigorous upside-down swearing. When I misread the tide charts during a shore excursion, and returned to find *C-Sick* sitting high and dry amidst the starfish and sea urchins, I trudged across the squishy tidal mudflats, climbed back aboard, and as punishment watched *The Perfect Storm* for the third time on my laptop until the tide came back up and we floated free. As long as no one was watching, I was content to work my way slowly, if expensively, up the nautical learning curve.

For the next several summers, I returned with *C-Sick* to photograph the length of the Southeast Alaska panhandle, then worked up the nerve to take her from Kodiak Island out to the forbidding Alaska Peninsula and storm-swept waters of Katmai National Park. I followed in "Grizzly Man" Timothy Treadwell's erratic and doomed footsteps, walking among dozens of brown bears for months at a stretch. But the bears didn't scare me half as much as the howling storms and murderous forty-mile open water crossings. I still remember some old coot of a bush pilot looking out at my boat and shaking his head in disgust, muttering, "You're gonna die cold and alone out here, boy. Cold and alone."

Maybe, old timer. But not just yet.

In between my solo boat trips aboard *C-Sick*, I also chartered proper expedition sailboats, steel-hulled seagoing yachts, to take more ambitious high-latitude trips; south to see penguins in the Antarctic and a couple times up to Norway's Svalbard archipelago, near eighty degrees north latitude. I wanted to photograph polar bears and the barren, Arctic landscape. The place was otherworldly, halfway between the top of Europe and the North Pole—stark, frightening, and breathtaking in its austere beauty. It was also not cheap. The boat charter alone cost more than $25,000, on top of the extortionate costs of plane tickets, food, and the abundant stocks of liquor required to maintain the skipper's good humor. Even during the photo industry's flush years, I could never afford a three-week charter on my own, so I cast a wide net and dragged along anyone who could pay. A few even remained friends after the yelling was over. Others, well, there is no enemy quite like the one you make on a cold, cramped boat in the middle of nowhere, with no possible escape from each other. I will accept much of the blame. I know that I can be difficult.

For all my faults, though, laziness is not among them. I had come to photograph polar bears, and photograph polar bears I did. I would stand on deck in the cold wind for hour after toe-numbing, finger-freezing hour, doggedly scanning the ice. I adopted my best steely-eyed, thousand-yard stare, feet apart, and scanned the ice through a pair of bulky and overpriced German binoculars. When I finally spotted my quarry, I notified the skipper with a curt flick of my chin to show our new course, and say simply, "Bear."

No wonder everyone hated me.

Before I found myself set adrift on some lonely iceberg by mutinous ship-mates, I needed to find another way. I turned to *C-Sick*. I imagined that if I could take her north, I might see polar bears on my own terms, living among them for weeks or months at time, with no one else around to complain about my personality quirks, poor hygiene, or wretched cooking. It would be just me, *C-Sick*, and the bears.

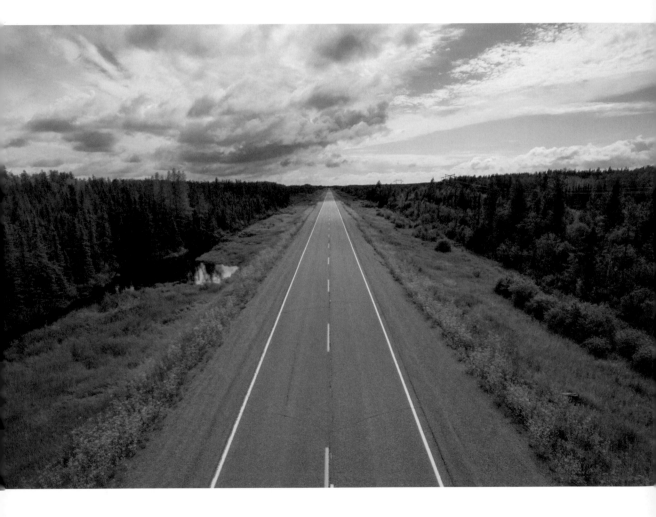

CHAPTER 6

DIRECTIONS NORTH

After that first Zodiac trip to Churchill, I reasoned that if I had found the polar bear of my dreams just thirty miles from town in a dinky Zodiac, there was no limit to what I might see during a whole summer out in *C-Sick*.

There was, of course, the small matter of getting two tons of boat across hundreds of miles of roadless wilderness to Hudson Bay. I could have saved myself a lot of trouble and simply loaded *C-Sick* onto a northbound freight train, retracing my previous summer's steps. But that felt like cheating. So instead, I envisioned a grand journey that would begin at the end of my driveway and ultimately deliver me to the top of the world. I started planning with nothing more than my outdated Rand McNally road atlas. I've always found something seductive about maps. They offer all the promise of travel and adventure and discovery, yet foretell nothing of the discomfort, misery, and expense my travels always seem to entail.

I traced the fat blue ribbons of American interstates to where they fed into an orange-colored line that marked the Trans-Canada Highway. From there, I could cross over the Rockies and traverse the rolling heartland prairie

Deserted highway, northern Manitoba

that spanned almost half the continent. After that, the path turned thin and red as it wound up into the northwoods of Manitoba, until finally dwindling to a tentative dotted track, like a string of breadcrumbs, that ended at a town I'd never heard of along a river I didn't know existed.

If I could get past that last pinprick of a town, Gillam, and find the spot where my map showed the Nelson River flowing winding and blue, it would be only seventy-five miles to the vastness of Hudson Bay. From there, I'd hang a left at the river's mouth and head north. It was only a couple hundred miles to Churchill. Beyond that, I counted five little dots, tiny towns or villages scattered along the coastline between Churchill and the Arctic Circle, more than five hundred miles north as the crow flies.

It sounded almost too easy.

Digging deeper, I read that the Nelson River once ran free, deep, and clear almost four hundred miles from Lake Winnipeg north to the Bay. That was until 1957, when Manitoba Hydro saw fit to run the first of what has become six dams to generate cheap electricity for cities far to the south. Cree Indian tribes once lived all across this rich interior. They paddled birch bark canoes along the river's fast-flowing waters to hunt and fish and trade. The arrival of French and British explorers, traders, missionaries, and settlers resulted in the familiar litany of colonial exploitation: Eden despoiled, fortunes made, and the local First Nations cultures displaced and dispossessed and forever changed.

In truth, I wasn't looking for a history lesson. All I wanted to know was if I could get my beloved, benighted *C-Sick* into the water, down the river, and out to sea. The internet was largely silent on the matter. Then I stumbled upon the Nelson Adventures website.

The owner and operator, Clint Sawchuck, worked for Manitoba Hydro by day, and ran a jet boat river outfit for the rare tourist who happened upon Gillam and wanted to travel downriver out to the Bay or the ghost town at nearby York Factory. When we talked on the phone, Clint said; "Yeah, sure, it's possible. If the river's up, you can make it." He said there was a rough boat launch not far from town, but there was only enough water to float a boat when the Hydro company opened the flood gates and raised the river level by several feet. He also mentioned that it was more than 150 miles

from the mouth of the Nelson River up to Churchill. "The old trappers would make that trip in big twenty-four-foot freighter canoes, wait for good weather, then run like hell. There's not a bit of cover for a big boat along that whole stretch of coast."

I put my fate in the hands of this affable stranger and set to work. I still had lots of questions. I found charts showing satellite views of the pack ice, lurid stretches of red that revealed thousands of square miles of impassable ice. I did some half-assed research on weather patterns and marine forecasts, but it all amounted to variations on the old song "Stormy Weather." There was still a long list of things I didn't know.

But I did know this much: everything about Hudson Bay was big, and in comparison, *C-Sick* was very, very small. But she was all the boat I owned, and she hadn't killed me yet. I figured she could carry sufficient fuel and enough food to get me from one remote village to the next. After years of Alaskan boating, I was no stranger to cowering at anchor, and reckoned I could take whatever bad weather the Bay threw at me. And if worst came to worst, I could always run *C-Sick* up on shore and start walking home.

A trip like this could, and probably should, take years of preparation: a slow acquisition of the necessary skills and training and professional-grade equipment. Given enough time, anyone in their right mind would likely come to their senses and decide to stay home and catch up on the yard work instead. For me, it's always made more sense to just go. Go before doubt creeps in, and then figure things out along the way. I wasn't getting any younger and I imagined that, if nothing else, I could fail in truly spectacular and memorable fashion.

There's a lot of talk these days about ultralight travel: bring only what you can carry on your own back. I'm more of a "bring-everything-and-the-kitchen-sink" kind of guy. In fact, better bring two sinks, because I'll surely break one.

First, I ordered maps. I bought a thick stack of nautical charts and topographical maps that detailed the coastline, from the Nelson River's mouth and nearby Cape Tatnam all the way up to Fury and Hecla Strait, at the heart of the famed Northwest Passage some eight hundred miles north. Sure, past

seventy degrees latitude the Arctic coast is perpetually locked in ice, swept by raging storms, and utterly suicidal for me to contemplate touring, but . . . I wanted to keep my options open.

C-Sick had suffered mightily through my clumsy and collision-prone Alaskan navigations. The few times I took her out on the water near Seattle, she started reluctantly and spewed smoke, apparently sulking. Someone needed a spa day. The guys at my neighborhood boat shop were notably unimpressed with my maintenance skills. They catalogued years of neglect and mistreatment, from fouled plugs and corroded carbs to mangled gears and a leaking head gasket. They made me feel like an abusive husband. The final tab of $2,809.89 gutted my bank account and still covered only half their long list of critical repairs. I figured my chances of getting all the way to the Arctic Circle, let alone back again, were at best fifty-fifty. By my distorted logic, authorizing only half of the needed work seemed a fair trade. I would get to the other half if I ever made it home in one piece.

The garage became ground zero for my planning. I searched the internet for every cheapskate deal and free shipping offer I could find, then began ordering mountains of food, like some paranoid hillbilly prepping for the end of days. I bought powdered eggs and canned ham, dried blueberries, salted nuts, an eighteen-pack of dehydrated vegetables, and two large vacuum tubes of chicken that resembled freeze-dried cat turds. There were pouches of Indian curry, boxes of Cajun beans and rice, and enough penne pasta to feed half of Sicily.

I even bought canned bacon. Bacon. In a can. Stuff you wouldn't eat until the waning hours of the zombie apocalypse.

Something happens in my brain whenever I start planning a trip like this one. I couldn't be trusted to tie a bowline knot or change a spark plug; my tool kit and its attendant collection of rusty spare parts were a joke. In the face of so many unknowns, I obsessed over the few tangible things, however meaningless, that I could control. Here, I compulsively gathered, labeled, and alphabetized two dozen miniature Ziploc bags filled with cooking spices.

I am all about priorities.

I unearthed layers of polypropylene long underwear that had seen me through one too many cold and mildewy Alaskan summers. But I was

traveling alone, so why spend money on replacements? Anything new would smell just as bad by the time I was done with it. Instead, I blew more than a thousand bucks on heavy Gore-Tex bibs and a matching jacket at the Helly Hansen outlet store, then drove back the next day and picked out a one-piece survival drysuit. All of it was as stiff as cardboard and as fashionable as a fireman's turnout gear. But the labels promised to render me impervious to hurricane winds and monsoon rains—if not from the withering scowls of actual yachtsmen. As a bonus, the survival suit was crimson red, convenient both for hiding bloodstains and improving the odds that a search and rescue team might locate my remains.

Over the decades, I have accumulated a small mountain of both camera gear and waterproof cases. Without too much regard for how it all fit, I set about cramming one into the other. I wasn't limiting myself to the usual assortment of cameras and lenses, either. I needed underwater housings and radio triggers for remote camera traps, along with an array of tripods, clamps, cables, and mounts. I bought a first-generation Chinese-built drone, hoping to shoot aerial pictures with both feet planted firmly on solid ground. I made a list of every single thing I might conceivably use on a six-week shoot, then bought two of them. And sometimes a spare.

The immensity of the expedition weighed heavily on me, and the preparations became a welcome distraction. All through my life, I have been afraid of the wrong things. Collapsing glaciers? All in a day's work. Large, unpredictable, and pissed-off wildlife? Bring it. Insurmountable credit card debt? No problemo.

It was grown-up life—with its sober commitments, responsible behavior, and the white-picket fence—that scared me stupid.

I spent decades of my adult life as if it was one long, college sophomore year. Then, to my considerable surprise, I woke up one day and realized I was about to turn fifty. Suddenly I understood that this would be my last chance to try growing up.

I had been dating a lovely woman for a few years. Like my mother and grandmother, she was a nurse, though unlike them she had left the operating room and moved into a new career working as a successful medical

sales executive. When we began dating, my friends shook their heads and said, "Dude, you are so punching above your weight with this one." As my semi-centennial approached, the topic of rings came up. Instead of running for the airport, I stuck around, and asked this beautiful woman to be my wife. Janet and I bought a sweet, old house in a quiet Seattle neighborhood. We adopted a dog. Together we began to perfect a normal, happy life together. It was the strangest sort of midlife crisis.

One evening while we were cooking dinner—well, Janet was cooking while I hacked away at some vegetables—I looked over in amazement and said, "We're just like normal people." And that, to me, felt like the purest kind of love. Nobody had to rappel off a mountainside that evening, or wrestle a python, or scuba dive beneath the polar ice cap. We could simply enjoy a home-cooked meal and a glass of wine and sit by the fireplace. It turned out normal was . . . nice.

And now I had something to lose by charging off with *C-Sick*. It frightened me in ways I couldn't even name.

Reluctant to admit any of this fear directly to my wife, I unloaded on her co-workers instead. My third cocktail into a wedding reception for one of her colleagues, I blabbered to half the table that this was "the most dangerous thing I've ever done," and "the scariest trip I've tried." And "whatever you do, don't tell Janet."

This did surprisingly little to inspire confidence on the home front.

I did what I could to control the hazards I thought I might encounter. I had once believed that polar bears to be stone cold, blood-thirsty killers, an animal that would track you, hunt you, and skin you alive for the sheer ugly joy of it. The reality I'd seen in earlier forays to Svalbard and Churchill showed the animals in a more realistic light. Still, in fevered dreams I imagined a bear climbing over *C-Sick*'s white gunwales like one more iceberg and bursting through the cabin doors. Come morning light, there would be nothing left of me but a smear of blood, a pile of smelly long johns, and that damn can of bacon, still untouched.

All the same, I may have gone a little overboard with the bear protection. I found a tripwire fence that would emit a deafening shotgun-shell blast if a bear stumbled through its perimeter—great if you wanted to try reasoning with a

wire-entangled, half-deaf, and fully enraged polar bear. I bought dozens of noisemaker shells and a pen-sized flare launcher, which was like the shittiest gadget from the worst Bond movie ever, a pen that goes "bang" . . . but not very loudly. I could deploy it in case stern looks and strong language failed to dissuade a marauding bear, or if I was set upon by angry marmots. In the end, I also packed last summer's shotgun, along with its unused case of rifled lead slugs, and two more boxes of twelve-gauge bear bangers.

In late June, after months of preparation and weeks of buying, sorting, and packing, I finally loaded everything into my aging Volkswagen Touareg SUV. It was a truck created more for divorced dads venturing back into the dating game than for rigorous off-road use, let alone serious transcontinental boat hauling. With *C-Sick* in tow, my VW looked like a silver ladybug pulling some enormous bathtub toy. But it was already paid for. And it got the job done.

It was closing time at the local boat shop when I drove down to retrieve *C-Sick* and pay my exorbitant tab. After releasing her back into my care, the mechanics watched with amusement as I nervously lined up the ball hitch and boat trailer. I attached the trailer and drove off amid muffled sniggering. I hadn't gone four blocks when, in the middle of traffic, I felt a sickening thud. I looked back to see the boat and trailer lurching skyward. Oh shit . . . I slammed on the brakes and the trailer hitch rammed into my truck, then bounced off, and started to roll downhill until safety chains brought it up short and yanked it back into the Touareg again. The process repeated itself two or three more times before both vehicle and boat trailer ground to a halt in the middle of the street.

In my haste, I'd failed to properly lock down the hitch. It could have been worse, of course. If I'd forgotten the safety chains, too, *C-Sick* might have careened back toward the sea in a kind of slow motion, made-for-TV-movie disaster that could have led to serious bodily harm and expensive legal action, and necessitated that I move to some other state—one that began with an I, like Iowa or Indiana or Illinois, a long way from any ocean. I might be stupid, but for once I was lucky. My neighbors, kind folk of humble Norwegian stock, refrained from mocking laughter. Some construction guys stopped their trucks, hopped out, and helped me block the trailer

wheels and untangle the mess. One even lent me a shop jack to help pry the trailer's hitch from beneath the undercarriage. Except for my embarrassment, the only real damage done was a shallow impact crater on the VW's hatchback.

I drove the rest of the way home feeling rattled. This was going to be a long trip.

I packed the boat and stuffed the Touareg with all of my supplies. I made an agonizing seventeen-point U-turn to maneuver the VW and boat trailer on our narrow street: back and forth, back and forth. I blocked traffic for what felt like a week, burning with shame, until I was finally facing the correct direction. I pulled to the side of the street and nearly ran over a neighbor's cat, then held Janet in my arms.

"I'll call when I get there," I sniffed, my eyes brimming. We had been doing this dance for years now. I always milked these departures for every ounce of drama. Janet, the trained healthcare professional, knew to tear off the Band-Aid in one clean, swift motion.

"You're driving to Spokane. It's six hours, but by all means . . ."

As I turned the key to restart my truck and begin the long drive east, she looked at me with her clear blue eyes and said, "Try not to get yourself killed, okay?"

From long practice, Janet and I had settled into a routine for handling these long absences. When loneliness stalked me, I would call her after dinner from whatever campsite or foreign hotel I'd washed up in, recount the day's anecdotes and indignities in a long monologue, then try to wrap up the conversation quick to save on long distance charges. This time, Janet was having none of it. Once I launched *C-Sick*, I was to call each evening and provide my latitude and longitude. She, in turn, would give me the marine weather forecast. After that, we'd begin another of our uniquely frustrating satellite conversations, filled with satellite delays and overlaps and "You're fading" and "Can you hear me now?"

Two long, full days on the interstate took me as far as North Dakota. I hung a left and, after crossing into Canada, drove east on the Trans-Canada Highway, traveling parallel to a massive storm system tearing across the

Saskatchewan prairie. The next morning, I drove past downed trees, power outages, and an aluminum canoe wrapped around a telephone pole.

Tornadoes in Canada? Who knew?

Lush farmland gave way to interminable spruce forest that stretched for mile after mile across northern Manitoba. Any time I stopped to pee by the roadside or stretch my sore back, a cloud of biting black flies swarmed in an angry circle. The grille of my truck was coated with a foul and sticky mat, and big, black ravens would descend to pick at their crushed remains.

The pavement ended in the gritty, nickel-mining town of Thompson, nearly eight hundred miles from the US border. From there, I still had two hundred more miles of rattling gravel roads to reach Gillam. Forest fires had swept through the area in the past weeks, closing the road for days at a time. The air remained thick with smoke even after the previous day's rain, but I managed to navigate the rough gravel, dodging bigger rocks and sluicing through mud. As I drove on, it occurred to me that I had almost no plans for what would happen once I arrived. How was I going to get *C-Sick* into the water? Clint, my only local contact, had left a garbled cellphone message of vague directions to some boat launch a few days earlier, then departed on vacation.

Ten miles shy of town, I drove across the broad concrete rim of Kettle Dam. When I stopped in the middle and looked over the side nearly two hundred feet to the river below, I could see a winding dirt access road leading to an unexpectedly well-tended boat launch. Well, that seemed to solve at least one mystery. I drove down and backed the trailer into the surprisingly placid Nelson River, floated *C-Sick*, then took the boat out for a quick test run. Hell, this was gonna be easier than I thought. I dropped anchor and took my truck the remaining few miles to town to top off my fuel tanks.

I drove first through the town's well-tended neighborhoods before reaching Gillam's grittier downtown. The old train station looked derelict and half-abandoned, with plywood nailed over broken windows. I found the local Co-op store where I could fill my gas cans. I said something to the attendant about my plans for heading downriver all the way to the Bay from the nearby boat launch. He gave me a puzzled look and said, "Yep, you can go a-ways for sure. Twenty miles down to Long Spruce Dam, I'd say. But after that, I dunno . . ."

So maybe that wasn't the right boat launch after all.

I slunk back to the ramp, hauled *C-Sick* out of the water, then drove another fifty miles downriver. I went past not one but two more dams, to the sprawling site of a third dam under construction at Conawapa. Work had only recently started, but bulldozers had already cut a rough path down to the river. The cut ended at an uneven rock shelf that served as a crude boat launch. I wandered around the rocks in my rubber boots, trying to pick out some workable path into the water.

I couldn't see the river bottom through all the silt, so I dug out an oar and started poking around, probing the shallows.

The water level rose and fell according to the inscrutable whims of Manitoba Hydro, which could release millions of gallons of water from the dams and raise the river by several feet. Or not. It was impossible to tell. I could have stood there until Christmas and never known for sure if it was safe to go. Sunlight danced off the river and filtered through a forest that seemed to stretch green and lush across the continent.

Finally, with a shrug, I began heaving a half ton's worth of fuel cans, waterproof hard cases, and random boxes of food on board. Then, inch by inch, I backed *C-Sick* toward the river. My gut sank when the trailer dropped hard off the rock ledge, but when I looked back, I could see the water was just deep enough for my boat to float free.

I let out enough anchor line to hold the boat in place, then parked my truck and trailer off in a corner, seemingly out of harm's way. I hoped they wouldn't finish building that dam before I got back in the fall.

The only thing I could remember from Clint's instructions was that the channel started on the far side of the river. I fired up both motors, then I stepped out onto the bow, hauled in the anchor chain, and headed out across the river and into swift, deep water.

THE RIVER AND THE BAY

The wilderness was vast and seemingly empty, but as I motored along I was nestled in a glowing cocoon of technological magic. Not one but two Garmin GPS chartplotters silently communed with the satellites overhead. My radar system could penetrate the thickest of fogs, though the day's clear skies and sunshine made the prospect unlikely. My depth-sounder pinged sonar pulses off the rocks below, and I even carried something called, in bureaucratese, an Emergency Position Indicating Rescue Beacon, or, more jauntily, an EPIRB. Supposedly it would, at the panicked touch of a button, supply my coordinates and credit card information to the nearest helicopter rescue service.

I may not have known what I was doing, but I could tell you exactly where I was doing it.

Later in my travels, I would encounter a number of Inuit who would sagely tap the side of their heads and say, "My GPS is right up here." To be sure, I admire anyone who can find their way through the wilderness unaided by modern technology. Then again, growing up in white-trash Pennsylvania, I could usually find my way home just by following the smell of chickenshit and the trail of broken beer bottles. But out here at the ass end of nowhere, I was

Following pages: C-Sick at anchor, Marble Island, Nunavut Territory

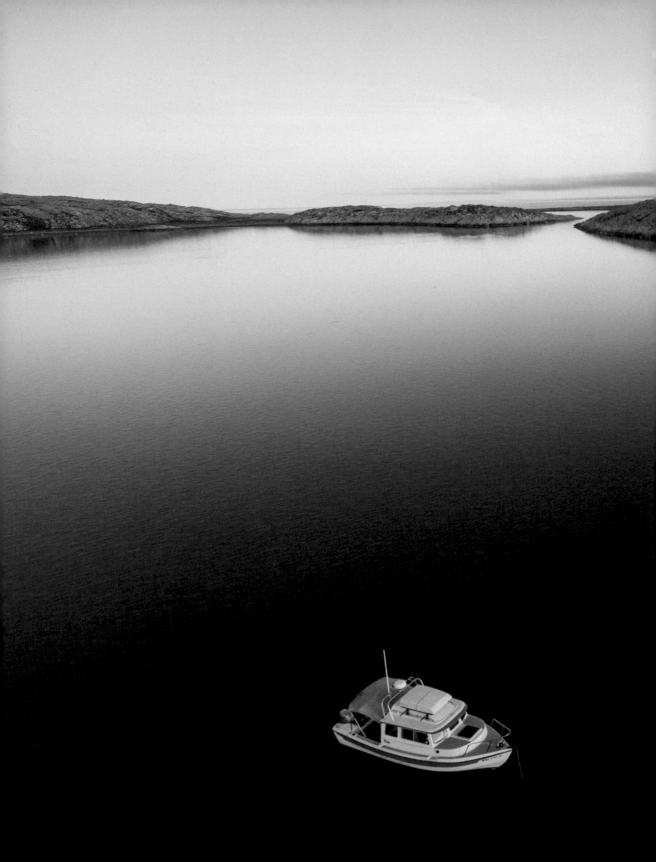

always one blown fuse or dead battery away from becoming an Arctic version of Tom Hanks' character in *Cast Away*, without the coconuts or the volleyball.

Even with all this technology, the way forward seemed little more than guesswork. I quickly discovered my fancy electronic charts displayed nothing about the Nelson River this far inland, and I hadn't thought to bring along a topographical map that might show the river's contours. Aside from the twenty-foot-high banks, there wasn't much in the way of topography, anyway—just hundreds of miles of flat, buggy forest that eventually gave way to flat, buggy tundra.

I motored along blindly, using my depth-sounder to steer clear of submerged rocks and the irregular shelves of hard granite, invisible in the milky green water. Every time I passed over a shallow spot, I unconsciously held my breath and lifted my feet off the floor, as if that was going to help.

When I reached the deeper main channel, a strong current swept *C-Sick* downriver. I was soon traveling at more than nine knots, nearly eleven miles per hour, with my engines hardly ticking above an idle. There was no turning back. I couldn't fight my way back upriver against this current even if I wanted to. Like it or not, I was on this ride to the end, seventy-five miles to the Bay and whatever came after. I let go of that unhelpful thought and settled in as best I could, relaxing enough to enjoy the warm sun and a gentle breeze blowing upriver. It occurred to me that I should remember this feeling—the beginning-ness of it. Lost in the swirl of planning and motion and action, I had spent weeks plunging blindly ahead without ever taking time to appreciate the moments as they passed. I took out my cameras and shot a few desultory frames to record the scene. Silty river, sky of blue, forest green. But for the most part I simply basked in the fleeting minutes when I might finally breathe in and out and slow the passage of time.

From a distance, the spindly spruce forest and dense carpet of moss atop crumbling riverbanks looked almost inviting, like something out of a fairy tale, if you could ignore the swarms of biting and blood-sucking insects. Where fires had swept through, stands of dead, sun-bleached trees stood straight as toothpicks along the river. I counted a half-dozen bald eagles, along with scores of Bonaparte's gulls and Arctic terns, diving for fish in the swirling rapids.

Gradually the river grew wider. In the late afternoon, I rounded a bend and suddenly the steep banks and endless green forest gave way to . . . nothing. Off in the distance, I could just make out the featureless horizon, and beyond it, the Bay.

I laughed out loud. It was all going to be okay, after all.

And then, it wasn't. The depth-sounder shallowed suddenly from ten feet to eight, and then five. I let myself be distracted by some rattle behind me and, as I turned around; the first sickening crunch of rock against boat. I scrambled to get my engines up without tearing off the propellers, but the current had me. *C-Sick* slammed into barely submerged rocks again and again, making a horrible grinding sound. When the music finally stopped, I was well and truly grounded.

On the bright side, I was unlikely to either sink or drown in less than two feet of water. The bad news was that we were stuck at least fifty river miles from another living soul. My big Arctic expedition ground to a humiliating halt before I even reached salt water.

If there was an instruction book for this sort of mess, I'd never seen it. Improvising, I started offloading sixty gallons' worth of extra fuel cans into the Zodiac I trailed behind *C-Sick*. Then I chucked in the heaviest camera and food cases on top. After that, I hopped over the side into the river shallows and began shouldering *C-Sick* with all my strength. I managed to get her off the rocks and scrambled back on board before she had a chance to drift out of reach. I didn't have time to celebrate, because she quickly grounded again. The next two hours devolved into a slow-motion nightmare: too many rocks and not nearly enough water. I tasted the rat-breath slick of desperation in my mouth as I struggled to float more than a hundred yards at a go before fetching back up on the rocks.

At one point, having floated *C-Sick* free, I strung the boat along by a rope tied to her bow, leading her through knee-deep water like a reluctant dog. Up ahead, I could see a group of seals swimming upstream. I climbed aboard to grab a camera, only to realize that the seals were really just more rocks sticking out of the fast-flowing current. The sun dropped slowly behind thickly forested hills. It was hours later and nearly dark before I found enough deep water to restart the engines. I painstakingly picked my way into the lee of

two small islands and finally dropped anchor with less than ten feet of river beneath me.

My anchor was sixteen pounds of tensile steel shaped like a three-toed claw and designed to bury itself in the muddy river bottom. It was secured to fifty feet of galvanized steel chain that was, in turn, spliced on to 150 feet of 5/8" three-strand nylon rope, and finally attached to a reinforced U-bolt through *C-Sick*'s hull. After I bought it, I found a spec sheet that said the anchor chain and line, called a *rode* by the nautically inclined, should withstand 8,910 pounds before breaking. I wondered uneasily who was in charge of testing that. I hoped it wasn't some college kid whose dad got him the job for the summer.

In theory, you could lift *C-Sick* out of the water and hang her up to dry by that anchor. I did know it had once held through eighty-knot williwaws that came howling out of the Alaska Range, kicking up a wall of white spray before nearly capsizing *C-Sick*.

At eleven p.m., the last light of day colored high cirrus clouds salmon and blue. This far north, the sky was still too bright for stars. I poured a dram of Irish whiskey to settle my frayed nerves and stepped outside to brave the mosquitoes out on the back deck. I raised a toast to absent friends, thanking them each by name as I pictured their faces, one by one.

I poured the last thimble of my drink onto the river's swirling surface, a small offering. I hoped it might reach the Bay and mollify its irascible gods. The whiskey was gone in an instant, swept toward the vast sea looming ahead.

That night I woke repeatedly to check the anchor's hold. In the three a.m. half-darkness, I looked up and smiled at the familiar sight of the Northern Cross as a pale band of aurora arched overhead.

At dawn, *C-Sick*'s GPS display showed us anchored somewhere up in the forest, hundreds of yards away from the river, a discovery that further eroded my already shaky confidence. I lowered one of the two outboard engines into the water, reserving the other in case I tore up the prop, and began to slowly nose my way into deeper water along the Nelson River's main channel. In the distance, I could make out the abandoned train trestles left nearly a century

before at Port Nelson. Early shipping magnates dreamed of a shortcut rail and ocean link between the prairie wheat fields and British and European markets. They pushed a railroad north across hundreds of miles of boggy forest, all the way to the Bay's shores, then built a shipping terminal there. Boosters loudly and unironically proclaimed in *The Hudson Bay Road* that the Bay would soon be "the Mediterranean of the North." During the port's brief time in operation, three ships sank in four short years, and the business collapsed with the start of the First World War. A hundred winters of river ice had shattered the bridges' timbers, and the rusted tracks now hung twisted and looked ready to topple into the water below. One of those shipwrecks was still there, hulking and rusted, lying half-submerged just off-shore. I find there is nothing quite like a grand spectacle of ruin and costly failure to shine the harsh light of perspective on my own fragile dreams.

I tempted fate with a playful slalom run through the old trestles, taking snapshots and wondering when the whole thing might crumble down on my head. Then, I headed out into the Nelson River's wide delta. I timed my departure out into Hudson Bay to take advantage of the ten-foot out-going tide, hoping to ride its current away from the braided shallows and into deeper salt water. What I didn't anticipate was an opposing east wind blowing in off the Bay. One minute I was traveling at nine knots over calm seas; the next instant, I was slamming into steep, standing waves. Cresting a three-foot roller, *C-Sick* pitched over hard and I heard a dismaying crash from overhead. I had started this trip with a large cargo rack bolted on top of *C-Sick's* cabin. It was a last-minute addition, to store lightweight but bulky supplies like toilet paper, my bear fence, and some empty fuel cans. Now it was upside down and floating away across the Bay.

I considered letting the damn thing go, but this would be a long trip without toilet paper. With a torrent of swearing and one-false-move-and-you're-in-the-water grappling, I wrestled the cargo box onboard, soaking myself as gallons of seawater poured out of it. I had long imagined the moment when I would finally reach Hudson Bay: it would mark a huge milestone and should have been a moment of celebration. As it was, I was too busy squeezing seawater from my eighteen-pack of toilet paper to much notice. By the time I bolted the cargo box back in place and lashed it down

with a couple heavy cargo straps, I was breathless and furious and soaked to the skin.

Hudson Bay covers nearly half a million square miles, and is connected by a narrow, tide-swept strait eastward to the Atlantic. There is an even more tortured and ice-blocked path to the west, via Fury and Terror Strait through the Northwest Passage and on to the Arctic and Pacific Oceans. The Bay's waters begin to freeze in early November, and do not thaw again until the long hours of daylight return in June and July. The last remnants of ice sometimes linger late into the summer months. These patterns change with the vagaries of each year's weather, but more than a century's worth of statistics show that a rapidly warming climate has left more open water for longer periods through the summer.

Environment Canada posts ice charts each day on its website, and I had been obsessively watching the winter ice's melt for weeks. As I prepared for my departure, I grew worried, then dismayed. All the ice along the Bay's west coast, between the Nelson River delta and Churchill, had melted weeks earlier than usual. The satellite maps now showed only a few icy remnants floating out far to the northeast of the Nelson's mouth. I had many miles to go before I might find enough ice to chill my evening cocktail, let alone support any polar bears.

My destination for the day was Cape Tatnam, still fifty nautical miles off. The C-Dory was designed as a speedboat; its twin forty-horsepower outboard motors could send a lightly loaded boat skipping along at more than twenty-five knots. She came from the factory with two twenty-gallon gas tanks, which, used carefully, might propel the boat for 150 miles. As my trips grew more ambitious over the years, I accumulated a stock of six-gallon plastic cans that soon filled every available space on deck. I kept the leaky red containers held in place with a tangle of bungee cords and ratchet straps. *C-Sick* now carried more than one hundred gallons of fuel, weighing close to six hundred pounds, and my woefully overloaded boat sat low in the water. Add to that hundreds more pounds of camera equipment, survival equipment, and food—and the additional burden of sodden toilet paper on the roof. If I had to, I could push the boat up to twelve or maybe fifteen knots,

but as I bumped up the speed, the engines would use exponentially more fuel. My plan was to go slow. At a leisurely pace of five or six knots, I burned a single gallon per hour, and could travel as much as five hundred nautical miles before I would need to start paddling.

Soon, I felt like I really was at sea. Port Nelson slipped beneath the horizon, and I traveled miles offshore to avoid the mudflats and shoals that stretched far out into Hudson Bay. Only a faint line of refracted, distorted forest marked the shoreline far to the south. There was nothing but sea all around and a flawless blue dome of sky above.

Along this part of the Bay, I never saw another boat. Or ship or barge or skiff or raft, either. Except for a few jet contrails far overhead, I might have been the last man on Earth. As hours passed, I began to feel a vague anxiety growing beneath the burden of the vast and featureless expanse. I felt every one of the six hundred open miles of ocean to the north like a weight teetering above my head, ready to come crashing down with the next storm. I didn't even know where I was going to anchor that night. Not that it mattered, really; there wasn't an island or a natural harbor or the slightest hint of shelter where I was headed.

Clouds of black and common scoters wheeled and turned in the coloring sky as the sun slid from the western horizon toward north. I could find not a hint of the promised sea ice. Instead, a forest fire billowed smoke from beyond the tidal flats.

I tried not to think about the fickle weather or how utterly exposed I was, five miles out from shore and ten times that far from shelter. Hours later, when I dropped anchor at sunset, the evening breeze calmed. The Bay went still: a steely blue pool, shimmering and magical. I climbed up onto the roof, and stared out at the water stretching to the horizon in every direction. I felt smaller than a dust speck floating on this endless sea. From my starting point on the Nelson that morning, I'd covered seventy nautical miles. A good day's work.

I woke to the smell of smoke—never a good sign, especially on a small boat. I bolted upright and stared wildly around, but was greeted not by flames, but instead by a thick white haze of forest fire smoke borne on the wind. A short night's sleep had left me punchy and a little slow out of the gate. I wanted

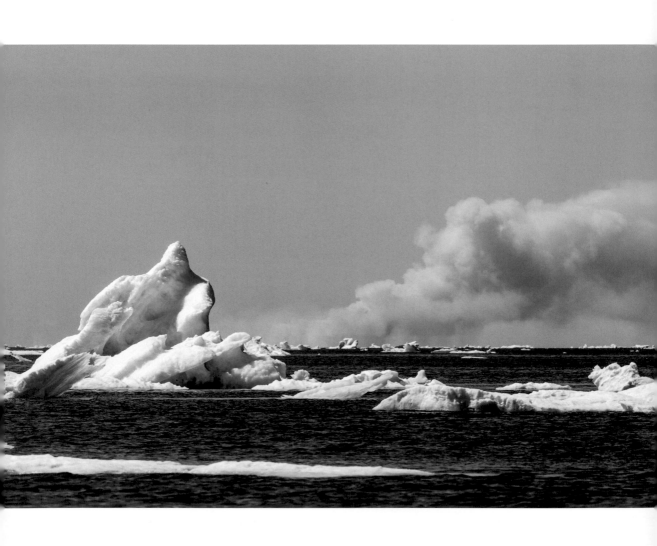

to run the Zodiac out to where I thought I might find the pack ice, and I set off heading due west. I motored along for several sleepy miles before it slowly dawned on me: I was heading the entirely wrong direction, and away from the ice. I swung the dinghy around 180 degrees, back the way I came and into what I thought was a line of morning fog. But in an instant, I was coughing and rubbing tears from my stinging eyes. I was motoring blindly along through clouds thick with yet more wood smoke.

I traveled nearly two hours away from *C-Sick* before I spotted my first pieces of ice. It was twenty miles more before I reached the edge of the pack. I spent the next few hours studying mile after mile of dirty, broken ice. No polar bears, just the disconcerting sight of distant trees burning in the summer heat, billowing plumes of smoke, and ice melting away before my eyes. Soon, the Bay's mood began to darken, and an easterly wind started to build. I turned the Zodiac back toward *C-Sick*, but before long I was struggling to muscle the inflatable dinghy up the back of tall waves. At each crest, we pitched forward over the top, crashing down into the trough below. I fought to keep the boat balanced, hold everything onboard, and not panic. I continually checked and re-checked my handheld GPS to make sure I was on the right course. Without that small battery-powered device, I never could have found *C-Sick*, not in a week of looking.

She was right where I left her, though now bucking angrily at anchor in the waves. I had no stomach for sitting out a storm in these conditions. I scrambled back onboard and didn't even change my sopping clothes before turning *C-Sick* west to ride the following seas back toward the Nelson River. The abandoned Hudson's Bay Company settlement at York Factory, forty-five miles southwest, offered a sheltered spot to anchor inside the protection of the Hayes River. I motored *C-Sick* for eight or nine hours, picking up speed each time the boat surfed down the face of a wave. At sunset, we reached the river delta's confusion of mudflats and unmarked, indistinct channels. I was desperate not to get stuck out on the flats on a quickly falling tide. As soon as I found more than four feet of water, I let out the anchor with a feeling of

Melting sea ice and distant forest fire, Cape Tatnam, Hudson Bay

resignation and disgust. I'd been on the road for more than a week and had yet to accomplish anything. I may have been taking pictures all along, but they were nothing but snapshots—unexceptional and unmemorable.

During the night, I woke to raindrops pattering in through my open window, and I looked out on a flat, gray sky. Come morning, there was enough east wind to keep me hunkered down. But by afternoon, I was itching to get off the boat. I hadn't set foot on land in four days, and I headed out to explore the abandoned site of York Factory. The settlement dates back to the late 1600s, when the Hudson's Bay Company (HBC for short, or simply and ominously The Company) established one of its first trading posts there, part of a centuries-long dominion over the northern Canadian wilderness. The small fort grew into the central operating base for its trade in furs and nearly every other facet of the frontier economy. Every year, nearly all of the trade goods that arrived—everything from casks of cheap liquor to cotton and wool fabric to knives, axes, and rifles—were off-loaded from the HBC's ships. The empty holds were quickly filled with the new continent's bounty: beaver and lynx, marten and wolverine, even polar bear and wolves were all trapped, killed, skinned, then bundled and stacked like cordwood and shipped back to England. For centuries, the HBC served as the de facto government across the Bay's vast watershed—the sole employer and its only store. The Company effectively ruled 1.5 million square miles of land, nearly half of what is now Canada. For centuries, York Factory's central location at the mouth of the Hayes and Nelson watersheds allowed canoes to probe deep into the continent's heart before the invention of steam-powered ships and trains. In time, HBC traders ventured north to the Arctic Ocean and west to the Pacific by river, lake, and overland portage.

The Company introduced white man's goods, weapons, and liquor to Native tribes unprepared for the oncoming rush of modernity. And York Factory, stuck out along the desolate southern shores of Hudson Bay, was at the center of it all. At its peak, halfway through the nineteenth century, there were fifty buildings, a permanent administrative workforce, and an even larger population of Cree and other First Nations tribes nearby, working and trading on the fringes of the new economy. Not everyone was a fan of the

place, even then. Peter Newman's sprawling book *Empire of the Bay* describes one clerk who, having endured the winter of 1846 here, grumbled that it was "a monstrous blot on a swampy spot, with a partial view of the frozen sea." The place wore down even the toughest Scots—men like James Hargraves, who served for years as an administrative chief, or *factor* in Company parlance. Plagued by rheumatism, he complained bitterly that the local climate was "nine months of winter varied by three of rain and mosquitoes."

The Hudson's Bay Company story is likely familiar to anyone who has cracked a history book. The unquenchable hunger for pelts nearly wiped out the beaver and decimated just about anything else unlucky enough to walk on four legs and wear a coat of fur. Vast fortunes accrued in London even as disease and dissipation shredded the fabric of indigenous tribal life. It wasn't until 1870 that the newly formed Dominion of Canada gained sovereignty over what had been a private HBC fiefdom across the Northwest Territories. Developing rail and shipping links farther south rendered York Factory largely irrelevant, its once central location now increasingly remote from the new markets and distribution centers. It struggled on, a shadow of its former glory, until 1929 when a new narrow-gauge railroad connected Churchill to the outside world. The facility fell into disuse and the last of the big ships sailed in 1931. The fort closed for good in 1957 and the few surviving buildings were handed over to Parks Canada. The whitewashed three-story Depot Building still stands, surrounded by acres of roughly mown grass. The crumbling banks of the Hayes River edge a little closer with each passing year.

As I walked around York Factory, I shouted out loud hellos, hoping to find a park ranger or anyone at all to chat with. Even though the doors of a maintenance toolshed stood wide open, there seemed to be nobody home.

A boardwalk led toward the old graveyard. Weathered wooden fences and teetering crosses still surrounded a few of the graves, but the surrounding forest was slowly reclaiming the site. Out of the wind, I was beset by clouds of mosquitoes and gnats. As much as I wanted to photograph the quiet grace of these century-old monuments, I found it hard to concentrate with bugs flying up my nose.

By the time I made it back to *C-Sick*, an enormous dark cloud loomed over the southern horizon. The storm soon blotted out the sky, spitting

lightning, and sending down great bursts of rain and lashing wind. Thunder rolled across the water. I might have been bound for the Arctic, but it felt like I was in a floating trailer park and the tornado sirens had begun to wail.

In the wake of the afternoon's thunderstorm, T-shirt temperatures returned. Hundreds of miles back in Thompson, I had crammed *C-Sick*'s tiny cooler with ice and frozen meat and produce. I now tossed what remained of my long-thawed and increasingly dubious-smelling bacon and sausage into a jambalaya mix. The pot, filled with rice and garlic, peppers, and spice, was nothing if not pungent. Not long after I sat down to shovel the gluey mess down my gullet, I looked up and there, mid-swallow, I spied the summer's first polar bear. The bear was slowly making its way across the exposed river flats, sniffing the wind, and clearly on the trail of something tasty.

If I had to guess, I'd say it was the bacon.

With his size, bulk, and thick neck, he looked to be a big male. Telling male from female polar bears remains, for me at least, an inexact art. There is the matter of size, of course. A big adult male, standing upright, can reach ten feet in height, nearly half again as tall as a fully grown female. The weight differences are even more striking. Females range from 350 to 650 pounds, while the heaviest males can roll in at 1,700 pounds, and the record trophy bear topped 2,200 pounds. There are other, more subtle physical differences, as well. Males, if you know how to look, have necks broader than their heads. Female bears' heads are larger, which is why they are the only bears to wear radio collars. I suppose the old "lift-the-tail-and-have-a-look" method might work, but I'll leave that to the trained professionals.

Lord, the bear in front of me was filthy, covered in slop after wading across the muddy tidal flats. Abandoning dinner, I hurriedly snatched up some cameras and hopped into the Zodiac, undid the lines, and began to drift downriver on the current. Just as quickly, the bear lost all interest in dinner—his or mine—and slowly paddled across the broad river, then waded out on the far shore. I consoled myself by muttering abuse at his retreating backside. "Didn't want to take a picture of your ugly polar bear butt anyway . . ."

Overnight the wind backed north, pinning *C-Sick* down where I had anchored her near the river mouth. As formidable as my wilderness boat trips in Alaska had felt at the time, they were child's play compared to this. Here, I had no shelter but this wretched and muddy river. I had shit for charts and I was left to rely on my wife's often creative interpretations of the incoming weather forecast. Small wonder no one in their right mind came out this way. There was nothing to do but sit in the rain, stare out at the brown water and gray sky, and listen to the wind.

For two long days, I waited for that wind to ease. I napped and read. I ate leftovers unimproved by time. Finally, I imagined a sip of whiskey might help, and then another, and pretty soon I was singing along with every one of the sad country songs I'd thought to bring. Contentedly miserable, I eventually curled up on my bunk and drifted off upon bourbon clouds.

BIG WATER

I was up before the sun. Halfway through July at this northern latitude, that meant crawling out of a perfectly warm sleeping bag somewhere shy of four in the morning. The sky was flawless and beautiful: pink to the northeast, deep blue overhead, with a line of dark indigo, the last shadow of night, falling away toward the western horizon.

Forty-five miles and eight hours later, I arrived back at Cape Tatnam, already starting to worry about my fuel situation. I was still more than 150 miles from the nearest gas station in Churchill. Leaving only the slimmest margin of safety, I needed forty gallons to get there. That left only eight, maybe ten, gallons to spare as I headed east on the hunt for ice and bears. If I used my light Zodiac and its small outboard motor, I could cover a lot more ground while burning far less fuel.

The sun felt warm, and the last few days' rains had discouraged the forest fires that were raging beyond the Cape.

I let the anchor out in thirty feet of water and again packed my cameras and survival gear into the small dinghy. I bounded off across the open water, trying not to dwell on the emptiness that surrounded me. I found ice after an hour of steady motoring, and made a mental note to haul some of it back to *C-Sick* to keep my dwindling beer supply properly chilled.

From the dinghy, I glassed all the different shapes and contours of the melting sea ice looking for any sign of polar bears, but from down at sea level

I could see next to nothing. I gunned the engine and popped the dinghy's nose up onto a large, flat iceberg, then gingerly stepped off and climbed a low hummock. I slowly, methodically scanned the horizon again with the advantage of ten feet of elevation. Nada.

I wish I could say I was the Bear Whisperer, that I possessed a secret communion with polar bears—some Zen mastery that allowed me to see the bear even before I saw the bear. Or that I could send a whisper out upon the wind, carried from my chapped lips to fuzzy ursine ears. If there is a secret to finding a white bear in an infinite field of white ice, nobody has shared it with me. Out here, it was simply a matter of grim determination: scanning every stinking piece of ice for hour after hour with weighty, overpriced Teutonic binoculars glued to my eye sockets. And still, nothing.

I'm apparently not the only one to have trouble finding and tracking these bears. Studying polar bear numbers and population trends has always been a difficult, expensive, and inexact proposition. Biologists have spent decades trying to accurately count these well-camouflaged and nomadic animals across hundreds of thousands of square miles of ice, but the numbers still sound more like vague guesses than hard scientific fact. A 2011 aerial survey put the number of bears along the western Hudson Bay's shores at just over one thousand, and there may be as many as two thousand more living farther north, in the Foxe Basin beyond the Arctic Circle. Though the population numbers appear more or less stable, studies have measured a direct correlation between dwindling sea ice conditions and lower body weights for female polar bears, along with poorer survival rates among their young cubs.

When the sun finally dipped below the horizon, the air chilled, and I pointed the Zodiac back toward *C-Sick*. As I reached forward to drain the last drops of hot cocoa out of my thermos, I leaned too far and accidentally pulled out the safety lanyard. It was there to stop the engine should I happen to fall overboard and prevent the unhappy prospect of finding myself bobbing cold and alone in the icy waters as my dinghy motored on toward distant shores without me. The kill switch did its job admirably. So much so

Following pages: Fireweed and setting midnight sun, Hubbard Point

that the engine could not be persuaded to start again, no matter how hard I yanked on the rope. I was still ten miles out from *C-Sick*. Pull. Mutter. Wait. Pull. Worry. Wait. Pull. PULL PULL PULL PULL! Oh fucking hell.

One minute passed. Two minutes. I sat and tried to calm my breathing. Then pulled again. Finally. The engine caught but I set out again feeling deflated and overmatched. My gear wasn't good enough for this trip.

Hell, *I* was not good enough to be so far out past the edge.

At long last, I made it back to the shelter of *C-Sick*, curled into my sleeping bag, and fell into a deep sleep. There was just enough tide, wind, and current to send the boat rocking on her anchor. I dreamed, not of flying, but of a sort of low-gravity soaring walk down some strange sidewalk. I imagined floating up and gliding impossibly far with each step. It's a dream I have only on boats, only when the world is rolling beneath me.

When I first imagined this trip, I expected to arrive at the ice edge, tie up to some convenient berg, then drift along for many happy and bear-filled days. As I looked around at the endless expanse of water, the notion seemed laughable. My inner voice of reason—along with its ugly second cousin, chickenshit cowardice—shouted down any talk of death or glory. I looked at my drained fuel tanks then looked at the charts and knew that it was time to move on. I danced the points of my nautical calipers end over end until I measured the distance to Cape Churchill. It was 113 miles, and thirty more to reach town. All in all, the better part of twenty hours' travel.

I set off and motored for hours on a northwest course through the middle of a flat, infinite plane, the sea calm, like a pool of liquid metal, reaching away toward infinity. By evening, distant forest fire haze turned the sun into a copper penny orb and a breeze began to stir, building choppy waves. I pushed on until nearly midnight, then shut down the engines and let the boat drift. I was desperate for sleep, but every time I dozed off, *C-Sick* would give a big roll and I lurched awake, bracing for a fall. The sun had long set and, as dusk settled, the wind built to twenty knots and low clouds scudded in. I stumbled back to the helm and set off again, pushing on through exhaustion and delirium, nodding off as I struggled to hold any sort of course in the gloom.

Clutching the wheel fiercely, I finally stuck my head out the window into the cold spray, trying to shock the sleep away.

Sometime around four in the morning, as I closed in on Cape Churchill, the bottom suddenly shallowed to twenty-five feet, then ten, and the depth-sounder's alarm bleated. All around in the foggy half-light, I could see breaking waves. "That's weird," I thought dumbly. "What are they doing out here?" I didn't put it all together until *C-Sick* slammed onto the reef with a sound like derailing boxcars. I managed to pull the motors up before breaking waves spun the bow around and shoved us further aground.

I scrambled out to the cockpit, shaking from the cold wind and adrenaline and fear. I grabbed my boat hook and used all my weight to try to pole off the rocks, but *C-Sick* was stuck. Most days, you can wind me up, and I will go on for hours about how "adventure" is nothing but a bullshit marketing word for "vacation." That moment when you find yourself standing, head in hands, on some distant, dismal shore amidst the scattered wreckage of your dreams, and you want nothing but to quit and go home to your warm bed: *that* is when adventure begins.

And, just then, I wanted nothing of it.

I tried to focus on the most pressing matters, like what I needed to throw into the Zodiac if *C-Sick* started to break apart. The cold wind howled and waves battered my poor boat, dropping her fiberglass hull onto the rocks again and again.

She wasn't leaking; that was good news. Running a fiberglass boat onto the rocks sounds and feels like the end of the world. But the thick shell of woven synthetic mat and epoxy resins, wrapped around a thick balsa wood core that forms a C-Dory's hull, are damn near indestructible. And by the dumbest of luck, I'd managed to run aground just shy of low tide. The water continued to fall until we'd settled nearly flat on the rocky bottom. I considered all the things I might do in this situation, and opted for the obvious. I took a nap.

Two hours of sleep made a world of difference. As the tide surged back in, an extended reef caught the worst of the breaking seas. I had just enough time to make a fresh cup of coffee before the rising water lifted us off the

rocks. *C-Sick* crunched down once, twice, then I managed to shove off and drift her out into deeper water.

"Well," I thought, "no blood, no witnesses, and no thirty-mile Zodiac hell-ride into town." Chalk that one up in the win column. I slogged east for six more hours, still battling to stay awake and keep *C-Sick* moving in a straight line. It seemed to take ages until the familiar grain terminal silos of Churchill poked above the horizon, but soon I was following the cargo ships' channel markers past Cape Merry and up into the river channel.

I had traveled 381 nautical miles since putting in at Conawapa, and it felt like coming home. For starters, I actually had some friends here. During my previous summer's visit, I'd met my buddy Remi Allen while he was working on his family's whale-watching boats. I hadn't warned anyone I was coming this time, if only because success seemed so unlikely. But Remi was right where I left him, wrench in hand, working on the boats by the mudflats, talking a mile a minute to anyone within earshot. He looked only a little surprised to see *C-Sick* and me puttering up the river.

"Dude," he yelled. "Nice boat." He ran me into town on his four-wheeler, and I happily checked back into my old room at the Polar Inn. Amazingly, they'd somehow managed to defeat the smell of wet wool socks that I'd left a year before.

When I finally put head to pillow, I slept for twelve hours straight.

In the morning, I ferried eighty-five gallons of gas in red plastic jerry cans between boat, shore, gas station, and back. Somehow, the purchases added up to $880 Canadian, at a time when the dollar was on par with American currency. I stood at the cash register, numbly trying to juggle metric and imperial measures and currency conversions, but soon lost the thread. Resistance was futile. In mute surrender, I handed over my credit card.

Still, after a good night's sleep, I felt better about this trip. I sat down with the only person I knew who had ever made the journey I was planning. A decade earlier, Dwight Allen, the Polar Inn's owner and Remi's dad, had traveled around the northern Bay on a buddy's heavy fishing boat, almost on a lark, just to see some new country. Dwight and I pawed through my stack of paper charts and he pointed out the only two sites that offered even meager shelter between Churchill and the Inuit village of Arviat, 150 miles north.

He showed me the places he'd explored, through Roes Welcome Sound, where their small boat was battered, all the way north to the Arctic Circle at Repulse Bay, and then farther east into Frozen Strait.

In truth, I was only half listening. I was already imagining the journey north. Half filled with dread, but dreaming, too, of the promised Arctic, a land of ice and bears. Adventure.

The outgoing tide swept me away from Churchill and out into Hudson Bay. As I was hurried along into the unknown, I scribbled a half-remembered Bible verse in my journal. "All the rivers run to the sea, but the sea is not yet full."

If you didn't know Hubbard Point was there, it would be easy enough to miss. Roughly forty miles north and west of Churchill, the string of low crescent islands, not much more than gravel bars, are spread across the mouth of the Caribou River.

After dropping anchor, I set off in the Zodiac and within moments spotted the day's first polar bear walking along a rocky spit. Dwight had mentioned that bears frequently gather here during the summer months, drawn by the scent of moldering beluga whale carcasses left by Inuit hunters. He went on at some length about lots of ground squirrels, too. "Cute little buggers," he said. "You gotta see 'em."

I motored toward shore, then killed the outboard and rowed up onto the beach, landing with a crunch of wet gravel. The bear seemed to hardly notice the intrusion. He simply sat and watched with supreme indifference as I struggled to drag the dinghy to higher ground. I racked in a banger shell and shouldered my shotgun, stuffed my cameras and the big telephoto into a backpack, and picked up my heavy tripod. Then I gingerly stepped from rock to rock until I was within a couple hundred yards of the bear. I studied my viewfinder, framed the scene, and thought, "Too far." I talked myself into halving the distance. Still, too far. Like an idiot, I slowly approached to within 150 feet of the polar bear.

The King of the North responded, with regal insouciance, by curling up for a nap.

It didn't matter if he was sleeping or not, I framed the scene and shot him every way I could think of. With the heavy lens supported on its

tripod and my subject, for the moment at least, unmoving, I had no short-age of time. I framed him vertically. Then I turned the camera ninety degrees and shot him horizontally. I placed him on one side of the frame, then the other. I remembered the rule of thirds and moved my horizon up and down within the black rectangle of my finder. That full-sized Canon digital camera in my right hand felt so familiar it might as well have been a part of my body. I've been doing this for so long that the techni-cal elements—shutter speed, f-stop, and ISO (film speed)—have become second nature.

In the absence of more pressing engagements, I stood around and waited. It might have been an hour before the bear finally woke, yawned, and had a luxurious stretch on the rocks. Then he sat up and began walking toward me. It was not a fast walk, but it wasn't exactly a slow one, either. And he was not at all deterred by any of the array of gentle persuasions I had learned in three summers of working around Alaska's coastal grizzly bears. I could have waved my hands overhead and yelled "Hey, Bear," until my arms fell off; this guy was having none of it.

I clutched my bear-banger pen and carefully began a backward stumble-walk over wet and uneven terrain. Never turning to let the bear out of my sight, I retraced my steps back toward the dinghy, struggling to feel my way over the rocks through thick rubber soles. I was so relieved to reach shoreline that I barely noticed the half gallon of cold water spilling over my boot tops when I finally scrambled back into the Zodiac. Until I was able to row out a safe distance, cold feet were the least of my worries.

The polar bear stood sniffing the spot where I had been, both of us won-dering if this was all some weird dream.

I left him to life's mysteries, and almost immediately I spotted another bear. He was sound asleep on the beach and looked very much like a pale, shaggy rock. There was another bear, lying nearby in the grass. And at sun-set, a mother bear with her solitary young cub stirred up an angry cloud of dive-bombing Arctic terns. The pair mowed through the frantic birds' nest-ing grounds slurping up tiny eggs and chicks.

All told, a half dozen bears on my first day north from town. Not a bad start. I never did find those damn squirrels, though.

Around midnight, I lowered *C-Sick*'s small table and re-arranged the cushions to make my bed. The alarm jolted me awake forty-five seconds later. My clock showed it was more like four hours and the sun was already clearing the horizon. Gorgeous morning light flooded the boat cabin. I was eager to get moving back toward shore, but soon discovered that the Zodiac's outboard motor was not. If I pulled the starter cord with sufficient fury, I could eventually get it going, but the moment I reduced throttle, it died again. I unscrewed and replaced both spark plugs, stared at the fuel filter and hoses for a while, then swapped back the old plugs. I accomplished nothing beyond squandering all the precious morning light and tearing some new chunks of flesh from my scarred knuckles.

I eventually got the outboard running, if only just, and set off hours later, sweaty and frustrated. I followed the rising tide up into the Caribou River, feeling like a spawning salmon pushing against the fast-flowing water, searching the clear shallows for rocks. Up ahead, I spotted a white dot on a nearby rise, then another, and finally a third. It was a mother polar bear with two young cubs, recumbent in the warm midday sun. I motored as close as I could, then quietly stepped out of the boat and into shallow water, pulling the inflatable behind me as I tiptoed closer to the riverbank.

One of the polar bear cubs spotted me, then the other, and both stood upright on the hilltop at the edge of a green meadow. They looked down at me curiously. Those two cubs looked like a handful, and their mother rose only reluctantly from her slumber. She had every right to be tired.

Rather than spending the long winter fattening up on seals, she had fasted for months in a snowy den, then delivered her two cubs, tiny and blind, into the icy darkness. She nursed them for months with her fat-rich milk reserves, probably losing as much as half her body weight, close to three hundred pounds. Polar bear cubs generally remain alongside their mothers for two full years. When they emerged from their birth dens into the cold and snow of an Arctic spring, their mother might have been fasting for as long as eight months. Nearly starving now, she had to quickly hunt and eat as many ringed seal pups, adorable little balls of fur and fat, as she could to regain her weight and strength. She also had to rebuild her reserve of fat to continue nursing those growing cubs through their first lean summer.

When winter returned, the cubs would venture out with her onto the ice and begin to pay closer attention to their mother's lessons in hunting and survival. Another summer, another winter. By then, most cubs should have been weaned, feeding alongside their mother on whatever seals or other prey she was able to hunt.

When a female bear stops nursing, she becomes sexually receptive and large male polar bears soon come calling. The mothers rarely need to drive their cubs away; most of the youngsters immediately sense the danger of an aggressive male bear and flee. At a little more than two years old, the young bears are left to fend for themselves.

But this was their first season in the new world, and the cubs looked bold and sassy by her side. When the mother bear followed the cubs' gaze, her curiosity was piqued, too. She set off, leading the cubs in a procession, calmly and surely in my direction. Through my viewfinder, it looked fantastic. Mom and cute cubs on a summer stroll across the rocky tundra. I watched her progress through the long lens, the steady *click, click, click* of the shutter matching her steps until she filled the frame. As she grew closer, her idle curiosity seemed to turn into something a bit more like menace. I backed up to the boat, stepped in, and began pulling hard on the oars, letting the river current pull me twenty or thirty yards downstream, but she kept right on coming.

I lowered the outboard into the water and it smacked a rock, hard. The water was too shallow but I yanked on the starter cord anyway. For the first time all day, it fired right up and I could feel the propeller banging against rocks as I put more distance between her and me. I try not to put too much stock in divine intervention, holding as I do that Providence must surely have more pressing matters to attend to than my pitiful wish list, but I'll take what help I can get. That was way too close.

From a more prudent distance, I watched the bear and her cubs stroll along the river's edge and past a small field of yellow wildflowers before lying down in the grass to sleep through the day's warmth. Under my heavyweight

Waking polar bear, Hubbard Point

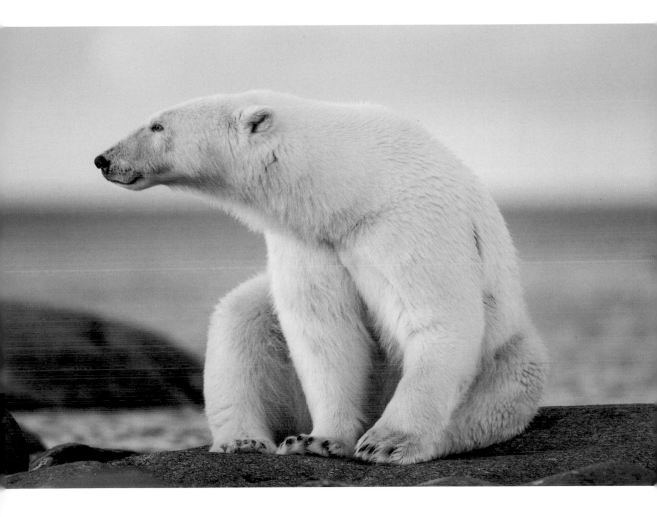

long underwear, fleece, and bulky drysuit, trickles of sticky sweat ran down my back and chest.

In the afternoon, the temperature soared past seventy degrees. I could see half a dozen polar bears, all splayed out, full Superman, above the tideline. Nearly all summer long, polar bears want nothing more than to be left to their slumber, conserving energy and calories until the ice and easier times return. Though polar bears have a reputation as vigorously solitary animals, it's not uncommon to find several bears resting, playing, and even feeding together in close proximity—particularly during the lazy summer months, or in the presence of an abundant food source. Beluga whale and seal carcasses left by Inuit hunters make for easy pickings during the lean months the bears spend on shore. The hunters would have stripped the carcasses of their calorie-rich fat, but smaller bears in particular will cheerfully feed on whatever scraps remain.

Storm clouds threatened from the south and let loose a torrential downpour moments after I hustled back to *C-Sick*. The rain lingered for hours, and I was left to spend my evening onboard reading and listening to old Miles Davis tunes murmuring from my laptop's tinny speakers.

I woke in the night to the sound of laughter coming from all around me. I looked around wildly, blankly, in the dark, then remembered. Beluga whales. They were circling my boat, singing just beneath the hull.

The old whalers called them "canaries of the deep," for their happy repertoire of underwater squeaks, clucks, whistles, and squeals—though all the cheerful singing in the world wasn't going to stop the hunters' harpoons. The commercial hunt ended more than half a century ago and the Bay's beluga populations are again robust. These waters are home to nearly sixty thousand of the sociable, voluble whales. They winter at the edges of the Arctic ice pack, and return in large numbers to the western Hudson Bay estuaries to rear their young calves and socialize while they molt off old skin. Whale-watching, swimming, and snorkeling tours are a welcome summer tourist draw in Churchill. The belugas oblige by swimming and playing alongside boats and chilly swimmers alike. Away from town, the local Inuit

maintain their traditional subsistence hunt, and the whales remain under-standably skittish at the noise of an approaching motor boat. Although not, apparently, at the sound of my snores.

Rain pattered against the boat's fiberglass roof. As another chuckle echoed up from the deep, I drifted back to mirthful sleep.

The morning turned windy and rain bucketed down. When the choppy seas grew worse, I motored south to find shelter in the lee of the islands. Still, I was determined to tough it out and, ignoring the weather, I headed out in the Zodiac to explore along the coastline. The landscape seemed lovely in a lush but desolate, low-moss-and-lichen sort of way. Fireweed blossoms carpeted the sheltered coves, pink flowers splashing a riot of color against acres of green ground cover. I peered through my binoculars, carefully studying the beach before venturing ashore, wary not to stumble across any sleeping polar bears. I carried the Remington with me as I walked, one banger shell in the chamber, nervously flicking the safety off, then on, then back off again. The rain came pissing down, relentless and cold. I stopped to photograph the vast, featureless landscape near an old Inuit hunting site. The bones of a half dozen beluga whales lay scattered in the grass, the vertebrae still held together by dried sinew. For centuries, the Inuit here have hunted seals and whales, walrus, and narwhals out on the water, as well as caribou and other game on land. But the picture of a lone fur-clad hunter slipping into his kayak and, with cunning, stealth, and skill, flinging harpoons at a passing seal is long outdated. It's not like I'm out here hauling Ansel Adams's old wooden box camera around, mixing chemicals, and making my pictures on glass plates, either. Times change and technology has moved us all relentlessly forward. For decades, the modern hunt has begun with the roar of outboard motors, as aluminum skiffs hurtle across the water carry-ing hunters armed with high-powered rifles. I'm not here to judge the relative merits; I'm just describing what I encountered in my travels. I have also heard stories of those same hunters spending weeks trapped by the ice, hunting and living off the land, not fighting the elements but patiently waiting for obstacles to yield in their own time. When I watched them roar past, standing upright in open boats, completely exposed to cold wind and freezing spray, I knew for a fact that they were tough in ways I could never imagine.

I tried to ignore the building north wind and struggled to frame a photograph that might capture a sense of the emptiness of this place. The elements were all there: gray-green tundra softening the barren shore, wildflowers, angry sea, and clouds . . . but it was hard to focus on the scene's artistic merits while continually looking over my shoulder for approaching bears. I wanted to keep working, but when I looked out at the white caps and breaking waves now covering the sea, a voice in my head told me, "Time to go."

I'll never know if that voice saved my life. The hour-long ride back to *C-Sick* was terrifying, as the wind began to scream and waves stacked up in steep, treacherous piles. The gale tried to pick the Zodiac out of the water, and as the bow began to lift, I instinctively hurled all my weight forward. If we flipped, I would never get this thing righted, never get the engine restarted, never make it out of here. In the distance, I saw the C-Dory heaving violently at anchor. I was soaked and scared, but there was nothing I could do except keep slowly clawing my way back to the only place that held any hope of shelter or safety.

The moment I reached *C-Sick*, the storm slammed down hard. At the end of its anchor line, the boat rolled and plunged deep into troughs of waves in this poorly sheltered cove. Spray whipped past. I'd never had to ride out anything like it. For lack of any better ideas, I called home on the satellite phone, hoping for the sound of a friendly voice and an updated forecast from Janet. My cell phone hadn't worked since before I left the road system, and I now had to rely on my Iridium satellite phone to stay in touch while traveling in this remote wilderness. For all my pretensions to lonely heroics, deep down I'm the guy who likes to call home every day, hear an encouraging word or two, and make sure I'm still married. I normally dialed out at night, after my daily dramas had wound down, and after Janet would have finished work and had time to download the evening's marine weather forecast. She was in the thick of some of her own job-related turmoil, and when I called hours ahead of schedule, she sounded worried, and maybe the least bit irritated.

"Why are you calling from outside in all that wind? Do you have to be a drama queen all the time?"

"Trust me, it's a whole lot worse out there," I said, and then, ever the drama queen, I went out on deck and stood exposed to the howling storm for the rest of the call.

I could only half hear the forecast, but even that small tidbit scared me plenty: gale warnings through the night, building to forty knots, gusting higher. If the wind stayed out of the northwest, I figured I should be okay. The low islands provided protection from everything but easterlies. But if the wind turned east, I'd be a sitting duck, with no shelter at all.

As the tide rose, I moved the boat closer to shore. When it fell hours later, I let out more anchor line until I cleared any of the shallow rocks that might punch a hole in *C-Sick*'s bobbing hull. I soothed my rattled nerves with some peppermint tea and read until the boat's lurching motion made me feel half sick. Then I called Remi back in Churchill to let someone else know where I was.

"We were just talking about you," he laughed. "Wondering if you were still alive."

By seven p.m., forecast notwithstanding, the winds had dropped to nothing and I was eager to get back out on the water. I motored the Zodiac over ocean swells and back up the Caribou River to a patch of fireweed glowing in the setting sun. Nesting Arctic terns skittered overhead, ceasing their intermural bickering long enough to unite against my intrusion. They rained down bird shit and abuse from the heavens. Other than that, it was a lovely night. A setting midnight sun colored the parting storm clouds and I turned to go, leaving the birds to their frantic summer routine as I returned to mine.

Come morning, I shrank from the cold. A small butane stove sat close by my bunk. I stretched my hand out just far enough to light it and set a small kettle over the flame, then burrowed back into my sleeping bag. Though *C-Sick* still had her original gleaming kerosene two-burner stove and heater, it hadn't worked in years. Repeated trips to the dealer had done nothing except drain my checking account and erode the repair guy's already low opinion of me. After my third visit, he suggested that perhaps a new $2,500 wünder-stove was just the ticket. Instead, for twenty-five bucks, I bought a food-truck butane cooker that used cheap, drop-in cartridges and worked without fail through four wilderness summers.

Slipping back into sleep, I ignored the kettle's banshee wail even as the boat's cabin filled with steam. I was finally forced awake by drops of tropical rain spattering down from the ceiling.

I was still groggy when I set off at first light. On a grassy rise just above the tideline, three male polar bears dozed near the Arctic terns' colony. With waves breaking over the bouldered coast, it was a tussle just getting ashore, much less finding a safe place to tie off the Zodiac. A big wave caught the dinghy and sucked it away from shore, yanking me off balance. Suddenly I was falling backwards into the water, kept afloat by my drysuit but clinging to the boat as waves pulled us out. Then another big wave dumped me back onto the rocks.

I was sure as shit awake now. I scrambled on all fours to haul the dinghy up and away from the surf. It was only a moment before one of the bears spotted me, and suddenly the others were up too, huffing with surprise. They were barely seventy-five yards away and moving toward me. I dug out my telephoto to frame a shot and pressed the shutter. A polar bear's head seemed to fill the viewfinder. I held down the shutter for a second, but survival instincts soon overrode any artistic considerations.

I had bears approaching from the front, the Zodiac was in a tangle behind me, and my gear case sat wide open at my feet, exposed to the next big wave. Everything was happening too fast. There was nothing to do but grab the pen-sized bear banger, pull the spring, and—nothing, except for the exquisite pain of metal pinching down fast and hard on that tender web of skin between thumb and index finger.

Blood blister or bear mauling: which hurt more? Remind me to look that up if I ever make it back to town, I thought. On my second try, the bear banger shot a small firecracker skywards. The *whoosh* stopped the bears, and the sound of its little *pop* turned them smartly around.

The bears headed back up the rise, setting off a small storm of circling and diving Arctic terns. In moments, all three bears had settled back down to sleep once more, perturbed not one bit. I stood there alone, panting and waiting for my pounding heart and the waves of adrenaline shakes to settle.

In my bear defense arsenal, there was an old can of pepper spray that I'd carried for three summers while photographing brown bears in Alaska. I used the spray only once, during a bushwhacking excursion when I memorably doused myself in a caustic halo after some branch caught the trigger. That

was years before, and I wasn't even sure the propellant was good anymore. I decided to give it a little test squeeze.

Standing near a bank of fireweed along the Caribou River without a bear in sight, I made sure my back was turned to the stiff west wind before releasing a quarter-second burst.

I'm sure there's a scientific term, probably even an elegant mathematical formula, to describe the circular turbulence and backflows created by a standing body that interrupts an otherwise smooth flow of air. But that all eluded me when the spray eddied and swirled into a scalding cloud all around me. The pain was everywhere, in my eyes and nose and even my mouth, weaponized cayenne pepper inhaled through lips puckered into a tiny "O" of shocked surprise. I couldn't see, couldn't even force my eyes open. I dropped to my hands and knees, crawled to the river's edge, and cupped cold water in my hands to flush away the burning spray out of my nose, mouth, and eyes.

It was a long while before I could open my eyes, longer still before I could actually see anything. By the time I managed to stand up, a big male polar bear was soundlessly closing in from a hundred yards away, looking for the source of the exotic peppery smell on the wind. I stood paralyzed, eyes streaming and nose adrip. The bear hesitated, then turned tail, and sped off at full gallop back across the tundra. The King of the North apparently does not like his meals spicy—or covered in snot and tears.

I waited patiently, sinuses still draining, for another bear to wander past. Four hours later I was still waiting as the sun set over one more stretch of lovely but bear-free wilderness.

CHAPTER 9

THE EMPTY COAST

I opened my eyes to a sky filled with flames. Layers of orange and red clouds burned in the northeastern sky. Half my brain was rushing me out the cabin door to photograph this wondrous sunrise, even as the other half whispered that old nautical rhyme: "Red sky at morning, sailor take warning."

The sun cleared the horizon at 4:35 a.m. and cast a magical orange glow over the world, illuminating three polar bears asleep on the beach a half mile away. It was utterly gorgeous, and I knew there was no way on earth I could make it to the bears in time to photograph them before the light faded. Five minutes later, the sun disappeared into a bank of cloud and remained there for the next three hours. Both the world and I sat bathed in a flat, gray funk.

Inexplicably, I was eager to get moving again. I came all this way for polar bears; here they were, bears aplenty, yet I was itching to leave. I was making new pictures every day, but I'd forgotten most of them by the time I put the camera down. The longer I sat here, the more it felt like there was a target on my back. I was just waiting for some big east wind to come along and drive *C-Sick* onto the rocks. Farther up the coast, who knew what manner of novel and inventive misery awaited.

I pulled up the anchor and set off into the unknown. Thirty-five miles north, near the sixtieth parallel, sat the abandoned Hudson's Bay Company trading post at Nunalla, on Egg Island, the halfway point between Churchill and the village of Arviat. The charts showed a tiny, sheltered cove tucked

behind the island, but nothing about the journey ahead looked easy to me. Dark clouds blotted out what remained of the sky and a west wind built steep, quartering seas. I never ventured more than two or three miles offshore, just far enough out to avoid the mudflats and random boulders, but three-foot wind waves slammed into the bow, sending gear cases crashing around the cabin. For my trouble, I arrived to discover yet more low, windswept, and inauspicious coastline.

The weathered hulks of two long-abandoned buildings were all that remained at this desolate outpost. There were dozens of these remote settlements scattered throughout the Canadian North—small trading posts where, at the behest of the Hudson's Bay Company, the local Inuit put the knowledge passed down through a hundred generations to a different use. They traded their traditional subsistence hunting for a new sort of killing—wholesale slaughter in exchange for guns and liquor and other trade goods. The skills of a thousand winters' survival devoted to the strange newcomers' unquenchable thirst for profit.

I nervously navigated *C-Sick* around the boulders and half-submerged reefs, then tried to tuck into the mouth of a shallow cove behind Egg Island. I'd been cold all afternoon, chilled from my repeated minor maritime disasters: righting the Zodiac after it flipped in a gusting wind; retrieving the roof cargo box as it attempted, once again, to fling itself into the sea; setting and re-setting the anchor in dangerously shallow water. I broke out my tiny propane Mr. Heater Buddy to break the chill. I used it sparingly, as my father's voice was forever in my ear, telling me to suck it up. I can't say for certain, but I'll wager he made it all the way across the North Atlantic and back again, standing watch on convoy escort duty as deadly German U-boat wolf packs lurked beneath the waves, without once sniveling about cold toes.

But mine will never be on anyone's list of greatest generations. I sipped my cocoa and warmed my cockles and worked up the nerve to check on the weather. If Janet went to the trouble of sending me each day's forecast during my interminable march north, the least I could do was read it.

Following pages: Nineteenth-century whaler's grave marked by bowhead whale bones, Deadman Island

The news was short but not at all sweet: winds turning northeast, building to twenty knots. When we spoke later, Janet reassured me that "Twenty's not so bad. At least it's not forty." Words spoken by someone who would sleep that night in a warm and comfortable bed, un-tossed by angry seas. As for my evening plans, when the tide came up, I could look forward to long hours of staring out my rain-spattered windows at the wide-open ocean, admiring waves that had rolled all the way from Quebec to pound me silly.

It made for a long night, listening to the timpani beat of breakers slamming *C-Sick*'s bow. I wedged my knees beneath a corner of the bunk and tried to grab some sleep during lulls in the storm. When the tide fell sometime before dawn, the water level dropped below an outer rocky reef and the boat steadied.

In the morning, I went ashore to explore the old trading post, mindful of the muddy polar bear I had glimpsed in the gray light of last night's storm. The outpost, floors rotten, windows smashed, was slowly fading away. Inside, rough wooden planks bore the scrawled names of travelers long past, mostly late-winter hunters from more than fifteen years ago. The outside walls were bleached by sun and etched by a century of windblown snow. Gardens of wild fireweed blossomed across the tundra, and bits of trash littered the ground: plastic liquor bottles, one dried-out leather boot, old snowmobile parts, marine flotsam blown in by storms.

While I walked, the winds dropped off and the white-capped Bay calmed with it. The Inuit village of Arviat was still seventy-five miles to the north, and I hustled *C-Sick* up the coast before the weather could change its mind. I tried to stick to my self-imposed ethical strictures and proceeded at a stately six knots, ensuring that I savored each mile of vast, featureless sea and the unvaryingly flat and dismal coastline. But after an hour or two, I hit the gas and passed the Nunavut Territory boundary at sixty degrees north latitude doing thirteen knots and burning through several hundred dollars' worth of Churchill's finest unleaded. Even at that speed, I didn't arrive until well after sunset. I anchored in a cove a few miles out, away from the unaccustomed noise of town and such Friday night diversions as Arviat had on offer.

The next morning, I woke to the sight of an enormous Sealift cargo barge anchored just offshore. It had snuck in sometime in the night, all the way from Montreal, bearing a shipment of the modern food and goods that the communities along the isolated Hudson Bay coast have come to rely on. These barges carried everything from Pop-Tarts to pickup trucks. I even saw a couple pre-fabricated houses stacked onboard. I motored toward shore in the Zodiac, looking around for a dock, but there was nothing except a low gravel and stone beach. The ramshackle houses started just a few yards above the tideline, not ten feet above sea level, strewn like so much debris across the flat coast. It was a startlingly homely town. I was no prize myself at this point, but I had shaved and washed up, and put on some clean-ish clothes. Just as well; I had barely stepped onto dry land before a local guy pulled up alongside me in an ancient pickup truck. Jerry hopped out wearing gray sweatpants and a too-big fleece jacket. Grinning with a busted smile, he welcomed me to town with a whisper of a handshake. The Co-op gas station wasn't open yet, so he took me on the grand tour, driving along dusty streets past the community center, the hamlet office, one hotel, two churches, and the Royal Canadian Mounted Police (RCMP) outpost. We even drove out to the town dump that locals jokingly called "Canada Tire," after the national chain of auto parts stores. It served as a graveyard for generations of abandoned four-wheelers, Ski-Doos, and trucks, and was the spare parts source of first and last resort in this isolated settlement.

After the eight-dollar-a-gallon gas in Churchill, I dreaded the prices I might find here, 150 miles farther north and almost completely off the grid. To my surprise, it was less than half the cost, barely a dollar per liter, cheaper even than fuel prices eight hundred miles south along the Trans-Canada Highway. I filled up ten of my six-gallon jerry cans and wished I had room for more. It was one of the few bargains to be found; a liter of gas cost less than a can of Diet Pepsi.

After topping off *C-Sick*'s tanks, I wandered the streets alone, admiring the broken snowmobiles, four-wheelers, and pickup trucks; all left to rust wherever they had breathed their last. Kids played in the streets, oblivious

to clouds of mosquitoes. Arviat is actually the third largest town in Nunavut Territory, with a little more than 2,500 people, predominantly Inuit. It is completely cut off by land from the rest of Canada. There was no road or train out of here; only an expensive plane ticket, a long and hazardous boat journey, or patiently waiting for winter's cold embrace and gassing up the snowmobile for the long ride south.

An enormous forklift kicked up clouds of dust as it roared back and forth through town, unloading wave after wave of supplies from the barge. The tourist in me clamored to spend more time getting to know the place. But when the wind stilled toward evening, I motored *C-Sick* out toward Sentry Island, a few miles offshore. Local subsistence hunters sometimes pursued beluga whales near there, and rumor had it several polar bears were about.

I saw my first bear along the island's western tip almost as soon as I launched the dinghy. He walked slowly along the sand beach, sniffing the air. Cutting the engine, I ducked down low in the Zodiac and let the breeze carry me toward shore. In the shallows, I rested one boot over the side to hold the dinghy still. I wishfully imagined that I might look like just another iceberg. Higher up on shore, the bear found what he was looking for: the decayed remains of an old beluga whale.

The whales' fatty blubber has been a mainstay of the traditional Inuit diet for centuries. Hunters carve off the *muktuk* using curved *ulu* knives, then leave the remains behind. That's usually at the water's edge or in the shallows, where they butchered the animal, which can weigh more than a ton. The carrion often becomes, intentionally or not, an easy meal for polar bears and other Arctic scavengers. Throughout the iceless summer, polar bears may dull their hunger pangs by nibbling on hunters' leavings, though it is only the abundant supply of plump seal pups out on the ice that allows them to survive and grow strong. The big bear strained only a little as he dragged hundreds of pounds of decomposing carcass up to the beach grass to feed. After a bellyful of the gray and rotting meat, he grew a bit more curious about me and slowly meandered to within thirty yards, then twenty, then ten. I gave the dinghy a small push away from shore with my boot, to get us both some breathing room. The bear followed down to the water and stared out. I have never experienced a polar bear's charge or leap, and this seemed a bad

place to witness it for the first time. So, like any good bank robber, I kept the getaway's motor running.

He stood close enough that I could hear his breathing, and the soft inhalations of air as he sniffed my scent on the wind. I had no need for the big telephoto now. He was just above me, each massive paw perfectly balanced on tide-slick rocks. He stared intently down at me and I avoided eye contact, keeping my movements slow and deliberate. Lift camera to eye, frame, one soft *click*. Reframe to include the sky above, another *click*. A herring gull squawked overhead. We must have been close to its nest, and the bird began a series of angry dives at the polar bear's head.

The bear's attention soon wandered, and as he walked back up to his cetaceous carrion, I returned to *C-Sick*. After sunset, I sat on the bow and watched as an enormous full moon rose, its reflection peek-a-booing through clouds above glassy water.

In the morning, the sea remained still, and it was hard to imagine a kinder summer day. I spotted a local man out fishing for Arctic char in his green freighter canoe. The boat was half-again longer and wider than its familiar recreational cousin, twenty-four feet in length and about five feet across. Powered by an outboard motor, these canoes can carry a ton or more of passengers and cargo. As I drifted up in the Zodiac, the fisherman looked up from his net and shook his head at the weather. "It makes me nervous," he said, then he cheerfully offered me a beautiful three- or four-pound Arctic char. "It was alive half an hour ago," he said, and it seemed as if that fish might still have some life left in it. Its silver scales glistened and it stared, clear-eyed, at the sky above, looking startled at the unfortunate turn its morning had taken.

As I swung *C-Sick* past Sentry Island and headed slowly north, something on the water caught my eye. Through my binoculars, I saw a swimming polar bear, maybe the same one from last night. Dropping anchor in shallow water, I grabbed my cameras and underwater gear, and dashed into the Zodiac. I drifted the dinghy closer. He was one hundred yards, then one hundred feet away, and as he drew close the sunlight and blue sky and water seemed to recede. My left hand gripped the outboard's knurled rubber throttle handle.

I slowed to an idle but kept the engine in gear. It pushed me gently forward, in sync with the bear. My jaws clenched and I locked my eyes onto the bear with a concentration that blotted out the rest of the world. I could feel my heart surge, a frightened thing now thumping in my chest. I struggled to still my breathing and steady the tremor in my hands. This wasn't some panicky fear; my body fully recognized the danger even as my brain struggled to ignore it.

The polar bear, on the other hand, seemed to neither notice nor much care. He kept swimming in his dog-paddle motion, apparently unperturbed, even as I lowered a boom-mounted camera within a few feet of him. Generally speaking, you can't just drop a professional camera into water. Well, you can and I have, but it doesn't end well. Instead, I protected my gear inside an elaborate aluminum housing with shutter control cables and a large acrylic dome, all of it hanging off a six-foot telescoping pole. The idea was to gently dangle this assemblage close to the swimming bear and start filming. Getting the camera beneath the water's surface, and then framing and shooting, was a clumsy exercise, but I got the thing pointed in more or less the right direction and held down the shutter. I could feel the vibration of my camera's motor drive faintly clicking through the pole's handle. The polar bear kept right on swimming toward shore. He emerged from the water, shaking himself off like a dog fresh from the bath, then turned around and strode back toward me, curious and unafraid. Fifteen yards separated us, maybe less, yet he never made an aggressive move.

Just looking.

Back out on the water, I chatted with all the Inuit hunters and fishermen I encountered, trying to gain some insight about what awaited me farther up the coast. They all talked about distance in terms of hours, not miles. It was frustrating, but when I stopped to consider it, that made perfect sense. They shared an intimate knowledge of the land and the coastline from a lifetime of experience, and they ran their boats hard and fast, racing along at thirty knots when they could. With none of their expertise, I applied an outsider's reliance on reducing the land and sea to compass points, degrees of longitude and latitude: all arbitrary units of measure that were unnecessary abstractions to them.

It took seven sun-filled and drama-free hours for me to reach an abandoned fishing camp, forty miles up the coast at Sandy Point. I arrived in the sheltered cove just as a dark line of clouds blotted out the sun and let loose a few fat drops, followed quickly by a heavy downpour. The wind shifted southeast and began to blow in earnest. "Knock yourself out," I thought. For once, I felt safe from anything the Bay wanted to throw at me, tucked in behind a thirty-foot-high spit of land.

As night fell, the rain brought a cold and damp chill that suffused my cabin, and I grumbled about how much colder it would surely get as I continued north. *C-Sick*'s high-tech heater refused another round of supplications and random wire-tugging and I dragged out the Heater Buddy instead. I imagined my boat shaking her head in disgust.

I carried onboard a small library of books detailing Hudson Bay's history, and by lantern light I settled in to read. It should have come as no surprise that these waters have seen their share of wreckage and shattered dreams. Nearly four centuries before I wandered past, Danish merchant captain Jens Munk became the first European to winter over on the Bay. He paid dearly for the privilege. His story is not well known, but I had found an out-of-print copy of Danish writer Thorkild Hansen's *The Way to Hudson Bay*. It read like a Charles Dickens novel, with a healthy dose of Joseph Conrad's *Heart of Darkness* thrown in.

Born in 1579, the bastard son of a jailed and disgraced Danish nobleman, Munk scraped and worked his way up from a near penniless childhood to become master of his own whaling ship. On its first Arctic voyage, pack ice crushed his wooden ship near Spitzbergen. Shipwrecked and lost, he somehow managed to save himself and his crew, but he returned to Denmark with his dreams and finances in ruins.

Still, you can't keep a good Dane down. He caught the eye of King Christian IV just as the financially strapped monarch had taken an abiding interest in opening trade relations in the Orient. Munk was given two ships, the small and maneuverable *Lamprey*, and a larger mother ship, the *Unicorn*. He left with instructions to find a Northwest Passage to Cathay. They sailed in 1619; it was a time of plague and war, though perhaps not great foresight. No

one thought to bring heavy winter coats or leather clothing along. The men were told they'd all be in China by summer's end.

Things did not work out that way.

It took them thirty-nine days of hard, cold sailing from the Norwegian coast just to reach the entrance to Hudson Strait. They lost more weeks to bad navigation, found themselves repeatedly trapped and nearly crushed by the ice, then got lost again in the depths of Ungava Bay. Finally, belatedly, they stumbled out into a vast, open sea.

They sailed south and west, imagining themselves crossing the Pacific Ocean toward China.

Six hundred miles later, they found themselves not in Cathay, but near present-day Churchill. Munk took a look at the river's wide mouth there, and against racing tides, submerged rocks, and crashing seas, he ran his frigate up the channel under full sail. It was an amazing piece of seamanship, and they had stumbled into the only decent harbor in hundreds of miles of coastline. But that was the last good luck Captain Munk saw for a very long time.

Some of the men already showed signs of scurvy. They shot a polar bear and divided the meat among the crew, but they had lost too much of the summer to wrong turns, bad ice, and worse weather. They had neither the provisions nor the clothes for the long winter that lay ahead.

Even as they worked feverishly cutting trees to make charcoal for the stoves, and shooting whatever game crossed their paths, they must have known.

It was never going to be enough—not to keep more than sixty men alive.

The first man died on November 21. After he was buried, cold gripped the land. When the next man died, and the next, the ground had frozen too hard to bury them. By January 10, the cook was dead, and during the following weeks Munk's journal became a litany of slow death. "All these days there was nothing save sickness and infirmity," he wrote in mid-February. Soon Munk found himself serving as doctor, chaplain, even carpenter, hammering together rough coffins for his dying men. By May, the survivors no longer had strength enough to heave the corpses over the side of the ship. The dead lay rotting in their bunks.

By June 4, Munk was alone, and he scrawled a sorrowful farewell in his journal: "I say goodbye to the world and give my soul into God's keeping."

But the Dane was too tough to die. The stench of decay finally drove him from the ship and as he crawled through the melting ice and snow, he discovered two other survivors huddled on shore. They plucked at berries and roots where the snow had melted. Their strength slowly returned, and their thoughts turned toward home, or at least of getting the hell away from this haunted and forsaken place. On the highest spring tide, they managed to float their smaller boat free. They were three men, utterly ravaged, trying to sail a ship that carried a crew of sixteen. Somehow, they managed. The three survivors skirted the ice, drifting and sailing all the way out to the North Atlantic. They were nearly past Greenland when a monstrous storm dismasted and nearly sank them. Their boat was half full of water, most of their sails were gone, and scurvy had returned. But they would not die.

In late September, sixty-seven days after leaving Churchill, they reached the coast of Norway. Captain Munk made it home to discover his wife had taken up with a new man more to her liking. To top it off, he was imprisoned and faced some awkward questions from King Christian IV regarding the fine ships and crew that had been left in Munk's care.

I looked at the Heater Buddy guiltily. Upon reflection, maybe I didn't have it so bad after all.

The next morning, when I passed Walrus Island, there were no walrus in sight. No polar bears either. Just a two-mile crescent of gravel with a rise of gray rock crowned by a towering navigational marker. The water temperature had dropped ten degrees, down to thirty-three, and with the change a cold wind cut through me.

I headed for the hamlet of Whale Cove, twelve miles off. A crowd of young boys spotted *C-Sick* from miles out, and they waited on bikes for my arrival. Soon they were joined by a parade of four-wheelers and pickup trucks. I tried to look like I knew what I was doing as I anchored and prepared the dinghy to motor the hundred yards to shore. A dozen people, all eager to introduce themselves and their families, welcomed me to Whale

Cove. Everyone wanted to know where I was from. Where did I start? Had I seen any whales yet? Did I want to see their polar bear? They'd shot it just last night.

A young Inuit guy offered me a lift on his four-wheeler and explained, "Oh yeah, it was here for four days, sniffing around the village. It started walking toward some young kids. So, we shot it. You can see the skin there." He pointed to the dead bear, not much more than fur and bones to begin with, now a headless pelt hanging from a rope, submerged beneath the tide.

The Inuit have traditionally felt a close spiritual kinship with polar bears. They hunted the bears but believed that any animal they killed had willingly offered itself up to the hunter. Gratitude was shown as the polar bear's meat was shared throughout the community. Twentieth-century trophy hunters, mostly wealthy Americans, added new economic incentives to the hunt. They would pay staggering sums for the pleasure of killing a bear, at least until 2008 when the US Environmental Protection Agency listed the polar bear as a threatened species and banned the importation of the animal's hide or any other "souvenirs." A handful of polar bears are still hunted under a strict quota system, and there are exceptions for bears like this unlucky one, when human life or property is directly threatened. But if that bear is killed, it counts against the limited hunting quota.

My new friend gave me a ride to the gas station where I topped off my fuel cans, and on the way back to the harbor he gave me a tour of the town's highlights: school, community center, health clinic, garage. The big finale was the Whale's Tail, a vaguely anatomical sculpture of a diving beluga's tail, rendered in four feet of poured concrete and covered with green stones that were falling off, one by one. The town, prefab and faded, spread out below us, surrounded by the sea. It felt like a pinprick of humanity—home to fewer than 450 people—on a vast and nearly empty coast. Nomadic Inuit tribes wandered and hunted along this coast for centuries. In the 1950s and '60s, caribou-hunting Inuit from hundreds of miles inland were facing starvation as the Barren Lands herds' migration patterns changed, and the federal

A sled dog barks while chained to battered pickup truck in Inuit hunting village along Hudson Bay.

government created this hamlet as a permanent settlement for that disparate collection of interior and coastal tribes.

Rather than race off, I stuck around and continued my explorations on foot in the afternoon sun. A baseball game, played with tennis ball and plastic bat, was underway in a gravel lot. The teams were fluid and any rules loosely observed, but there was a lot of running around, ball caps used as mitts, a few punches thrown, and rocks tossed. Good kid fun, with a little *Lord of the Flies* thrown in. The game sent me four decades back to long summers of absolute freedom: climbing century-old oak trees, playing backyard short-handed baseball, hurling dirt clods at my brothers, and setting stuff on fire.

At sunset, I took batches of the kids out on the Zodiac, racing the little boat in circles and trying not to lose anyone over the side. I even let them peer in through *C-Sick*'s open windows, at least until I caught one kid reaching through and trying to pocket my iPhone. Back on shore, they poked and prodded the headless, pawless polar bear carcass in shallow water. I recoiled for a moment, but then I remembered what it was like to be a kid. Every summer when I was growing up, a new crop of inattentive groundhogs would appear, and make the same mistake of raiding our family's vegetable garden. My father dispatched them, one by one, with a single .308 rifle shot from his sniper perch on our back porch, and I devoted a curious number of unsupervised hours to their forensic study.

I settled in to watch the fat golden moon rising above glacier-smoothed granite shoreline, serenaded by the growl of racing ATVs and children's voices yelling, "Goodbye, Paul."

I spent most of the next day's sixty-mile journey to Marble Island ghosting over submerged rocks and reefs. The island gleamed white as an iceberg on the horizon. I followed a narrow, fast-flowing channel that was apparent only on the GPS chart, slowly maneuvering my way right and left, before discovering a magical cove hidden behind the island's rock walls. It was completely protected from whatever fresh villainy the Bay might conjure.

Now, where was a howling gale when I needed one?

I set off to explore in the dinghy, and spotted a local hunting boat in the distance. Through my binoculars, I saw them checking me out, so I waved. The boat with four men came in close and pulled up alongside. I started to introduce myself, but they already knew all about me. Someone in Whale Cove had taken *C-Sick*'s picture and posted my little story on the Nunavut hunters' news website. I greeted this development with equal measures of amusement and consternation. I had been hoping to keep a low profile, but I supposed it couldn't hurt to have some friends on the water. They were Ernest, Ernest, Bronson, and another name I didn't quite catch.

"Have you crawled?" one of the Ernests asked me.

I had stumbled and tripped over rocks while wrestling with the Zodiac, but that wasn't what he had in mind. He pointed past the cove entrance to a low gravel barrier island, and a series of mounds on the ridge. They marked the graves of more than two dozen crewmen who died back in the 1870s, when one of the whaling ships wintering here was crushed and sank in the icy water. Ernest told me that it was customary to crawl six feet across the stone to soothe the dead men's spirits and avoid similar misfortune.

I hadn't seen a beluga in the last three hundred miles of travel, but they told me that two had been shot just yesterday near the far end of Marble Island. He let me know that the weather was set to turn, then they all left to continue their hunt. I headed off to explore the island in my dinghy—but not before I stepped ashore, dropped to my hands and knees, and paid my respects to the men who died such a long way from home.

I circled the island slowly, stopping to glass the slope from time to time. The sunlight made every stray rock on that white-on-white landscape look like a polar bear. In the distance, I heard the distorted *bloop-woop* of rifle fire and could just make out the Ernests' boat drifting on the shimmering horizon. It was another hour before I made my way over to them, and they'd already butchered their catch: another beluga whale. One of the men said simply, "I hit her with the harpoon. I must have got something important. We didn't have to waste many bullets."

The small whale hung limp by the side of the boat, trailing blood in the still water, skinned for its fatty blubber but otherwise intact. Ernest said,

"You can dry the meat into a kind of jerky, but it's a lot of work. The whales are here for a short time. Too short. The rest of the year, it's ice."

They towed the whale toward deep water, out of reach of any hungry polar bears. I asked the hunters for permission to shoot a few photographs as they let the whale go. The carcass sank slowly through clear water into the darkness. Before heading back to town, Ernest offered me a bit of *muktuk*. I reflexively declined even this small piece of the beluga's freshly carved flesh, then immediately felt guilty for having refused his hospitality, for seeming to turn up my nose at their offer of friendship.

I've always made a joke of it: what if the other whales smelled it on my breath? Over the years I have cheerfully wolfed down entire herds of our domesticated bovine and porcine friends, as well as more esoteric delights like Botswanan kudu, Norwegian reindeer, and walrus in Alaska. But whales have always given me pause.

I was once scuba diving off the coast of Patagonia, and a massive southern right whale and her calf swam above me. They descended toward the ocean floor where I kneeled, breathless and goggle-eyed. She was the size of a box car and must have weighed more than forty tons, but she drifted down no faster than a falling leaf. She paused ten feet away and studied me with an eye the size of a dinner plate: her huge, dark iris surrounded by a ring of white and a speckled brown cornea. It felt like looking into the eye of God, wise and sad and seeming to forgive of all my many trespasses. Still, better safe than sorry, and I give whale meat a pass.

Though it was a month past the summer solstice, for me the days were still growing longer as I traveled north. It was almost eleven o'clock when the sun painted the island in burnt amber light, the fireweed glowing like candle flames. When the sky turned pink in the day's dying light and finally faded to indigo, I stared down into the blackness stretching beneath me, searching for signs of the sunken whalers' ship in the cold, still water.

PIT STOP

I smelled gas.

Truth be told, I had been smelling it for days. I'd also been hoping that if I ignored it long enough, the problem might go away on its own. That's not how machines are understood to work in the real world, but here aboard *C-Sick,* hope springs eternal.

The moment I squeezed the outboard engines' priming bulbs, a sheen of gas spread on the water and rippled in all the colors of a toxic rainbow. Pulling off the engines' cowlings, I saw a steady drip, drip, drip of gas leaking from the fuel pumps of both outboard motors. For lack of a better plan, I started the less weepy of the two, and prepared to limp the final twenty-seven miles toward the town of Rankin Inlet. What I'd hoped would be a quick fuel stop with a semi-ironic side trip to the world's northernmost Tim Horton's donut shop looked to become a longer excursion.

As a precaution, I also began cramming essentials into the small orange waterproof case I carried as a ditch bag. If *C-Sick* did burst into flames, I might have just a few seconds to crawl out through a hatch and, if I was lucky, swim back to the Zodiac at the end of its twenty-foot tow rope. As for what would happen after that, I was a little hazy—beyond freezing to death, I mean. But for now, the day was warm, the water calm, and all of it felt rather idyllic, if I ignored the swirl of refinery fumes trailing in my wake.

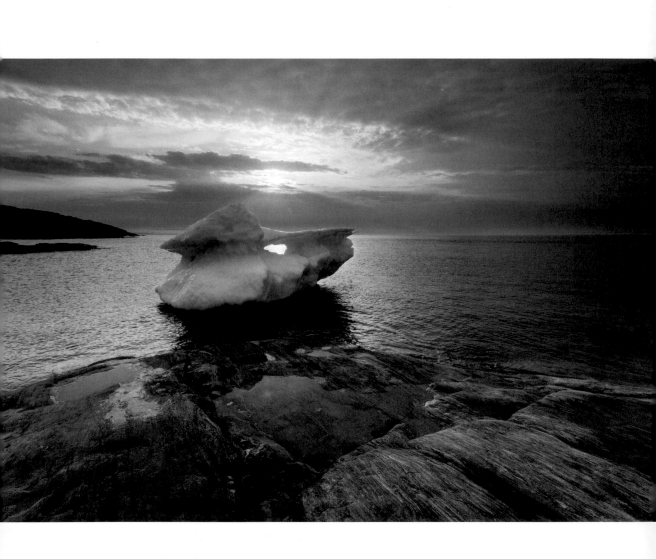

Sans fireball, I motored into Rankin Inlet's small, protected harbor, lowered my anchor in ten feet of water, then quickly shaved and changed into clean street clothes. Within three minutes of reaching shore in the Zodiac, I found myself barreling through town in the passenger seat of John Hickes's truck, listening to a stream-of-consciousness history lesson about the town, his life, and the Arctic, and a wealth of other subjects. The numbers and facts flew past me in a whirl. Second biggest town in Nunavut. Close to three thousand people. Thule people here first, then Inuit, then the nickel mine. That closed up, but the gold mine down the road should open soon. More jobs, more people. Bringing back sled dogs, got a couple teams right at the lodge.

In no time, John had helped me track down a mechanic at the airport, shuttled me to the hardware store for the forty-five-dollar Torx wrench I'd need, and settled me into a room at the Nanuq Lodge, which he operated with his wife and partner, Page Burt.

John was a big guy. He was loud and talked fast, and knew everyone and pretty much everything here in Rankin. After all the solitude and quiet, I felt a little overwhelmed, but I was plenty thankful to have a helping hand and a friend in this unfamiliar town.

Back at the lodge; a hot shower, clean sheets, and phone and internet access reminded me of the virtues of modern civilization. I dialed home on the land line and for once was able to maintain a real conversation, without the dollar-a-minute meter running. Even when bought in bulk, the satellite phone minutes came at a cost not conducive to meandering, romantic, "how-was-your-day" chatting. For one day at least, Janet and I could take a break from the steady string of "You're breaking up," and "I think we're losing the satellite," and the empty silence of another dropped call, or my muttering, "Goddamn fucking phone," just as the next satellite picked up the signal, leaving Janet to ask, "What are you swearing at me for?"

The fuel pumps arrived on the next afternoon's Calm Air flight from Winnipeg. I tried to wrap my brain around the fact that it had taken me

Melting sea ice lit along Wager Bay

more than three weeks to travel a distance this jet covered in two hours. Installing the pumps was straightforward; loosen a pair of 8 mm bolts, pull off the gas lines, pop out the old pump, and slide in the new. The engines sounded considerably happier and, as a bonus, no longer left a trail of flammable liquid on the water.

Next morning, when the forecast twenty- to-thirty-knot winds failed to materialize, I made up for lost time and set out roaring north at twelve knots. I covered the seventy miles to Chesterfield Inlet in six calm and sunny hours. The temperature in the tiny town of Chester was above eighty degrees. It felt practically tropical, and half the town seemed to be eating drippy ice cream cones from the small Co-op store's freezer. This would be the last gas station until Repulse Bay, nearly three hundred miles to the north. I topped off both twenty-gallon internal tanks and filled every container I had on board. I half considered dumping out my water bottles and filling them, too.

There was plenty of evening light left, so I pushed on across Chester's namesake inlet. The inlet itself runs more than one hundred miles northwest, deep into the interior. Huge tides race in and out through its five-mile-wide mouth. Steep, standing waves up to six feet high regularly build here during spring tides, but I encountered nothing but modest speed bumps, just a foot or two of swell. They were just enough to keep *C-Sick* working to climb each wave's back at five knots, before surfing down the face like a kid on a sled.

A broad band of forest-fire smoke, blown in on warm, southerly winds, covered the horizon. As the sun dropped, it turned into a pale, red globe, setting closer to north than west near the sixty-fourth parallel. Air chilled by the Bay's frigid water met a warm breeze drifting in from the sunbaked tundra and created a fun-house view of the barren landscape: low rock islands distorted into dramatic cliffs and mesas. Castles and towering cities emerged, then slowly morphed and melted back into the sea. The scientific name for all this is *fata morgana*, from the Arthurian legend of the enchantress Morgan le Fay. She created visions of illusory fairy castles in hopes of luring sailors to their deaths. She was also something of a bad girl, bedding half of King Arthur's Court.

Small wonder the early explorers had fits up here.

I made it across the broad mouth of Chesterfield Inlet and ducked into shallow and rock-strewn Winchester Inlet a few miles farther up the coast. I struggled to find a decent anchorage amid a confusing maze of islands and shallow reefs, and finally settled on a small pool of water thirty feet deep. Surrounded by a ring of low islands, the bay promised a modicum of shelter, though sadly, no obliging enchantress.

When I looked at the charts and then at my calendar, I realized time was already running out. I'd been traveling for more than three weeks and had seen and photographed what seemed a mere handful of polar bears, and most of those were not much better than record shots, technically accomplished but certainly nothing to write home about. I was already more than halfway through this trip and had, aside from beating the stuffing out of *C-Sick*, accomplished almost nothing. For all my blather about capturing the soul of this place and touching the spirit of the bear, I had a job to do. I needed to come home with some remarkable—or at least highly saleable—photographs to pay for all this scenic wandering.

With renewed urgency, I abandoned any pretense of saving fuel or going slow. I hit the gas, and at 4,500 rpm, was again making twelve knots over the water. I spent ten long hours roaring east and north along the coastline. I donned a pair of headphones to block out the engines' constant noise and protect what little hearing I had left. Back in Churchill, Dwight had warned me that the strait between the mainland and Southampton Island could kick up ugly seas. I had scrawled the word "nasty" on my nautical chart and underlined it twice at his insistence. But today at least, I might as well have been driving down the interstate. The water was glassy smooth, and in the warm sunshine I started to nap-jerk at the helm. I stuck my head out the window, tried some clumsy yoga stretches—anything to stay awake.

Twenty miles south of Wager Bay I had my first glimpse of sea ice since Cape Tatnam, weeks earlier. The ice was off to the east, nearly halfway across the sound, and a long detour out of my way. I was reluctant to add another hour to the already interminable journey. Sure, I'd love to magically find a polar bear out there, but what were the odds of that?

I motored out anyway, heading toward the biggest piece of ice I could find, a tall iceberg nearly two hundred yards long. As I approached, I dug out my binoculars and glassed the ice, playing the "If I were a polar bear, where would *I* hang out?" game. There was something yellow there. Right color but wrong shape. One more lump of dirty ice. Then the lump opened its eyes and stood up for a better view. It was a polar bear—a good-sized male, from what I could tell at that distance.

Well, hell, that was easy. Especially if you didn't count the last four weeks and 950 miles of travel.

The bear stared out from his perch, curious and unafraid. He looked almost cozy up there, and could surely see every seal for miles. I idled the engines and drifted closer, cradling my largest telephoto lens in hand and adjusting *C-Sick*'s course to keep the bear in frame. His black eyes glistened in the sun, his nose lifted to catch my scent as he stood with big paws almost pigeon-toed, his coat shining glossy and bright. The only sound came from the gentle ocean swells rolling under the ice edge, a noise almost like breathing.

Something—maybe the clicking shutter, the crunch of ice against my hull, or the outboards' *thunk* when I shifted into reverse—broke the spell. The bear climbed down and slid into the frigid water. I tried to follow, but he was clearly done with me. Once a bear starts moving away, there's not much you can do to change its mind. There was too much ice and current to chance going out in the dinghy. I didn't want to risk losing sight of *C-Sick* or leave her to be trapped or crushed in the drifting and unpredictable icefield.

I watched as the bear silently swam away, then I scrolled quickly through the images on my digital camera's screen. There were some nice frames. Bear atop iceberg. Bear slipping into water. Bear swimming off and disappearing into the distance. It was . . . okay. Maybe I even had something usable. Anyone on the adventure cruise ship version of this trip would have been thrilled, and the one-upmanship would have already commenced down in the bar. But here, in my solitude aboard *C-Sick*, I wasn't ready to break out the champagne.

I motored along farther and found some ringed seals and a few larger bearded seals sunning themselves on the drifting ice. One small ringed seal pup clung to a melting berg as I approached, holding on tenaciously even

after the boat scraped hard against the ice. The boat's sounder showed the water temperature at thirty-two degrees, so I could hardly blame the little guy for wanting to avoid a dip. I tried to buck the breeze and reversed to properly frame and photograph him, but just as I found my spot, the sun dropped into low clouds and the picture was gone. I left the small pup in peace.

I angled back toward shore, aiming for a tiny bay marked on my charts. Less than one hundred yards wide, it looked promising in theory, but when I arrived at midnight, I could see the water was dangerously shallow. Still, it seemed shelter enough for a calm night like this. I woke around three a.m. to the crunch of rock on boat. Alarmed, I looked out into the predawn half-light. The ground around me seemed flat enough, so I decided to stay put and let *C-Sick* bottom out. For a few hours, we sat motionless on the tidal flats like it was the parking lot at Walmart. When the tide returned a few hours later, the hard ground vanished, and we floated free once more.

Ignore some problems long enough and they will fix themselves.

Having already burned more than half my fuel, I set off at a slower pace in the morning. I aimed north for Wager Bay, site of the rarely visited Ukkusik-salik National Park. Wager Bay forms a narrow channel more than ninety miles deep into the hinterlands, and makes for daunting travel. Hudson Bay's already impressive tides are magnified in the long, narrow inlet, and powerful currents form at its mouth. Legends tell of whirlpools big enough to swallow a polar bear, or a boat. Wager Bay was first charted in 1742 by Christopher Middleton as he sailed the ships HMS *Discovery* and *Furnace* north from Fort Churchill, searching for the Northwest Passage. His crew spent three weeks trapped by ice before finally pushing their way north through Roes Welcome Sound. When they finally reached open water, they imagined themselves at the gates of the Orient, bound for untold riches and fame. Then they got a better look, and found themselves at one more dead end. The captain was not shy about expressing his disappointment, and called the place "Repulse Bay."

For at least nine centuries, Wager Bay was home to generations of Inuit families and hunters. A handful of families held on and lived there into the 1960s. Inuit from nearby villages still hunt and trap along the shoreline in summer and winter, but the bay is now administered by Parks Canada.

I didn't have nearly enough fuel left to explore deep into the bay, so I made *C-Sick* my base camp in a sheltered cove and planned to take the Zodiac out for a quick look around.

Before setting off, I looked around at the masses of ice left stranded at low tide on the shores all around me. They ranged in size from large truck to small house, and I worried that if one of them floated free it could take down *C-Sick*. But I could either sit there and worry, or go explore and trust that she'd still be right side up when I returned. I struggled into my drysuit, loaded up the dinghy with my gear and gun, and patted *C-Sick* on the gunwale saying, "Don't go anywhere."

As I motored west, I was pushed along by the incoming tide. My little Zodiac spun beneath me like a leaf in the swirling, boiling water. The angry water's power was impressive and I stayed close to shore to avoid tempting fate.

From a distance, the bay's coast looked almost as barren as the endless tundra marsh I'd traversed in the past weeks. But here, it was composed of mile after mile of glacier-polished granite. Not exactly the stuff of photographic dreams, but a step up.

When I went ashore and was able to look more closely, I saw that patterns abounded everywhere. Lichens swirled on the exposed rocks in spirals and fractal laces, and the shoreline was covered with caribou hoof prints. There were polar bear tracks, too—days old, and the size of a frying pan. There might be a picture here after all, I mused. I devoted a happy hour or two crawling on my hands and knees examining centuries-old orange and black lichens that clung to nearly every stone and boulder. I read somewhere the orange ones only grow in the presence of urea, pee from nearby ground squirrel colonies. I reminded myself to wash my hands sometime this month.

Because of the forest-fire smoke, the light had gone orange and strangely dim on the landscape. The unexpected warmth and still air, the blurred sky and weird shadows—it all unsettled me, as if something wicked was this way coming. This close to shore, I could see there was life here—bug-bitten caribou stood warily in the distance, their coats patchy at the beginning of the summer molt. Snow buntings scattered at my approach. A mother ptarmigan with almost perfect camouflage guided her seven chicks to safety across the boulders. In a moment of deathly silence, I heard the snort of a walrus,

then the splashes and exhalations of its mates at they swam and dived somewhere across the bay.

But I felt utterly alone, as if the emptiness or the land itself was ready to swallow me up.

Making out patterns in some flat stones scattered along the shore, I realized with a start that they had been arranged to hold down the edges of a tent; this was an old Inuit campsite. Tundra flowers bloomed amid thick moss inside the circle, and a few sun-bleached caribou bones lay scattered nearby. I couldn't tell if the site was fifty years old or five hundred, but I knew whoever slept here was almost surely dead and gone and long forgotten. Another wave of loneliness washed over me.

A pretty, arched iceberg stood in a protected cove, glowing blue and orange in the sunset. Zipped into my drysuit and with camera in hand, I gingerly walked out until the cold water reached my knees, then kept going to waist- and finally chest-deep level. I moved left and right, looking for the perfect angle of ice and reflected sun, trying to frame the scene. I stepped off a hidden ledge and sank in up to my neck. I managed to stay upright, but only barely. Arms out and camera overhead, I bobbed up and down in the water, struggling to keep my feet beneath me. I half levitated on tiptoes back toward shore. My pockets were filled with salt water soaking my gloves and some spare shotgun shells.

It could have been worse; at least I'd remembered to zip up.

Still, I was shaking with the chill, my hands raw and numb by the time I made it all the way back to *C-Sick*, hours later.

When I departed Wager Bay, a north wind began to clear out much of the high-level smoke, and the sky turned blue again. I was down to my last thirty gallons of gasoline, and there was still a long way between me and Repulse Bay. The weather was so sunny and warm that I resisted the urge to rush. Instead, I broke out the poor man's autopilot. *C-Sick* used a simple push-rod cable steering system that didn't easily lend itself to a proper autopilot—not

Following pages: Underwater view of swimming polar bear, Hudson Bay

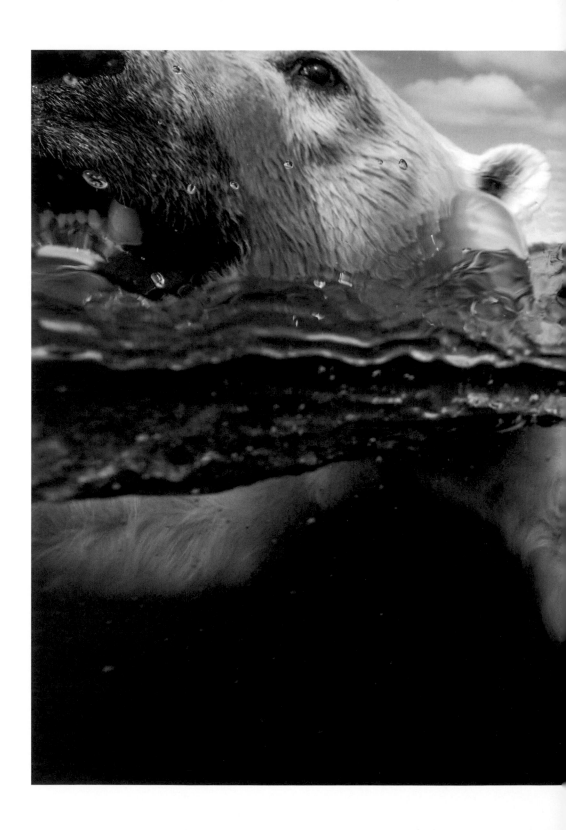

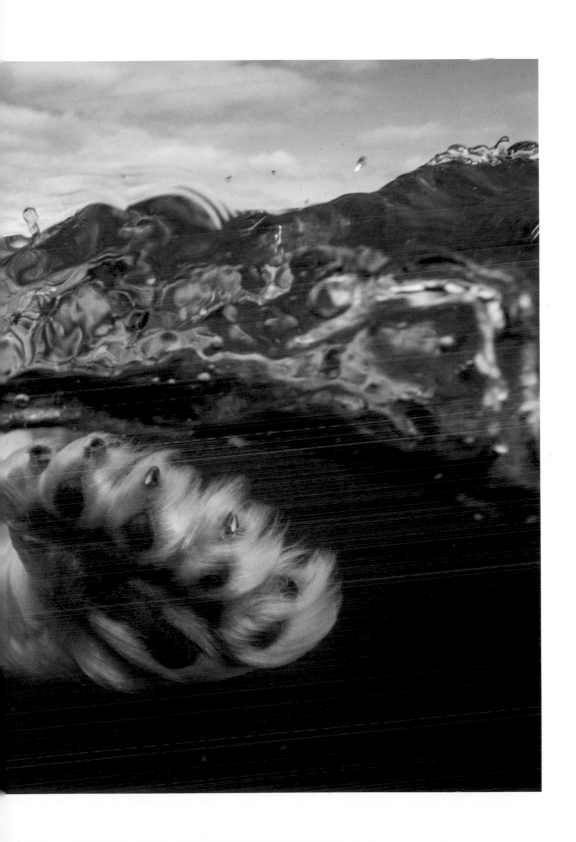

that I could have afforded one anyway. So, while the boat motored along, I firmly wrapped both hands around the cabin roof's steel rails, and with my feet balanced on the narrow gunwale, I carefully edged my way forward to the cabin's window. From there, planted on a slippery ledge of fiberglass barely six inches wide, I could reach through and make minor course corrections, all while standing out in the fresh air and sunshine.

It was crazy, of course; one slip and I'd be in the water watching *C-Sick* motor away. It wouldn't be the slowest or most painful way to die, but it would definitely be the stupidest.

With one hand on the cabin rail I nudged the steering wheel as needed, but the boat mostly steered herself in these flat, calm conditions. I doubled down, and took another couple steps forward, and perched midway across *C-Sick's* cabin roof. From there, I could shift my rump a few inches left or right to steer. Sunlight pierced deep into the clear water, rays converging and rippling into the blue depths. In the distance, I could make out a white dot; it looked like a seagull sleeping on the water. I ignored it, but my conscience nagged at me. I finally stood up and reached inside for the binoculars, and the dot resolved into a polar bear, swimming miles offshore, seemingly headed toward Southampton Island, nearly forty miles east.

I shut down *C-Sick's* motors and let her drift, then pulled the Zodiac's outboard to life and set off. To avoid stressing the bear, I moved slowly and cautiously on a matching course, waiting to see if he might be curious. Soon, the big male was less than ten feet away from me, swimming alongside my little rubber boat. I felt a surge of adrenaline, my heart pounding and blood in my ears. I reminded myself, not for the first time: You fuck up, you die.

I gently lowered my underwater camera housing into the water, less than a yard from the bear's face. He swam past. I pulled forward and tried again. He swam past. But this time, as the boat's momentum carried me beyond him, he stopped and glared into the big acrylic dome. I don't know who was more surprised, him at the sight of his reflection or me when he took a mighty swat at the camera with his massive paw. I took the hint.

On my way back to *C-Sick*, I stopped to glance at those frames. I had it. I'd managed to get a picture of the polar bear just at the moment he took a swing at my lens. To be honest, it was a hell of a photograph, the bear's

mouth open and teeth exposed, his paw outstretched with claws extended, sunlight glinting off his eye. But, shooting blindly, I'd managed to crop half his head at the edge of the frame. It was still a dramatic image, and I could likely convince people that I cropped it that way on purpose; to create visual tension, artistic ambiguity . . . purity of vision.

But wasn't it all just horseshit shoveled atop one more stupid mistake? What the hell was I doing out here? I had traveled nearly 1,100 miles over the water, from the end of the road almost to the Arctic Circle. The town of Repulse Bay lay just over the horizon, but already it felt like a hollow victory.

REPULSE BAY

In a flurry of activity, I muscled my full gas and water cans from Repulse Bay's Co-op's gas pump back down to *C-Sick*. Along the shore, one of the village elders sat in his boat along the muddy tidal flat, the waterline more than one hundred yards away at low tide. He stared off into the distance, listening to Inuktitut chatter on the CB radio. In a few hours, the tide would come in and his boat would float again. Unlike me, he seemed to feel no need at all to rush through this fine day.

Though I had hoped to pick up some local knowledge about the nearby waters while refueling, chatting up random strangers yielded odd looks, half-hearted shrugs, and a few instances of, "Oh yeah, I saw you on Facebook."

Arriving at the Harbour Islands a couple hours southeast of town, I found rocky outcrops scattered among confounding reefs and shoals. Whaling ships sometimes sheltered among these islands in the 1890s and early 1900s, and a few hardy crews even allowed their boats to freeze in.

Unlike the whaling ships that hunted the waters off Greenland and the eastern Arctic, these were mostly American boats and crews. Sailing from

Inuit elder in beached hunting skiff, Repulse Bay

New England's Atlantic ports beginning in 1860, they discovered untapped hunting in northwestern Hudson Bay. But there was a catch: the waters north along Labrador and through Hudson Strait were raked by storms, contrary currents, winter sea ice, and massive glacial icebergs. The boats often didn't reach the Bay's whaling grounds until summer had nearly passed, and they would have only a few weeks of hunting before the coming winter forced a dash for home. It was far more profitable to do what hunting they could before the ice formed, then find a sheltered anchorage and allow their boats to freeze in and winter over. Come spring, the killing resumed. Over the next half century, they hunted bowhead whales almost to extinction.

The arrival of the whaling boats was the first sustained contact the native Inuit of this region had with the outside world, and it changed the Natives' lives forever. The ships arrived with metal implements that soon replaced stone and ivory utensils and tools that had been used for centuries by the Inuit. But more importantly, these ships introduced new weapons, muskets and rifles vastly more powerful and accurate than the traditional harpoons and arrows. When the whalers stayed on through winter, they hired Inuit men to keep them supplied with fresh meat, and paid the women to sew fur clothing. With each new innovation that arrived, native life was altered, and the traditional skills that had fostered their independence and survival for generations atrophied, or were lost entirely.

My own plans for exploring the islands were modest: get off the boat for an hour or two, stretch my legs, look around, and call it good. I rowed ashore and set off for a short hike along the rocky coast. Out of shape from idle weeks aboard *C-Sick*, I was soon breathless, hot, and sweating buckets. I walked past dozens of tent rings of unknowable age. They were surrounded by animal bones, sun-bleached white and porous with age where they lay on the tundra. There were splashes of color along the black rock cliffs—orange lichen and dwarf fireweed blossoming pink in sheltered clefts. Far offshore, I could make out a few outboard-powered freighter canoes and aluminum skiffs speeding past, locals hunting for narwhal and seals.

In a remote settlement hundreds of miles from anywhere, hunting offers a source of fresh, nutritious, and relatively affordable food. It's also a rare source of income and productive activity. Regulated numbers of narwhal are

taken during the short summer season, and the tusks are legally and lucratively sold at the local Co-op store. The hunt is a cultural touchstone, a link to Inuit history and land. It could be argued that the vibrant hunting culture in Repulse Bay distinguishes the hamlet from many other Arctic communities. It continues to give the town a sense of identity and purpose. The echoing whine of outboard motors along the town's waterfront can be heard day and night throughout the short summer months.

I thought about hiking some of the other islands, but I couldn't ignore the afternoon's still wind and calm seas. I set off east in *C-Sick*, crossing fifteen miles of Havilland Bay's unsheltered, open water, and headed toward a small rocky outcrop called Hall Islands. It felt like I was inching out past the edge of the world.

I found the remains of a seal along the shoreline, a bloody red scrap of meat just below the tideline, surrounded by concentric sprays of seagull shit. Nearby, I saw a polar bear mum with two second-year cubs, but they were skittish and wanted nothing to do with me or my cameras.

A few miles farther east, I reached the low hills that line the Melville Peninsula coast and I noticed more bears, though all were miles away. Another sow with a big cub. A mother with two spring cubs. They kept to the high ground. All appeared as nothing more than white dots on black rock.

I greeted a boatful of narwhal hunters traveling up from Rankin Inlet. They seemed wary of me. What was this stranger doing all the way up here, all alone?

They asked me point-blank, "You're not Greenpeace, are you?" It wasn't the first time I'd heard the question, and certainly wouldn't be the last. Memories are long here. It's been nearly forty years since animal rights protestors launched a boycott that nearly destroyed the trade in seal skins, but "Greenpeace" is still used as an epithet here. In recent years, environmentalists have tried to make their peace with traditional hunters, but many remain suspicious and even openly hostile.

The hunters questioned me about a supposed secret anti-hunting campaign, then about underwater sonar beacons used to warn off the seals and whales. I couldn't quite follow any of it, but their hard, flat stares stifled my chuckled denials. In fairness, nothing about me made much sense either: a

lone stranger moving oh-so-slowly in what was, at least by local standards, a big, fancy boat. But from what little I knew of Greenpeace, I imagined that they'd have sent some hot French actress out with full video crew, a social media team, and a flotilla of military-spec Zodiacs if they were looking to make a splash up North. A balding and homesick white guy in a leaking crap bucket? Not so much.

One of the men suggested maybe next time, I should bring my wife along, spend the winter in Rankin, and get to know people. "We need some new blood," he said.

"There's no way I'm letting any of you near my wife," I joked nervously, but nobody laughed.

We parted ways. I motored off, newly anxious and a little disheartened. I've traveled on my own through dozens of countries and have, with rare exception, exchanged smiles and pleasantries with almost every stranger over the years. I wondered what was different here—was it me? Was it them? Had I stepped in some cultural turd pile without even knowing it? I told myself that I was there to see the land and photograph the wildlife. I would always be an outsider. Best to leave the hunters to their own pursuits and do what I could to stay out of their way.

A few miles south, I found a cove just big enough for *C-Sick* and deep enough for her anchor. As soon as she was secured, I took the dinghy back out on the water, looking for some of those polar bears I'd seen earlier. On the Hall Islands, I had watched a young bear sitting atop the rocky summit. When I returned, he was still waiting up there with the patience of the Buddha for the tide to drop and uncover that dead seal. My arrival stirred something in him, and he slowly wandered down closer to shore, and toward me.

All through the afternoon, a band of clear sky fringed the northern horizon, a narrow blue crescent beyond the heavy overcast. As the midnight sun descended, an otherworldly light set the world ablaze, as if a furnace door had cracked open. The polar bear and rocks alike glowed like hot coals against an indigo sky.

I sat on the Zodiac's inflated tube and spread my feet for stability. There was no point using a tripod; the dinghy shifted beneath me with every movement of the water or my weight. I cradled the heavy 500 mm telephoto lens in

my left hand, tucking that elbow into my ribs for stability. The lens weighed nine pounds and contained $6,000 worth of steel, glass, and mysterious electronics—but all I really cared about was that it brought that bear ten times closer. I switched to autofocus, and with small, instinctive movements of my thumb, I scrolled the focus sensors across my viewfinder, keeping the polar bear's eye—the most important part of my photograph—as sharp as possible. In spite of the cold and damp, I yanked off my gloves to give my fingers and thumb better contact with the camera's fine controls. I followed the polar bear as he carefully picked his way down the granite cliffs, changing the composition each time he moved. He stopped atop a rocky outcrop and stared down. I put his face at the center top of the frame, orange rocks below, purple clouds above. *Click.* Turned the camera to vertical, reframed. *Click.*

I automatically kept his rump close to the frame's edge to let the image breathe, giving his torso, head, and all-important eyes room to move within the picture. When the sun hit his eyes, their black pools came alive with a diamond-bright catchlight.

Click.

My right eye was glued to the viewfinder, constantly checking the corners of my frame. I'd long ago trained myself not to squint my left eye, using it to keep watch on the world outside the camera's lens. Each time the bear raised a paw to take a step, my index finger's gentle press triggered another volley of shutter *click*s. When he stood motionless on a cliff, considering his next move, I saw open sky behind him and imagined a different picture entirely. I silently paddled the Zodiac until I could see the bear in profile, a silhouette against salmon-colored clouds.

Click.

For those few moments before the sun set and the bear slipped from view, I was in photographic heaven. It was five cold miles back to *C-Sick*'s anchorage, but I was damn near glowing the whole way home.

The next morning, I motored several hours farther east, skirting Melville Peninsula, checking my chart for landmarks. Winter Island. Repulse Bay. Frozen Strait. Cape Shackleton. While the cartographers were at it, they could have thrown in Existential Despair Point and Credit Card Default

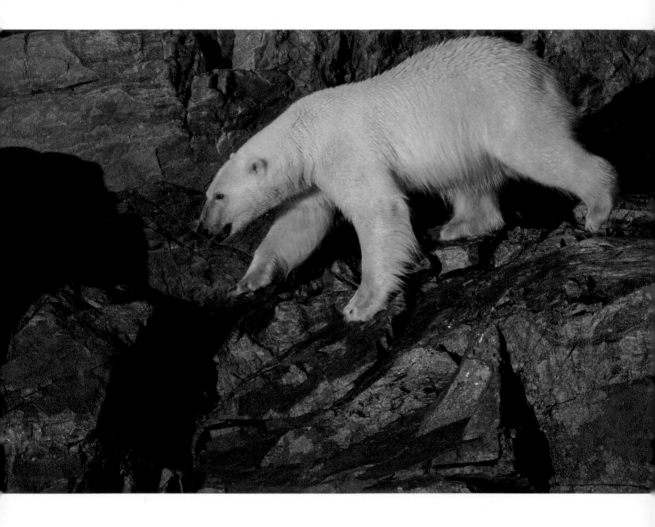

Inlet. As it was, the charted names felt like a thinly veiled threat of the struggles that had gone before and lay ahead.

Many European explorers, as one of discovery's privileges, bestowed the names of wives, patrons, and of course their esteemed selves upon the lands they encountered. The names of minor nineteenth-century Admiralty functionaries and petty grandees are scattered like confetti across the Arctic.

The Inuit had their own names for these places that were far more relevant to their experience and to the nature of the land. Wager Bay was named after Sir Charles Wager, an eighteenth-century First Lord of the British Admiralty, who never set foot within 1,500 miles of the place. The Inuit called it *Ukkusiksalik*, after their name for the soapstone they used to make bowls and pots. My maps told me nothing about *Tuluarvik*. The word means "bumping into something," and referred to a shallow place where bowhead whales sometimes became stuck in shallow water. *Sirmiq*: an inlet where the snow does not melt. *Majuqtulikuluk*: where the Arctic char swim upriver.

Inside *C-Sick*'s unheated cabin, I grew chilled after six hours of motoring. The water temperature hovered just above freezing, and the thermometer read thirty-nine degrees, both inside and out. I decided it would be more productive to go outside and freeze than to remain in there and mope.

Among my cargo was a heavy black case filled with "art" cameras that I'd packed all the way here and had yet to touch. I opened the case and hauled out my seventy-year-old 4x5 Speed Graphic. There was nothing electronic or digital about this camera; it was a leather-covered mahogany box with simple bellows and a big aerial reconnaissance lens of similar vintage mounted on the rails. The camera might have been considered state-of-the-art for news photographers when they still chomped on cigars and wore bowler hats out on assignment, sometime in the 1930s. Now, it provided an entertaining diversion, producing photographs that were blurry and moody and entirely unpredictable—in every way the exact opposite of modern digital perfection. Maybe one time in ten, it was almost worth the effort.

Polar bear lit by setting midnight sun, Hall Islands

The landscape seemed desolate, and I wasn't feeling all that cheerful myself. But I lugged my tripod across rain-slick rocks as a chill wind stirred the water. It hadn't been eighteen hours since I had been kicking up my heels on photographic Ecstasy. But like most highs, it hadn't lasted long. I already craved another hit of that magical golden light, but the sky and land were a study of somber grays.

I went through the motions anyway, setting up the camera and staring at the ghostly landscape. I moved two feet left. Stared some more. When I brought my eye in close to focus the Speed Graphic, I caught a faint whiff of decades-old tobacco. The image on the scratched ground glass was dim, blurred, and inverted; upside-down and backwards. I closed the lens shutter, guessed at the exposure, slid in the old film holder with its single sheet of unexposed four-by-five-inch black-and-white film. Then I pulled out the protective black slide and pushed the shutter's cable release. A thirtieth of a second later, that momentary exposure to light had subtly altered the silver-halide coating on the film. I remembered to push the dark slide back in before removing and stowing it in its waterproof hard case. It would be two months before I got the film shipped off to a lab in Los Angeles. When it came back, I would stare for long minutes at the processed negatives, trying to remember what I was even looking at.

I reached Gore Bay after five more hours of motoring farther east. Amidst a lingering chill of misting rain, the night was graveyard still.

The following day, I looked out and thought, as I so often do, Be careful what you ask for. I'd been searching for pack ice for more than a month. Now it stretched before me, an unbroken wall of white, the stuff of explorers' nightmares. I felt unmanned. Far better men than I and ships vastly stronger than poor *C-Sick* had come to grief amidst these northern icefields. Driven by wind and current and tides, millions of tons of unpredictable and implacable ice moved constantly through these waters. Back home, I had an entire shelf of books that might best be described as disaster porn, tales of shipwreck and slow death. Those stories came flooding back—accounts of scurvy-riddled crews watching as the marauding pack splintered their boats, leaving them to starve and freeze on these wretched shores. One suitably

harrowing and unnervingly relevant chapter in history unfolded just a few short miles from here.

In 1818, George Back signed on as surveyor and mapmaker with infamous English naval lieutenant John Franklin's first, disastrous Arctic expedition to the Coppermine River, and nearly starved for his trouble. He was either a slow learner, tough as nails, or a bit of both, since he went north with Franklin again in 1825. He earned a reputation for arrogance and breathtaking rudeness toward underlings, yet was a sycophant and suck-up to his superiors. He was neither well-liked nor particularly trusted, but he did have a knack for well-timed heroics and managed to rise to the rank of captain. Given command of one of Britain's strongest ships, the HMS *Terror*, he was sent north in 1836 to overwinter in either Wager or Repulse Bay, then was to set off overland and begin mapping the remaining miles of unexplored Arctic coast.

He got a late start, struggled against the usual assortment of contrary winds and foul weather, and had already put his crew on short rations before they even cleared the coast of Greenland. They struggled through Hudson Strait and into the Bay, but in late August they faced impossibly thick ice. He described it in his journal: "At length we came to a solid and unbroken pack, of such fearful extent as to throw a sudden damp on our hopes."

That would do it.

It started snowing on the last day of August. The ice held them and slowly tightened its grip. They tried to sail out. They tried to haul the ship clear with heavy lines. They even tried using saws and picks and axes to cut their way free. In their spare time, they amused themselves by shooting at passing polar bears.

But they were trapped. Drifting ice tore at *Terror*'s flanks, squeezing her so tight that wood beams eighteen inches thick bowed under the pressure and the ship seemed to groan in pain. Back's journals are filled with hundreds of pages describing the ice's movements, the ship's torments, and his own anxious misery. The ice was never quiet. They spent ten months wondering if they'd survive to see home, or even live until dinnertime.

They drifted for ten months frozen in the same ice floe. Storms carried them back and forth past the ironically named Cape Comfort. The ship

was pinned and heaved onto her side, her rudder and stern post nearly torn away. She was driven against a cliff and pushed forty feet above the surrounding ice. By spring, the constant pressure had rent the *Terror*'s hull and three-feet-an-hour of seawater poured in. Men worked around the clocks at her pumps, while the ship's carpenters struggled to repair the shattered hull.

When the ice finally relented, Back declined to abandon ship, and instead sailed for home. They made it across the Atlantic even as the *Terror* was sinking beneath them. She was half full of seawater when they ran her aground on the first Irish beach they could find.

The HMS *Terror* was one of the strongest warships of her day, just over one hundred feet long and, doubly reinforced for her Arctic duties, she weighed more than 325 tons. I looked out at the same ice that had almost broken her to matchsticks.

C-Sick was a plastic bath toy in comparison.

The incoming tide pushed the ice closer and, no hero, I turned tail and ran like a dog. I retreated out of Gore Bay but found more ice blocking my path. I drove *C-Sick* slowly west for hours along the edge of the ice floe, probing for a path through the maze. At slack tide, the wind backed north and a small opening appeared that allowed me to slip through to open water. I hurried across Frozen Strait and headed south toward the rocky coast of Vansittart Island. The clouds hung low and spat cold rain. I saw nothing but miles of choppy water, dirty ice, and dismal skies.

As the north wind continued to build, I scoured the shore for shelter. The day's gray light was fading before I finally anchored deep within Petersen Bay. When I dialed the satellite phone, Janet sounded no happier than me.

"You've been gone all summer. Are you ever coming back or should I just start forwarding your mail?" she asked. I recognized an edge of impatience in her voice and I could hardly blame her. It had been more than four weeks since I'd left home and I was still traveling away from her. Any day now, I feared I might slip out of her orbit and keep right on going, sailing off into the dark unknown.

When I woke, it was practically raining inside the boat. There were low clouds and fog outside, but somehow it was even wetter inside. Shimmering

moisture collected on the cold fiberglass ceiling. One fat drop gathered into a heavy tear, wavered, then surrendered to gravity and hit me square in the eye. Time to get moving. I opened the cabin windows and tried to air the place out while I performed my morning rituals. I spooned out three heaping soup spoons brimming with dark, Sumatran coffee into a paper filter and plastic cone precariously balanced over my dented and stained stainless steel camp mug. I mopped condensation from the walls with a fistful of paper towels while I waited for the water to boil. When the kettle finally whistled, I filled the mug in one long and continuous pour of scalding water until there was just enough room left for a single cube of sugar and a splash of increasingly suspect milk.

The north wind had moaned through the night and I wasn't in much hurry to launch into a new day. Most mornings, especially if the light was good, I could inhale a bowl of instant oatmeal and have the boat up and running in under two minutes. In the absence of such urgency, I cooked blueberry pancakes, spooning the mix into my chipped non-stick pan, then eating them steaming hot and doused in maple syrup. After four of those bear-paw-sized creations, I was ready to hibernate myself.

Instead, I looked at the calendar—August 4—and surveyed my stocks of such critical provisions as whiskey, coffee, beer, and cooking gas. All were in low supply. I gave myself a week before I'd turn for home. Already, I had begun to harden myself to the prospects of, if not complete failure, then at least bitter disappointment. I wasn't leaving empty-handed. I'd seen some new country, had a few stories to tell, and I'd gotten some okay snaps. But as for breaking new photographic ground? Let's just say I wasn't unduly worried about being pushed into a higher tax bracket.

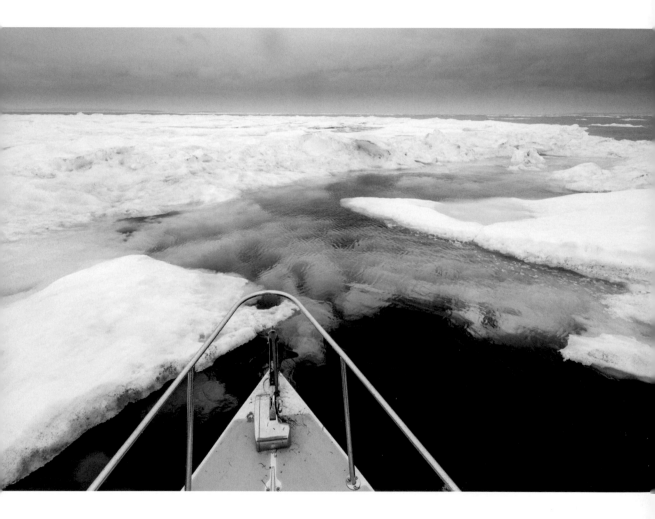

CHAPTER 12

ICE

I'll admit now that the message I left on my wife's voicemail did me no favors.

"Hi sweetie. I'm um . . . okay. This is my position: latitude 65° 38.92' north . . . longitude 83° 49.54' west . . . Hey . . . I've got a bit of a situation here. Could you take a peek in my office and look up the numbers for the boat insurance policy?"

I was standing on an empty stretch of gravel beach, satellite phone in hand, not another living soul within fifty miles. *C-Sick* sat trapped precariously on the rocks, surrounded by massive icebergs. From shore to distant horizon, I saw nothing but an uninterrupted sea of white.

I was so very, very fucked.

None of this was part of my plan for the day, of course. But almost getting yourself killed so rarely is. I had blithely motored out of Petersen Bay, giddy in the morning sunshine. A thin band of pack ice had blown against the shore, but a mile offshore the water remained open. *C-Sick* glided outside this ice edge on calm seas, and I scanned for polar bears and walrus through

C-Sick and arctic sea ice, Melville Peninsula east of Repulse Bay

137

my binoculars. I didn't get far. Just a few miles south, at the next little spit of land, ice blocked all but a narrow path. Beyond that, it stretched all the way to the horizon.

I heard the chuffing exhalations of a small herd of walrus swimming toward the ice and I gave chase, hoping to get some sort of picture. At the same time, I repeated to myself, "I do *not* want to get stuck in this." The walrus quickly vanished, so I let out the anchor chain and rowed my dinghy ashore, to take a look around from what meager elevation I could find.

The view was as stunning as it was disheartening: nothing but the unrelieved white of thick pack ice as far as I could see through the binoculars, all the way to Southampton Island twenty miles south. No open water, no channels or leads; a solid wall. The only way I could go any farther would be to start walking.

I scanned back and forth with my binoculars with what must have been a stupid look on my face. I kept thinking, "Where did *that* come from?" All the while ignoring one of the first rules of the Arctic: Watch your back.

When I finally turned around, the bay behind me was filling with ice. Like pieces of an enormous jigsaw puzzle, icebergs large and small began to assemble themselves into a solid mass, blocking my retreat. I took off at a dead run toward the shore, leapt into the dinghy, and rowed madly back toward *C-Sick*. On board, I gunned her engines and began weaving frantically through, around, and over the gathering ice, looking for any way out. Horrible crunches and grinding noises filled the cabin as I scraped through narrowing passages. It sounded like the fiberglass hull was splintering beneath me, and I waited for geysers of freezing water to start gushing in. I steered *C-Sick* toward shallow water, remembering that she drew less water than the biggest, more dangerous bergs.

In ten feet of water, the depth-sounder began its incessant beeping alarm. I smacked it again and again to silence the distraction, all while edging in closer to shore. Eight feet, then six feet of water under me. A small opening still led into the big, protected bay where I'd spent the night before. When I first looked, I had a quarter mile of open water. Suddenly it was down to two hundred yards, then fifty. I watched helplessly, in growing panic, feeling like a gate was slamming shut.

If I stayed out in the ice, I would lose all control. The pack would take us where it wanted. I might spend hours, or even days, trying to push my way clear. A four-thousand-pound boat against millions of tons of ice? I had a better chance of pissing over the side and trying to melt my way out. Worse, *C-Sick* faced the very real threat of being pinned, then slowly crushed between moving floes.

As the ice carried me closer to the rocks, I spotted one small patch of gravel beach. I had run aground more times than I cared to admit in my checkered boating career, but never on purpose. I turned hard to port, nudged the throttle, and pulled the outboards' blades halfway out of the water, where they egg-beatered behind me. Then I drove *C-Sick* right up on the shore. I thought the ice had sounded awful, but the noise of rocks grinding the length of her hull was far worse. My poor boat howled in protest, a sound like something dying. When *C-Sick* would go no further, I killed the motors, leapt overboard in rubber boots, and shouldered her in until she was firmly grounded in the shallows. Then I dragged the anchor and chain out thirty yards to make sure she didn't get any bright ideas about leaving me for good.

I needn't have worried. The ice continued to pile in all around us. *C-Sick* and I were stuck.

I was shaking from a cocktail of adrenaline and fear, and I looked wildly around the beach for something to do. Anything. But what?

I pulled out the satellite phone. My mind raced. Who exactly did you call to fix this? I had a few phone numbers scratched in my notebook, but there wasn't much anyone could do without a helicopter. I wondered how long I had to sit here before I could reasonably call the insurance company and start explaining my little . . . situation. I imagined hauling the Zodiac a couple miles across the peninsula on foot, then coming back for the outboard, and again for enough gear and gas to make a seventy-five-mile emergency run back to Repulse Bay. I could probably do it if I had to, but it sounded like an awful lot of exercise.

I settled instead on calling home, even though it was hours ahead of schedule. Janet didn't pick up. She must have been in a work meeting or on some conference call, so I left the message that would surely undermine what little confidence she still had in her husband's skills, safety, or sanity. I

sounded like one of those lost and doomed Everest climbers calling home for a final farewell.

That done, I settled down to my next agenda item: lunch. Nothing fancy, just a can of split pea and ham soup. It was the least bad food I had left, a favorite that I usually reserved for rainy days, but for this I was willing to make an exception. Then, in the manner of all castaways, I went off to survey my surroundings.

I made for the highest ground, a craggy ridge about 150 feet high. From there, I could see the ice stretching off in every direction I cared to look. To the north, the broad entrance to Petersen Bay was now blocked. I stared west across Frozen Strait. It looked packed solid, yet as I watched, more ice continually streamed in, borne on the tide. I did not want to dwell on my plight, and instead tried to enjoy the walk for its rare warmth. It must have been sixty degrees in the sun—tanning weather up here in the Arctic.

Fireweed and wild poppies filled the tundra like a well-tended park. I wandered through beds of luxuriant green moss, occasionally staring out to the (endless . . . unforgiving . . . frozen . . . white) horizon. Along the southern shore, slabs of sea ice were stacked on top of each other like building blocks, grounded on the tide. They towered fifteen to twenty feet high in spots, old multi-year ice from beyond the Arctic Circle, somewhere up near the Northwest Passage. In the soft sand, I deciphered no fewer than three sets of polar bear prints, including those of a big male. I could fit both my boots inside a single print.

The tracks were windblown and softened at the edges. The bear must have passed at least a day ago, but I was drawn to follow his tracks all the same. I hiked up the beach and over a draw, then stopped when I found a piece of fur. Polar bear fur. Twenty steps on, I found a skull and a scattering of bones. Judging from their size and the bear's gnarled, well-worn teeth, I guessed the skeleton belonged to an old, adult female.

Her fur lay wind-scattered across the stones and tundra, fireweed blossoms poking through the coarse white mats of hair. The skeleton had been there for some time—years probably. The hide and meat were gone, her bones scattered, and the skull lying a few yards off from the rest, bleached white by sun and wind. Enormous fangs and massive jaws dominated the skull; her

small front teeth were crooked and chipped. I couldn't tell what killed her, starvation, old age, or something else entirely. Big male polar bears aren't above cannibalizing cubs, nor taking on a frail old matriarch like this. She might have lived through twenty-five winters or more, and raised dozens of cubs. I stood with her a long time before turning to walk slowly back, past another perfect Inuit tent ring six or seven feet around. Moss and lichens, hundreds of years old, covered the rocks. I could feel the wind of centuries whistling through my bones. Cresting the ridge, I stopped again to scan the resolutely ice-covered horizon one more time through my binoculars.

That was when I saw the other bear. This one was very much alive. Perhaps two miles offshore, head held high, he sniffed at the air and began walking purposefully across the moving ice. Straight toward *C-Sick*.

Fear knotted my guts and a slick of sweat broke out across my body. With *C-Sick* grounded high and dry on the beach, I had no place to go, nowhere to hide. I set off downhill at a trot, clutching the twelve-gauge, and clicking the safety's action back and forth. Black side out, the gun wouldn't fire no matter how hard I pulled the trigger. Red side out: *bang*. I mumbled over and over the old gun safety mantra, "Red, you're dead." I had my cameras in a backpack, but didn't even think about wasting time with them now. If that bear got to the boat ahead of me and tore into the cabin, drawn by the scent of food, or even worse, if he caught me out in the open . . . I did not want to think about it.

I lost sight of the polar bear as I hit the beach at a run. Reaching *C-Sick*, I bounded over the gunwale and into the cockpit in one leap. I rushed inside to grab more bear-banger shells. Then, I counted out six other shells from another cardboard box, the lethal lead slugs I kept stowed away. I stacked them in a neat row.

Just in case.

In the boat, down by the tideline, I had no line of sight on the bear. He would be less than a hundred yards off before he even cleared the horizon, so I climbed back over the gunwale and stalked up the beach. When I could see the bear, he was still out on the ice, holding his nose to the air. Analyzing. Tracking. Thinking. And then, he yawned, in the way a bear does when nervous or stressed.

He must have picked up my scared-and-sweaty-old-man stink, over all the other smells of boat and food and dirty long johns. It was enough to spin him on his heels and send him off the other way, back out onto the ice.

Thank you, mister bear.

I dried my sweat in the afternoon sun, gulping down a nerve-settling beer. The falling tide had left at least one hundred yards of ice stranded between me and the water's edge, and the pack was pushing north at a brisk clip. Still, I could see some open water was now mixed in there, and it gave me dim hope that I might squeeze through when high tide returned.

The days were getting shorter: the sun set five minutes earlier and rose five minutes later each day. When I left around nine o'clock to hike back up and photograph the polar bear's skull in the setting sun's golden light, I misjudged the timing. The daylight was already fading, and the bear's remains blended into a mountainside of indistinguishable, lichen-covered rocks. It took me ages to find her bones, lost in the shadows. The last rays of sun still lit the ridge crest, and I carried the skull, heavy in my hands, with as much reverence as I could muster back into the light.

I placed her skull, like an offering, atop the stones. For just a moment longer, the midnight sun warmed her bones, then it was gone. The fading heat of the day radiated off those rocks like a warm sigh. I sat for a long time with the bear, staring into those empty eyes. The sky turned pink, then violet, and finally ebbed into a deep twilight blue. The first stars I'd seen in a month began to flicker overhead as I carried her bones back to where she fell.

One last time, I placed my hand on her smooth skull. I said a silent prayer to her spirit, hoping for some benediction for safe passage through her domain. Then I walked back to my stranded little boat.

When I reached the beach, *C-Sick* was already floating on the incoming tide. I felt a flood of relief as rushing currents broke the ice, and I could make out the beginnings of a narrow channel through open water extending to the west. I gathered the anchor chain, gave one last shove to encourage *C-Sick* off the beach, and we cast off. When I scrambled back over the gunwale, the

Polar bear's skull at sunset, Vansittart Island

boat shifted beneath my weight and seemed to waggle like a happy dog. We were back in business. Cautiously, I steered with the current through the shifting pans of ice near shore.

A path to safety slowly opened up before me. Last night's anchorage, less than an hour away, was now packed solid with ice. I pushed farther east into the bay, then tucked into a broad cove that promised some protection against the rising wind, the ice, and the chop.

I called home to reassure Janet that all was well, that my earlier phone message had been yet another example of unnecessary dramatics.

"Hey, honey. Everything's fine. Nope, no helicopter ride. No rescue," I chirped in my most reassuring, faux-jovial voice.

Relieved, to be sure, my wife remained unamused and unconvinced. She told me in no uncertain terms, "Don't ever leave me a message like that again. Do you have any idea . . ."

It was nearly midnight. I didn't bother making dinner. I just collapsed into a dreamless sleep.

PAY DIRT

By morning, drifting ice had filled the bay around *C-Sick*, and with it came a white wall of fog. I wasn't eager to head back out into the maze, but as ice crowded into my anchorage, I no longer had the luxury of choice.

As the fog erased my view, I was left to crawl blindly through the ice at one or two knots. The GPS told me I was moving west into Frozen Strait, but my radar showed only a Rorschach of vague blobs. As I stared at the display, I could see that it revealed hidden openings through the ice, a shifting but navigable pathway ahead. For the longest time, I had considered the Furuno radar dome another of Pastor Kirby's indulgent nautical purchases, one more electronic toy I neither needed nor wanted. I'd turned it on from time to time, strictly for its entertainment value, but had never even bothered to read the instruction manual.

Now, as I wound my way through the labyrinth, I sent a mental thank-you note out to the good pastor.

The fog continued to play tricks on me. In this white-on-white seascape, jumbled pack ice morphed into fantastical shapes. Soon, everything looked like a polar bear.

Nearby, I saw three slabs of vertical ice. I casually picked up my binoculars for a quick check and realized, with a start, the slabs were three polar bears—a mum and two large cubs. I slipped a telephoto lens out the window, composed the frame, and began to shoot. It was a ghostly scene: white bears

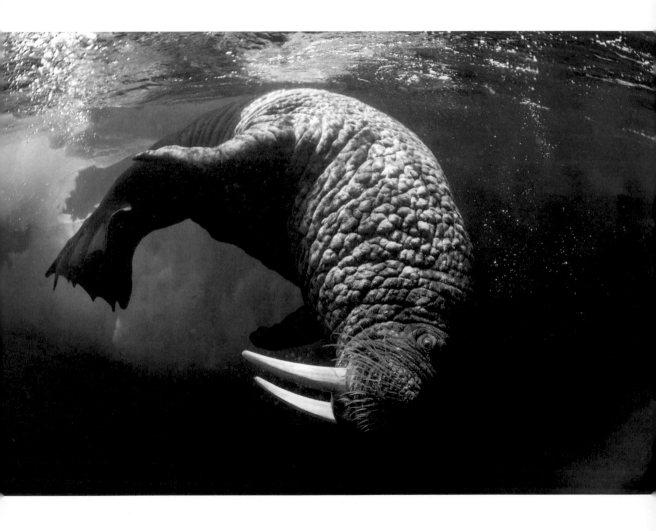

on white ice in a sea of white fog. Only their eyes and noses stood out, like a snowman's, black as lumps of coal. They seemed to look out at this rumbling ghost emerging from the fog with equal measures wonder and wariness. Soon, curiosity satisfied, they trundled off at a brisk pace across the ice and vanished into the mist.

The fog burned slowly away, and to my surprise, the day turned fine—staggeringly so, with a flawless sky, sunshine, still winds, and a mirror sea. The water here was three hundred feet deep, Caribbean blue, and clear as gin.

I spied five walrus nestled together on an ice floe and took *C-Sick* over for a closer look.

Walrus might be foul-smelling, ill-tempered, and unpredictable, but compared to polar bears, they are absolute pussycats. Large and brown, they gather in sociable groups and are a good deal easier to find. Their bulk and lassitude leave them disinclined either to run away or to tear your face off.

I shot them with the telephoto. I shot them with the wide-angle. I got inventive and hung my camera off a seven-foot pole and stuck it right up in a walrus' grill. That earned me stern looks and a gob of snot blown onto my lens, but otherwise they were imperturbable.

When I approached another herd nearby, one walrus shifted weight and the ice shelf collapsed, tumbling the whole group unceremoniously into the sea with a chorus of snorts and a collective splash. Even fifteen feet under the surface, I could see them swimming with all the grace they lacked on land. I had never appreciated just how elegant they could be in motion.

Then I pushed my underwater camera a little too close. A big male turned, gave the dome two powerful thwacks with a long ivory tusk, and swam away.

Suitably chastened, I motored back toward *C-Sick* and ghosted along the ice floe's edge. I glassed back and forth, searching for the shape of a bear amidst the shifting ice. To torture a metaphor, it was not so much a needle in a haystack as a vast field of haystacks set in motion by wind and tide. Maybe there was a needle in there, but probably not.

Walrus swimming beneath sea ice, Frozen Strait

I ranged back and forth for hours, but by day's end I had found no more bears and only a few, distant seals. Recorded on the GPS's screen, *C-Sick*'s wandering track read like a child's looping scrawl. The setting sun bathed the world in golden light, and in the day's waning moments the ice glowed pink with cobalt blue shadows. Just before it dipped beneath the horizon, I watched the sun flash emerald green for just an instant.

All my old anchorages in Petersen Bay were now clogged with ice, so I continued west toward White Island. My charts showed a promising-looking bay called Toms Harbour. When I arrived sometime after eleven, I had to admit that this Tom guy knew what he was doing. The cove was snug and well-protected. The surrounding hills were steeper and craggier and taller than any I'd seen since I first floated *C-Sick* into Hudson Bay.

After nearly 1,400 miles of travel, it felt like I'd finally arrived in the land I had been dreaming of.

I had seen five polar bears before eight a.m. but had made precisely zero pictures when I started grumbling to myself, "So that's how you're going to play it." I headed away from shore and back out toward the drifting ice, but hours more scanning in the harsh midday light yielded only a low-grade headache and a growing sense of frustration at this single-minded pursuit. The breeze stilled in the late hours of the day, and the sea again turned to glass. Sunlight reflected off the water in sinuous golden curves.

The ice, an impassable wall across Frozen Strait two days before, had dissipated into lacy ribbons. I motored at dead slow speed through the remaining frozen pans, eyes glued to binoculars, scanning . . . scanning. Every fifteen minutes or so, I cut the engines and marched out to *C-Sick*'s bow, then slowly turned a complete circle, peering hard through the 12x binoculars at every piece of the dirty snow and melting ice.

For two more hours, I muttered to myself over and over, "I know you're out there."

And for once, I was right.

There was one more yellowish fleck in a sea of white ice. I stared hard, then, maybe, could just make out the form of a sleeping polar bear. I motored closer, my eyes glued to the binoculars, afraid to lose sight of him in the

shifting jumble of ice. At a half mile, I could see his face: a fine-looking young male, fast asleep in the snow. I took my time and let the current push me in closer, briefly tapping the engines into the gear to stay on course. All the while, I struggled to organize my cameras. Weeks of cold and damp had taken a toll on their sensitive electronics; I could not find a single one that reliably worked. I had a half dozen cameras on this boat, thousands upon thousands of dollars' worth, and yet not one of them actually worth a damn.

C-Sick had settled into the ice fifty yards away from the still-sleeping bear when I started pulling apart my underwater housing. Ironically, the only camera that still worked was the one that actually *had* been dropped in the ocean.

I caught my breath and waited for the bear to wake. Eventually he yawned, did a big, full-body stretch, and sat up. He gave the air a sniff and, finding something to his liking, started to walk. Straight toward me. I switched from the telephoto zoom to a wide-angle. The bear wasn't slowing down at all.

I was standing out in *C Sick*'s open back cockpit, and the boat's gunwales stood even with the iceberg's surface. In less than ten seconds, I would find myself eye to eye with a confident and now quite curious polar bear. In the rush to find a working camera, I had neglected to bring anything else out on deck with me—not even that pen-sized bear banger. The bear calmly crested a small hummock less than forty feet away. Whatever nerve I had to stand my ground vanished as he picked up speed for the final approach.

I backed into the cabin, closed the door, and dropped the engines into gear, eager to put a few yards of open water between us.

The commotion was just enough to dampen the bear's curiosity. He casually stepped off the ice into frigid water and soon disappeared into a maze of drifting bergs.

Almost immediately, I felt like a coward. Had I come all this way just to go chickenshit at the last second? In hindsight, it sounded like utter madness; no one in their right mind stands defenseless in front of an approaching polar bear, snapping pictures, no matter how pretty the light might be. Right?

But damn, it would have made a great picture.

Anchored back at Toms Harbour, I jerked awake at two in the morning when an iceberg raked against *C-Sick*'s hull. It was only a small berg, and,

in spite of the racket, unlikely to send me to the bottom. In the almost full darkness, I stared up for a moment at the novelty of twinkling stars. It felt like my Arctic summer was almost over.

While summer might have been winding down, at daybreak warmth wafted over me like a dry desert breeze off the land. It brought a cloud of mosquitoes that circled diligently until I motored *C-Sick* farther out from shore. It was a beautiful, still day on the water. Coming out of the harbor, I saw several ice floes packed with walrus. I motored out slowly, not wanting to spook any into the water. Walrus had been hunted for centuries here, and I would have understood if they were a little skittish.

In the Zodiac, I let the current pull me toward the nearest herd, but some reflection or noise startled one of the animals, and suddenly everyone was in the pool. One group swam in a slow circle close to the iceberg, and through the clear water the youngest of calves stared up at me with saucer eyes, small whiskers, and the sweetest expression of wonder, nestled under the protective flipper of his mother.

I took what pictures I could, then started looking around for *C-Sick*. I swallowed a small twinge of panic. I was forever losing things: keys, wallet, sunglasses . . . but my boat?

The water here was far too deep to anchor in, and the drifting ice rendered that idea foolish, anyway—a passing floe could easily catch the chain and drag *C-Sick* under. So, I'd simply let her drift. I had begun wearing my drysuit whenever I left the big boat, in case an errant iceberg or irate walrus flipped me and I had to swim for it. And I usually remembered the bright orange waterproof case that held my EPIRB beacon, satellite phone, and flares. But, still.

I so did not want to have this conversation with the hard men of Search and Rescue.

"Sorry to be a bother but I seem to have misplaced my boat. Could you fire up the chopper and give me a lift?"

Without binoculars, all I could see was an endless panorama of white reaching to the horizon in every direction. With the tide running, the ice, *C-Sick*, and my inattentively piloted Zodiac had all been moving at varying speeds and on different headings. I resisted the urge to backtrack at full

throttle, and instead forced myself to stay calm, remain still, and keep looking. Finally, I made out *C-Sick*'s radio antenna sticking up from behind a distant iceberg. She had drifted more than a mile. It felt like I'd turned my back on a much-loved puppy for one second and she had made a run for it.

I didn't let her out of my sight as I headed back.

As soon as I climbed on board, nerves still jangling, I made a point of squeezing the spare pair of binoculars into my survival kit.

I found the day's first polar bear, blood-smeared and looking pissed off, not long after that. In a moment, I saw the second bear of the day, molars deep in a walrus who was clearly past all sorrow. And the morning's third bear was busily swimming out from shore intent on joining the fun. I grabbed all my cameras and hopped right back into the Zodiac. Only belatedly did I think about my life jacket or the survival gear. Screw it. There were bears right here, and I didn't plan on going far.

There followed the usual ursine hijinks, even more spirited than normal with three hungry bears vying for that one tasty and nutritious walrus. For a bear-obsessed photographer, it was almost too much of a good thing. Where to even begin? I reckoned the walrus wasn't going anywhere, but kept one eye out for a brawl between the dining patrons. I focused at first on that bear in the water. If he kept swimming closer, or even better, arched his back and dove, I might be able to catch him floating underwater: a shot I've been imagining for years.

While I struggled to position the underwater housing near enough to get his face in the frame, the Zodiac drifted in closer. He lashed out with a warning growl, splashing me with ice water and raking his claws across the boat's thin, inflated surface.

Okay, maybe too close.

I threw one look over my shoulder toward *C-Sick* and my heart sank. Trapped in moving ice, the current was driving her toward White Island's rocky shore. In my haste, I'd also left the cabin door standing wide open with several hungry polar bears within easy snacking distance. Only then did I notice the slight but unmistakable hiss of air leaking from my dinghy. One of the tubes was already going squishy. I tried not to panic, but I turned the Zodiac toward *C-Sick*, racing back before it went completely flat.

I steered the dinghy in a wide loop away from the bears, shifting my weight off the deflated tube. Sweating inside my drysuit, I ran the dinghy into the ice hard enough to lift the bow out of the water. I hit the gas, trying to force a path in, but nearly tipped over instead. I grabbed hold of the bow line and scrambled over the side and onto the nearest iceberg. It wobbled ominously, but before it rolled completely I leapt to the next, then the next. With each step, the ice sank beneath my weight and threatened to pitch me into freezing water. Dragging the dinghy behind me like a sled, I hopscotched across the final ten yards and hauled myself into the cockpit as that last small berg spun out from beneath my outstretched foot.

Panting, I swore I would *never* do that again. I fired up *C-Sick*'s motors and nudged her out through the ice and away from shore.

Once I caught my breath, I realized there hadn't been much real damage except to my pride. And to my detumescent dinghy, of course. I idled back to within sight of the feasting polar bear and that walrus kill. It was good, bloody fun, and I sat for a long time, watching and photographing the tableau. All the characters were assembled: King of the North, victorious and smeared in gore; Walrus, defeated, dejected, and partially devoured; the Jealous Rivals, waiting in the wings to steal his prize. They could have sold tickets.

But something was missing.

To paraphrase Mark Twain, the difference between a great picture and a good one is the difference between lightning and lightning bugs. I could see this was a good picture, but for the life of me I could not turn it into something great. The sun stood high in a cloudless sky and cast scalding light and harsh shadows on the bear and blood-smeared ice. I let *C-Sick* drift to within fifty yards and watched it all from the bow through my big telephoto lens. It was a record shot—perfect, or at least perfectly adequate, to illustrate predation in some obscure textbook. But fine art it was not.

Finally, the feeding bear, harassed by his circling brethren, began to drag the walrus to the edge of the iceberg. He backed into the water, and even as I was saying, "Oh man, you don't want to do that," he pulled the carcass in after him.

It turns out that, much like my deflated Zodiac, dead walrus don't float.

I motored until I found a sheltered cove farther north, along White Island's shore, then tossed the anchor out, and took a moment to regroup. Through all of my years of travel in inflatable boats, I had been inordinately lucky, never needing to fix a puncture out in the field. I'd always been more than happy to let the boat shop deal with any minor leaks when I got home.

I dug the repair kit out of *C-Sick*'s bowels. It contained a number of patches, a withered glue tube, and some vaguely translated and altogether non-specific instructions. While I lacked much in the way of boat repair skills, I could still conjure up memories of the many flat tires I fixed during a childhood spent bicycling over country roads that sparkled with broken glass. To a surprisingly cheerful tune, I began whistling to myself thinking, I got this.

My whistling soon turned chapped and dry, before expiring in a short, unhappy sigh. Perhaps there were not that many similarities between patching a bike tube and wrestling one hundred pounds of soggy, flaccid boat out of iceberg-filled waters at the Arctic Circle after all. It took me an hour of fiddling with ropes, improvisational rigging, and vigorous swearing just to tilt the injured boat up on one side and tie it into place with a series of half-assed half-hitches. I had to stand on tip-toes atop *C-Sick*'s gunwales before I could finally see the long series of parallel scratches that led to one pinpoint puncture.

Hmmm. That shouldn't be *that* hard to fix. I cut out a patch, smeared around some glue, made a suitable mess, and slapped it all together.

After lunch, I added just enough air to keep the dinghy properly afloat, then clipped it on its tether and motored *C-Sick* north.

The landscape along Frozen Strait held a stark, spare beauty, where craggy cliffs and steep hills fringed with soft meadows of tundra. In a distant alpine valley on the slopes of White Island, I counted twelve polar bears. They were all no bigger than white dots, not a single one close enough to photograph.

Even though I wouldn't have camped out there if you triple-dog dared me, I didn't want to leave.

There was, however, the matter of my dwindling reserves of gasoline, money, and patience. I was down to my last twenty gallons of fuel and I still faced at least seventy-five ice-choked miles back to Repulse Bay's gas station.

I took a hard look at the calendar. In years past, I'd been happy to extend trips and stay as long as I damn well pleased until I got the pictures I wanted or got sick of trying. Married life, even with a wife as understanding as mine, required compromise. Janet had been telling me for weeks, "It's been too long." I had been gone almost six weeks, and I still needed to retrace my steps and find a winter home for *C-Sick*, then make my way back to Seattle.

I turned the helm toward Repulse Bay and felt a sadness rising in my chest. I told myself, "That was that. Whatever you got, that's all you're gonna get."

Near the halfway mark, I ran into ice again, and reached around for my binoculars.

By the time I turned back, I hardly needed them. A young male polar bear was sauntering casually across the shifting floes. He picked me out almost immediately and stopped to watch my passage without a hint of fear. I bobbed on the lumpy waves as the wind pushed me toward him. For just a moment, as he passed in front of the setting sun, his fur glowed like an orange halo of light.

With my big telephoto lens balanced on the window ledge and my shutter finger pressed down, I sprayed frames and hoped I might just get lucky. I whispered to myself and to the heavens above, "That is one handsome bear."

I wanted to stop time, but I couldn't even stop the damn boat. The wind pushed me one way while the tide's drift pulled me another. I flung *C-Sick* into reverse and wrapped the dinghy's tow line around both propellers, stalling the engines. I'll never know what photographic magic I missed in the following few minutes. I was too busy hanging head-down over the transom, feet in the air and hands deep in ice water, struggling to untangle the propellers and get moving again to notice. Over all the cursing and the splashing of tangled lines, there just might have been the sound of ursine laughter.

By the time I emerged, breathless, freezing, and furious, the bear had swallowed any last chuckles and was headed off into the sunset.

It took three long days of motoring to run *C-Sick* back to Rankin Inlet, and getting her out of the water turned into its own dismal adventure. I'd taken John Hickes's polite but perhaps not entirely sincere offer to keep an eye on my boat as an iron-clad contract. I had hoped to avail myself of a corner of

his covered and heated Quonset hut garage, but *C-Sick* couldn't clear the doorway. John was out of town, so I relied on his friend Harry's borrowed trailer and fraying temper.

"Boats belong outdoors," Harry muttered as I unbolted the radar dome to shave a half foot off the top. "Goddamn boats belong fucking outdoors," he swore more emphatically when I started letting some air out of his tires.

Given the quantity of broken glass and number of vandalized vehicles I'd seen all across town, I was reluctant to leave *C-Sick* to the tender mercies of Rankin's under-supervised youth. But it was Harry's trailer, so we moved on to Plan B: John and Page's sled dog lot. There, Harry hit the gas on his pickup truck and unceremoniously dumped *C-Sick* onto a carpet of old tires I'd hurriedly salvaged from the dump. My beloved boat sat listing and forlorn. It felt like a crummy end to the summer's adventures.

I was up early the next morning, scurrying to clean out *C-Sick* and prepare her for the long winter ahead. By the time I finished, soaked in sweat and feverish from anxiety, she was wrapped stem to stern in enormous tarps and looked like a giant blue burrito trussed up in dominatrix knots. There wasn't much time left for an emotional send-off. I felt like a cad as I patted her on the stern, thanked her the fun times, then headed off to catch my plane.

Those final three or four days after I drove *C-Sick* onto the rocks and escaped the crushing ice had been almost magical, dreamlike. The sun shone brighter, the colors were more vivid, the animals more fearsome and graceful and beautiful. It had been riveting. I had made more good photographs in those few days than I had in the previous six weeks. Still, after all the time and money and risk, I wanted more. More time. More bears. More to show for all this trouble.

It was killing me to have worked so hard for so long, only to leave just when the going had finally gotten good.

There was something even more dispiriting about retracing my arduous, months-long northbound journey in less than an hour. I watched the miles rewind out an airplane window. Marble Island's haunted and protected harbor. Whale Cove with its headless and fly-covered polar bear carcass. Soon we were so high I could see only sea and sunlight and boggy tundra curving toward the distant horizon.

Even as the plane winged south toward Churchill and I began to feel gravity's pull toward home, I was already thinking about next year. How to get back, where to go, how long to stay. Oh, the things I would see.

CHAPTER 14

THE NEW YEAR

A brief historical digression is perhaps in order.

When the smoke cleared at the end of the Napoleonic Wars in 1815, England ruled the seas, but the Admiralty found itself at loose ends. They were in charge of the most powerful naval force the world had ever known, but they needed something to keep that Navy's men and officers occupied until the next war came along. They looked around for small bits of colonial housekeeping to attend to, like finding the long-sought Northwest Passage. Navy lieutenant John Franklin was one more demobilized officer in need of a ship, scraping by on half pay. He had been lucky in battle, fighting with Nelson at Trafalgar and later at the Battle of New Orleans. And he must have felt fortune's smile to be plucked from obscurity and awarded command of a survey expedition deep into the Canadian wilderness. Pudgy and unfit even in the prime of youth, he wasn't anyone's picture of an intrepid explorer.

His mission was to travel from the Hudson's Bay Company's settlement at York Factory to the high Arctic, and begin mapping the continent's unexplored northern coastline. The expedition was cobbled together in a few months and suffered from poor planning and worse luck.

From the start, nothing went right. Supplies, boats, and men were all in short supply, and the locals took a dim view of the greenhorn and his half-baked plans. His team of four naval officers and their small band of *voyageurs* were barely out of sight of York Factory before, woefully overloaded,

they had to abandon much of their food, including seven hundred pounds of bacon, along the Hayes River's banks. How those lost rashers must have haunted his dreams in the long miles to come.

When he stumbled out of the wilderness three years later, half of his men dead, Franklin had mapped only a small portion of the coast, and any dreams of finding the Northwest Passage had gone the way of all that bacon. By the end of it, he was reduced to scraping lichens off frozen rocks and boiling his old leather shoes just to stay alive. Still, there is something in the British national character that loves a disaster, so long as it is carried out with noble suffering and bravery. His expedition was a train wreck, but Franklin was promoted to the rank of captain and returned to London a hero and a legend.

The man who ate his boots could have dined out on that story for the rest of his days. But he was, in fact, rather shy and deeply pious, nearly immune to public acclaim and official accolades.

Which makes exactly one of us.

For years I had smugly left the world of social media and photography contests to the amateurs and those who found themselves in greater need of validation. That was until a friend pointed out that some of these competitions handed out serious swag. My first contest left me runner-up for the prize of a new Land Cruiser in South Africa.

I had entered my image of the polar bear peering out from beneath the iceberg near Churchill—a photograph I chalk up more to dumb luck than vision or skill—in the BBC Wildlife Photographer of the Year contest. I woke poor Janet from a deep slumber when the news arrived that my picture had placed first in one of the competition's categories and had won us tickets to London. The winner of the £10,000 Grand Prize remained a closely held secret until the night of the awards ceremony, a black-tie affair held inside London's Museum of Natural History, in a grand hall beneath the skeleton of a giant dinosaur.

I rented a tuxedo and Janet bought a smashing evening gown. It was like prom night, only better, since we didn't have to sneak out to the parking lot

View from *C-Sick*'s helm in northern Hudson Bay

for cocktails; they brought them, one after another, right to our table. The big moment came, but I heard nothing except the pounding of my own heart and the rush of blood in my ears, nothing until Janet touched my arm and softly said, "Remember this moment." Then the announcer said, "And the winner is" . . . not me. A moodily artistic baby elephant photograph handily beat out my artistically moody polar bear. They still made me go to Broadcasting House the next day for a live interview on BBC World's news show. The makeup lady had her hands full when I arrived after two hours of sleep and in the grips of a savage hangover. They sat me down in front of the camera and words apparently sprang forth from my mouth, though I remember almost nothing of what I said. My reference to the other photographers as a pack of mean third-grade girls was just the vodka talking.

Back home and licking my wounds, I threw one last Hail Mary and entered the picture again, in the annual *National Geographic* Photography Contest. And this time, nothing but net. There was a not-insubstantial cash prize, along with a surprising buzzsaw of unexpected publicity. The December morning the prize was announced, I found myself at the center of my very own media feeding frenzy. It must have been a slow news week. For seventy-two hours, I fielded dozens of interviews and answered the same questions over and over. Yes, I was out there all alone with the polar bear. Okay, maybe I was a *little* bit scared. No, the picture was not a photoshopped fake.

With the prize came an all-expenses-paid trip to the magazine's annual photographers' gathering at the *National Geographic* headquarters in Washington, DC, along with a chance to meet the magazine editors. A chance to peek behind the palace walls? Meet the gatekeepers? Feel the love?

An invitation to join with the heroes of my profession was an honor, but it turned out this wasn't exactly an intimate gathering. I arrived to find the *National Geographic* main auditorium filled to overflowing. I saw famous photographers, names and faces I recognized, standing in the back of the hall because an abundance of lesser lights like myself had taken all the good seats.

My promised tour of the editors' offices turned out to be just that—a tour of the editors' offices. The editors themselves were off in conference rooms, meeting with real photographers. I did have a nice chat with the guy who built all the magazine's remote-control cameras, though. They kept him

hidden away down in the basement, and we bonded like lost brothers—two happy nerds chattering away while the cool kids were off having fun.

I might have sulked longer if it hadn't been for some new and unexpected emails that landed in my inbox. Canon's Hong Kong-based advertising agency had, without so much as a whisper in my direction, designed a massive ad campaign featuring my polar work. The agency's first offer was three times more than I would have settled for after a week of haggling. They booked three hundred feet of wall space inside the city's metro subway tunnel to create a gallery of my Arctic images. My polar bears hung inside the airport's cavernous arrivals terminal. Last summer's walrus decorated the city's bus stops.

Stranger still was a cryptic email string from a Los Angeles ad agency inquiring about my use of Intel products. I have, for more than two decades, loyally clung to generations of Apple desktops, laptops, phones, pods, and pads. In my own admittedly meager defense, I was up front about all this. But I cheerfully jumped ship and, without a backward glance, began shilling for Intel. They wanted a wildlife photographer, and I was all too happy to be their flavor of the month.

The storyboards and script were already done. I just had to fly to Los Angeles and perform for the cameras. They would film me as I photographed (captive) elephants on an African (by way of southern California) safari, drove a (rented) Land Rover, set up an (ersatz) remote camera, all while magically capturing the hero shot that would anchor the entire Intel advertising campaign. That last part was real. Amid all the takes and re-takes and breaks for lunch and stops to dust off the Land Rover, I had to shoot a picture that would stand alone as the centerpiece of this entire production.

No pressure.

I arrived and saw no fewer than six tractor-trailers overflowing with video gear, lighting, and props. I could feel the eyes of dozens of men and women in the crew, the creative team, the Intel executives, the animal handlers, even the elephants, all looking at me and thinking, Uh oh. I hid out in the makeup trailer and tried not to throw up. By the end of our first day of shooting, the light was fading, the smoke machine was on its last legs, and the elephants had grown so cranky they'd begun throwing rocks at their trainers. Yet in the

final minutes before sunset, I took a knee and when the elephants entwined their trunks in a final playful embrace, I pushed the shutter.

Click.

When I saw the image on my laptop for the first time, I breathed a happy sigh of relief. And then I realized that I'd been going about this safari business all wrong. Traveling halfway around the world, spending weeks in the wilderness, desperately tracking wild animals through the bush? Screw that. I'm renting my own damn elephants next time.

In two days, I was back home in Seattle, wondering if it had all been a strange dream.

Six weeks later, the commercial debuted and blanketed the airwaves. It played everywhere from *Dancing with the Stars* to *Monday Night Baseball* to reruns of the *Walking Dead*. It appeared on the Las Vegas JumboTron. It might have been visible from space, for all I know. I restricted my personal TV viewing to the DVD player until the storm passed. For a short while, I was the most famous wildlife photographer in America. Fifteen minutes later, it was all gone. I was surprisingly happy, relieved really, to go back to my normal life of cheerful obscurity, and get back to work. I imagine Captain Franklin would have felt much the same.

Here on the fringes of lone-wolf-expedition photography, I like to imagine myself as one of those nineteenth-century diamond prospectors. Sure, you're broke, your back hurts, the food is vile, and most nights you sleep in the dirt. But come morning, you wake up thinking today is the day it's all going to change, and all that work will finally pay off. And maybe once, every ten or twenty years, it does.

That polar bear shot: that was my diamond. And I was itching to head back north and find myself another. During the winter, I went through the previous summer's notes, dozens of scribbled asides under the broad heading of "next time." Next time bring more backup camera bodies and spare lenses. Next time bring better food. Next time don't be in such a hurry to go home. Oh yeah, and next time, get the goddamn shot. My plan was to stay out for six weeks, maybe two months if the boat, the weather, and my morale held up.

With *C-Sick* already waiting for me in Rankin, I planned to haul another mountain of gear with me as excess baggage on the plane. Chucking everything in the back of my truck until the axle threw sparks turned out to be a lot easier than struggling to neatly apportion and pack six large boxes filled with camera gear, camping gear, cooking gear, outdoor gear, my un-beloved shotgun, and food. Remembering the dismal rows of seven-dollar-a-can soup lining the grocery store shelves up North, I created enough onboard menus to open my own restaurant. Not that *C-Sick* could sit more than one dining patron.

I discovered a temporary quirk in Amazon Canada's shipping policies. For a one-time fee, I was able to send hundreds of pounds of newly purchased supplies all the way up to Rankin Inlet, which was otherwise surpassingly expensive to reach. I shipped everything from maple syrup to a case of Campbell's seafood chowder to a new gas-powered 110-volt generator. I was half tempted to try sending up a new boat while I was at it.

At home, stacks of boxes also arrived on our front porch with each passing day. More food. New camera gear. Another packing case. Janet kept one eyebrow keenly arched while she watched my growing frenzy. "If you're moving out, just tell me, okay?"

What could I say? I told her the same string of untruths I always did: "It's just a couple weeks. You'll hardly know I'm gone. I'll be back in no time . . ."

More spoils from my online shopping spree were waiting for me inside John's garage when I landed back in Rankin. After I arrived, I sat on the floor for long hours, tearing the boxes open one by one. Three separate packages of peppermint tea. A dozen cans of chicken sausage gumbo. A handheld CB radio. Four different kinds of breakfast cereal. I had even found someone who had been willing to send two dozen otherwise unobtainable butane stove fuel cartridges via air freight—which I'm fairly certain was both ill-advised and totally illegal. Because that soup wasn't going to cook itself, now was it?

By the time I had unpacked everything and added it to the piles of gear and food I'd dragged along on the plane, I knew one thing for certain: I was going to need a bigger boat.

A knot of young, local kids wandered into the garage and stared in disbelief at the bounty unfolded in front of them. When I turned my back for

a moment, they rifled through the pile of snack bars, ate some, and began shoving more into their pockets. One of them announced it was her birthday, and I gave each of them another bar. I looked around the Everest of food and figured that starvation was the least of my worries.

At some point my satellite phone beeped with a text from Janet. She had just been to the dry cleaners and was wondering what had possessed me to buy yet another down jacket, which she found in the picked-up clothing. I looked around the scattered piles of gear and scratched my head, mumbling, "Where *is* that damn coat?"

But it all came back to me: In the hectic final weeks before I left, I had dropped my old coat off along with my wife's sweaters at the dry cleaners. She texted again brightly, "Too bad you forgot that. It doesn't even smell like homeless person anymore."

Searching through the garage, I managed to locate my Zodiac, now covered in dust beneath a pile of caribou skins, and nearby the two plastic bins that held most of my foul weather gear. My outboard motor had found its way inexplicably into the back seat of an ancient GMC Suburban, and I noticed that it had been stored upside down. I hauled it out, choosing to ignore the two quarts of motor oil that now soaked the truck's upholstery.

Down past the dog lot, *C-Sick* sat right where I had abandoned her last summer, atop her throne of old tires. Her protective blue tarps had been reduced to tatters after eight brutal months of winter, and streamed almost gracefully on the summer breeze. I started cutting away string and flapping blue plastic, nervous to see what was left inside. To my considerable surprise, she looked just fine. Like a friendly and familiar old dog, she shook off the last of her winter coat and seemed to tremble with excitement, waiting to see what new adventures the season held.

I took a quick inventory. No broken windows. No water damage. No electronics.

Hold on a sec . . .

I distinctly remember something about a couple chartplotters and a depth-finder, since I couldn't have found my own ass without their electronic assistance last summer. I had some faint recollection of stowing them inside an orange waterproof case for safekeeping at last summer's end. But they

were not on the boat. And they were not in the garage. And I was not going anywhere until I found or replaced them.

I will say this for the modern electronic marketplace: plop me down in the farthest corners of the world and, with an internet connection and sufficient room on my credit cards, I can outfit just about any expedition, including this one. Captain John Franklin and his exploring ilk had to make do with the materials at hand, but those were different times. I may not be resourceful, but I know how to spend money. I quickly bought an $800 replacement GPS on eBay and a new depth-sounder via Amazon, and had both shipped out with all due haste and no small expense. I resisted the urge to buy a new down coat while I was at it, but only because Page generously offered one of the family's parkas.

While I waited for the shipments to arrive, I started loading supplies onto *C-Sick*. Each time I walked past with another duffel bag or equipment case, John's sled dogs hurled themselves at their chains, barking furiously. I was a little hazy about how I might get my two-ton boat back into the water, but with a single call John came to my rescue again and summoned an enormous front end loader. The driver lined up the front forks, slid them under my boat, and lifted her like a child's toy. Camera in hand, I jogged behind the big, yellow beast as it hauled *C-Sick* down dusty streets and deposited her gently on the gravel, just above the waterline at low tide.

She was floating in less than an hour, seeming just as happy as I was to be back on the water, and together we found our old anchorage a quarter mile offshore. By the time I had everything properly stowed, there was still time to take John and Page out for a short sunset cruise. By the following afternoon, two boxes containing my replacement GPS and depth-sounder were waiting for me at the post office.

I didn't even have to mess around with the wiring; it was as simple as plugging them into their purloined predecessors' cables, and soon it was time to go. Page and her fluffy snow-white Samoyed dog, Frosty, walked me down to the docks to see me off. She took snapshots as I motored past in a slow loop. I waved and tried to look competent, veering at the last second to avoid some half-submerged rocks. Within minutes, she had emailed the pictures off to my wife, proof I was still alive. Page had watched over me like an

overworked guardian angel; now she could wash her hands of me. From here on out, I was on my own.

I motored slowly out of the harbor, so excited I was practically bouncing in my seat at the helm. My mind was already far to the north, imagining polar bears and sunset light and miles of open ice. By the time I thought to look back, Rankin's squat profile had almost disappeared. Barely a breath of wind stirred and the Bay remained a picture of serenity.

I covered the first fifty miles painlessly at ten or eleven knots. The forecast had mentioned something about a cold front, but in my eagerness to get moving I had barely listened. Now storm clouds began to darken the horizon.

As I took the long detour around the shallow offshore reefs at Baker Foreland, I turned north and ran straight into a stiffening wind. Flat seas gave way to an annoying chop, which soon stacked into ugly three-foot whitecaps. I pushed *C-Sick* into the wind. She gave it her best, but she bucked hard in the face of waves breaking right on her bow. She rose over the top of each wave, then the bottom would drop out and her flat hull landed with a shuddering crash. I turned the wheel hard to the right, trying to sidestep the biggest waves and take them on the port quarter. Then I'd have to turn hard over left to get back on course. With the wind still rising and blowing against an outgoing tide, the waves grew steep and dangerous, pummeling *C-Sick* and sending unsecured gear smashing onto the floor. The old girl took the beating without complaint. Unlike her owner.

I searched the GPS charts for a protected anchorage nearby, some bay or small island to hide behind, but there was nothing to be found. With evening coming on, I elected to take my punishment and push on to the village of Chesterfield Inlet and its protected harbor. As the sun slipped out from behind dark clouds, the ocean spray lit up like sparks flying off *C-Sick*'s bow.

By the time I reached shelter, I felt shattered by the days of travel and packing and now these first tentative northbound miles. Even with my anchor set, the howling wind slapped waves against the hull and twisted *C-Sick* back and forth like an angry dog on a chain. Wearily, I picked through the day's wreckage and mopped up a gallon of seawater that had leaked in somehow. Beneath the cold half-light of dusk, I gulped down a bowl of instant noodles

and alternated sips of warm herbal tea and Irish whiskey, trying to soothe my nerves and bolster what courage I could muster for the long trip ahead.

The fat man in a torn and filthy T-shirt said, by way of greeting, "You're a stranger here."

Welcome to Chester, eh.

I smiled unconvincingly and explained, as best I could, why I was there and what I was doing this early-August morning. I wanted nothing but to gas up and get out. The village was preparing for the summer's bowhead whale hunt and seemed particularly wary of uninvited newcomers.

I filled up and ferried the full jerry cans back onboard. I made the one small concession to mechanical prudence I knew, and checked the oil in each of *C-Sick*'s two motors. As soon as I pulled the dipstick from the port engine, oil began spewing out. I don't know much, but I was pretty sure it wasn't supposed to do that. I cast an ironic look around for the nearest authorized Honda Marine repair facility, but I already knew there was nothing I could do but mop up the mess and keep moving north.

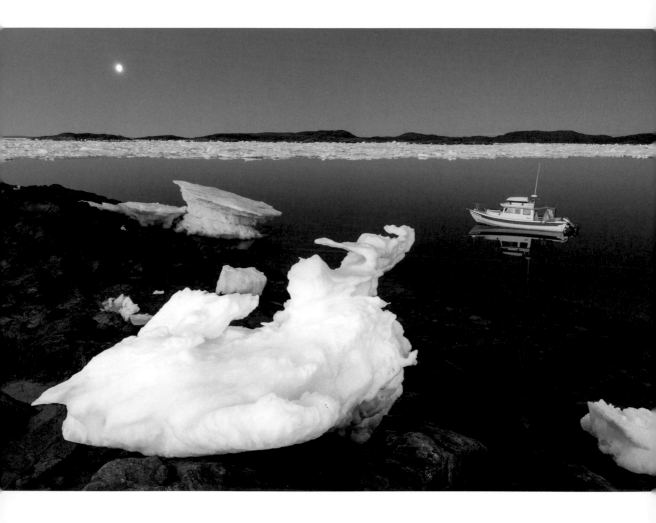

CHAPTER 15

THE ICE KINGDOM

The morning I arrived back in Repulse Bay, things were hopping. I'd covered more than 250 miles in the last three days and felt a glimmer of satisfaction at being back, even if getting here wasn't exactly the point.

All the able-bodied men in town were gearing up to go out hunting. It seemed like every pickup truck in Repulse, along with the road grader, the dump truck, and a small squadron of ATVs, had all gathered in an orderly queue stretching out hundreds of yards ahead of me at the gas pump.

It took nearly six hours to fuel up, then head back to the Co-op and replenish my stocks of bacon and other less critical provisions. With my shopping done, I motored back out of Repulse Bay and southeast toward the Harbour Islands. I saw dozens of bearded seals breaking the water's surface just long enough to catch their breath before disappearing again with a splash.

I spotted my first polar bear within a few hours, an off-white patch on the rust-colored rocks. And it was like I had never left. I saw the bear. The bear saw me, then turned an abrupt about-face, and headed for the hills.

C-Sick and melting icebergs beneath full moon, Frozen Strait

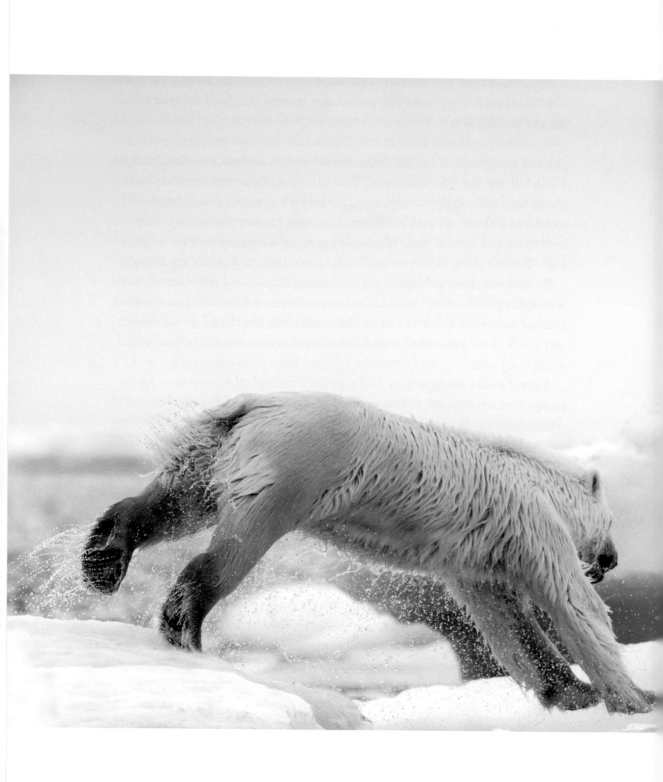

to appreciate all this scenic wonder without any bears. Ice shots, no matter how pretty, were unlikely to sell. I already had a file cabinet full of those in the basement and a computer server brimming with their digital cousins. I motored back to my little anchorage, then sat there staring at the rising full moon for a long time. I should go back out and shoot that scene, but my heart wasn't in it. Instead, I called home to check on the incoming weather and confirm that I was not completely alone in the world.

"How's it going up there?" Janet asked. The satellites and distance always flatten my wife's voice. She tells me I usually sound like I've been drinking. With marbles in my mouth.

"Slow," I grumbled. "Too much ice. Too few bears." I sniffled a little for effect, and tried not to spill my drink.

"Maybe you should take a day off and curl up with a good book."

"I already have one going."

"Let me guess, is it the one where a bunch of guys go off to the Arctic, and everybody eats their shoes, then they all freeze, and die?"

"Don't spoil the ending."

Just before the satellite cut out, she said from a million miles away, "I heard they're turning *Endurance* into a musical for Broadway. I know all about you and your Shackleton man-crush . . . "

I returned to scribbling in my black Moleskine journal. If there is one constant in the centuries of Arctic exploration it's this: everyone who came here suffered, and most all of them wrote about it in often excruciating detail. Page after maundering page of ice and cold and longing for the comforts of home. And, often as not, the folks back home didn't really need to hear about it. All the way back in 1633, Captain Thomas James wrote of the "intended discovery of the Northwest Passage into the South Sea wherein the miseries [E]ndured Both Going, Wintering, [and] Returning" in his *Strange and Dangerous Voyage*.

To be sure, Captain James's journey was no pleasure cruise. He sailed the *Henrietta Maria* through Hudson Strait and across the Bay to its southern reaches. Caught out along the wide-open and desolate coast in an early winter storm, in desperation he ordered his men to start drilling holes in her hull to sink their own ship. It was that or watch her be broken apart in

the pounding surf or be swept away by ice. They endured a cold and horrid winter, plagued by hunger and scurvy. But the good captain did have plenty of time, what with his boat encased in twenty feet of ice, to collect his thoughts and catalog every detail of the Gothic horror that unfolded. They buried their fallen comrades one by one in the ice. One of the departed men reappeared six months later, almost good as new except for the dead part, suspended in the ice right by their ship. They had to dig him out and try again, presumably in a deeper hole.

It was summer before they managed to refloat the ship. Before they sailed for home, they tried one last time to light a signal fire, hoping to attract any nearby Native tribes, or passing Chinese traders. The Captain climbed a tall tree to survey their surroundings, and one of his crew promptly set it alight, nearly incinerating James and laying waste to thousands of acres of forest.

The voyage was a disaster, but the Captain's book was a great success. Not everyone was a fan, however. Sir John Barrow, one of the Admiralty's great nineteenth-century boosters of Arctic exploration, scornfully dismissed James's writings from a century and a half earlier as "a book of lamentation and weeping and great mourning."

Everybody's a critic.

Almost as soon as I headed out the next morning, I spotted a polar bear mum with a two-year-old cub walking along the jagged ice edge, some three hundred yards out. I gaped for a moment, then grabbed my big telephoto, but she was too far off for any sort of picture. Blocked again by the ice barrier, I could only put down my camera and watch through binoculars instead.

The mother bear hesitated, and then stood and unfolded to her full nine feet of height and stared back at me. For a long moment, time seemed to stop, until she turned with her cub and continued on their way.

I looked out across the ice until the pair receded from sight, then I turned *C-Sick* slowly south. The sun beat down out of a flawless blue sky. It was a rare privilege to travel through this land, wild and unpeopled, bearing solitary witness to each day's wonders. I tried to savor it all for a moment or two, before returning to the tedious business of pissing and moaning about the pictures I was not getting.

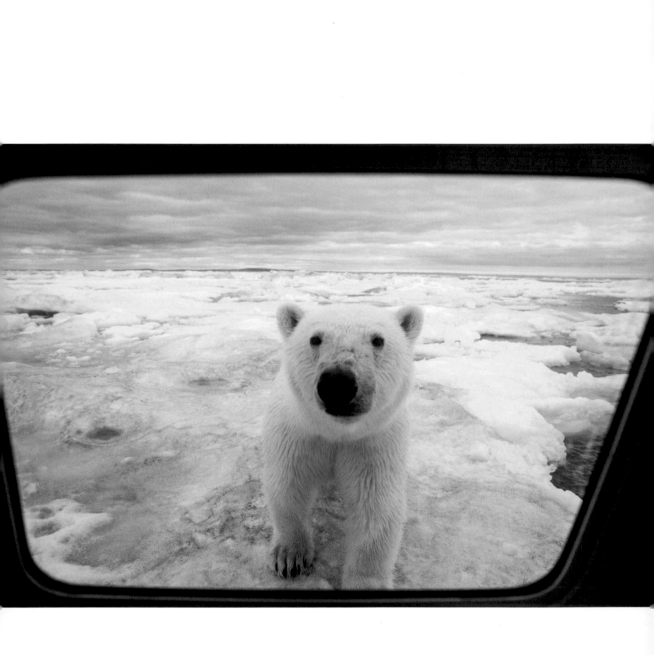

CHAPTER 16

THE HALF SHACKLETON

With each passing day, I ran the boat a little slower, nursing *C-Sick*'s ailing engines and meager fuel reserves. I told myself that the slower I went, the more I'd see, and I spent hours gliding across flat water at a grandfatherly shuffle. But as soon as I left the protection of the dogleg cove where I had anchored for the last several nights, the ice closed behind me and cut me off.

The way north was now blocked. So south I would go. But the channel ahead narrowed, eventually ending in a cul-de-sac bay. Within minutes, I came upon a young polar bear near the ice edge. And just as quickly he headed off in the opposite direction. The morning's next two bears proved equally eager to put an additional mile or two between us. Apparently, word had gotten around.

All through the day, I kept one nervous eye on the ice wall stacking up behind *C-Sick*. I finally resolved to get a better look from a three-hundred-foot hill rising above the channel—maybe from there I could divine some way around or through the ice. I motored the dinghy ashore and hiked up. From that outlook, I didn't need my laptop or the new satellite antenna I'd

Polar bear outside *C-Sick*'s window, Frozen Strait

dragged along, and I didn't need to download any ice charts. I could see everything I needed to know, stretched out below me.

Ice, as far as I could see. There was no way out.

I fiddled with the laptop anyway, and wasted time scrolling through my email. Maybe *National Geographic* had a sudden change of heart. But no, it was only the bank, wanting to know if I planned on staying alive long enough to make my minimum monthly payment. When I looked up, I could see a thick tongue of ice caught on the incoming tide galloping closer. *C-Sick*, anchored a hundred yards from shore in shallow water, lay right in its path. I scooped up cameras, shotgun, and computer, and scrambled down the hill in a clumsy, clattering run.

I dumped it all into the Zodiac and raced out as the ice drifted within twenty yards of me. Pulling up to *C-Sick*, I killed the dinghy's outboard and yanked the safety lanyard free. Fumbling in my haste, I dropped the plastic key into the clear water and watched it sink. Without it, I wouldn't be able to start the dinghy's outboard. It was as good as dead.

I plunged my arm into the frigid water, right up to my armpit, and somehow caught the lanyard between grasping fingers.

Bloody hell.

I had no time to strip off my sopping wet fleece. I just scrambled up to the bow to haul anchor and run for it. I urged *C-Sick* to life and we barely slipped through the narrowing gap between ice and rock. There was only one direction to go: farther down that dead-end channel. A sick, sinking feeling gripped me as the channel closed tight behind us, one final door slamming ominously shut.

I motored two miles to the channel's southern end, a J-shaped nook that would be my last protected harbor, my last stand. A sudden urge to batten down the boat and to organize every last bit of gear swept over me. I went ashore with my plastic container to collect fresh water from a nearby stream, and topped off the gas in my fuel tanks. I looked guiltily at my disorganized collection of cooking spices and started alphabetizing them again.

Eventually, I calmed down enough to load the Zodiac and go out exploring in the evening light.

Truck-sized chunks of sea ice lay stranded along the shoreline at low tide, melting into fantastical shapes. I walked along the tideline, tripod over one

shoulder, shotgun slung over the other, mindful that not all polar bears were as bashful as the ones I'd encountered that morning.

After sunset, I cruised slowly up to the ice face. Yep, still stuck. Every decision I had made felt reasoned and sound at the time, but all the same, I'd wound up trapped in this dead-end bay.

Settling in for the night on *C-Sick*, I listened to the north wind as it began to rise. Sometime in the half-lit night, I woke in a panic. Gusts shrieked outside. In my dreams, I had seen the Zodiac caught in a sudden blast, flipping it and drowning the outboard motor.

When I looked out, the Zodiac was right where I'd left it, dinghy and outboard bobbing angrily on their tether. I stumbled out in my long underwear to lash a fifty-pound water jug into its bow anyway, hoping that would be enough to keep things upright for another hour or two. Then I slipped back into my warm sleeping bag.

At what point do you admit you've been beat? That you were utterly wrong? That your sacred quest was a fool's errand?

I had plenty of time over the next three days to stew and sulk and think about it long and hard. In truth, it was still early days, not even two weeks since I motored out of Rankin Inlet, and hardly three weeks since I left home. But I was already feeling confident that I had never spent so much time and so much money to accomplish so very little. After another restless night, the ice relented and gave me enough breathing room to wind my way back up the channel and return to that same dogleg cove where I'd started. But I had nothing more to show for the long day of motoring. I was still surrounded by ice, still trapped.

I always start talking to myself after a couple weeks alone. Sitting at my table, steaming coffee in hand, I told myself to buck up. I reminisced, totaling the time I'd spent on this boat, reliving memories from seven summers in the North. Humpback whales in southeast Alaska. Grizzly bears along the Katmai Coast. Cruising along the fogbound Inside Passage through British Columbia. Now Hudson Bay. I could count more than ten months living, eating, and sleeping aboard *C-Sick*. But that didn't really capture how much she'd changed my life, my career. I never imagined that I would become

devoted to—obsessed with, really—chasing these photographs to greater extremes, to the ends of the earth. But life on the water has done stranger things to men's minds.

Each evening when I powered up the satellite phone, I thanked all the science and engineering majors whose hard work and lucrative Department of Defense contracts made my daily calls home possible. If not for them, I'd have been even farther on my way around the bend. I imagined those hardy old explorers, Franklin and his brethren, would have taken a dim view of all this. They had to rely on the rare passing whaling ships and naval vessels to bring any word from home, and to forward their letters back to loved ones, along with progress reports for their masters at the Admiralty. They could go years without making contact with the outside world.

"I'm thinking of making the carbonara again tonight. But the parmesan is a little moldy around the edges. And it smells funny. Do you think it's okay?" I asked my loving spouse.

"Cut off the green bits, it'll be fine," she reassured me. "Just try not to get eaten yourself, okay?"

"The weather's pretty bad," I grumbled.

"The weather's always bad. That's why no one in their right mind goes there. It's eighty degrees here, and I just cut the lawn. You're missing the best part of summer. And really, please try to be careful. I don't do mourning."

"I don't know, you look good in black."

And on and on, as the satellites whirred past, far overhead.

The ice was inexplicable. If there was a rhyme or reason to its comings and goings, it surely escaped me. I suspected there was a higher and malign intelligence at work. When I nosed *C-Sick* out of the protected cove, I was surprised to find the entrance to Frozen Strait nearly wide open for miles. A bit of ice off in the distance, sure, but just enough for scenic value. *C-Sick* and I had all the room we needed to maneuver. After a week icebound, I was ready for a change of scene, and I motored north, then east out into the strait.

And just like that, there was a polar bear.

I whipped out my binoculars. This was not just any bear; this was the bear you did not want to meet alone in a dark alley. She looked like a young

female, not particularly big, but she took one look from across a mile of broken ice and made a beeline toward me. I cut the engine and let the breeze carry me into her ice floe. The bear didn't hesitate and strolled right up like she owned the place. Which, upon reflection, she pretty much did.

I slid open *C-Sick*'s port window and leaned out to photograph her approach, first with the big telephoto, then the small telephoto, and finally with my wide-angle. She filled each camera frame in succession, so confidently and quickly that my nerve failed me. I leapt back and slammed the window shut as she closed to within five feet. She stared in at me through the glass, and for the first time, I had an inkling of what a seal felt in the last seconds before the lights went out. Practically pressing her nose against the glass, the bear looked almost comical, like she'd just dropped by to borrow a cup of sugar.

I hardly dared breathe, but I kept my eye to the camera and kept right on shooting as she sniffed at *C-Sick*'s flanks. She worked her way down past the open cockpit and seemed half ready to climb aboard for a closer look, but instead she shambled off to take a good whiff of the Zodiac trailing behind. If she took a bite out of that, I would find myself in serious trouble, so I opened the cabin door and tiptoed out. I didn't plan to tackle her or anything, but I could probably have roused myself to deploy some strong language and a bear banger or two, should the need arise.

It didn't. In the absence of a quick and easy meal, and with her curiosity satisfied, she walked back the way she came. It hurt my feelings a little. C'mon, I thought, I bet that Zodiac tastes bloody fantastic. A part of me, the stupid part, wanted to run after her, pleading my case like some desperate restauranteur chasing a customer down the sidewalk.

I tried following in the boat instead, but ice blocked my path. The western wind picked up, producing a steep chop that sent wave after wave of spray against my windows. Between the boat's jarring motion and the roiling sea, my odds of spotting anything else fell from slim to nil.

As the sun passed behind White Island's hills, the last pinpoint of light glowed emerald green, then turned a piercing sapphire blue. The wind ratcheted up steadily and soon *C-Sick* and I were fighting our way back to last night's anchorage. All through the evening, I listened to the angry gusts until, sometime toward dawn, they ran out of steam.

In the morning, I set out again. I stared down at the random lines and scrawled circles on my GPS screen, the digital trail from weeks of wandering. It looked like someone had produced a schematic of my attention span. Entering the familiar dead-end channel again, I somehow picked out a big male polar bear in the water. He was swimming amidst broken ice, and his camouflage was nearly perfect, just one more floating piece of white. I didn't dare take my eyes off the binoculars for fear of losing sight of him.

I grabbed the bare essentials, hopped into the Zodiac, and tried to get closer. When he climbed onto a small iceberg, I thought he might be the one—the perfect bear. He gave me some serious stink eye as I let the dinghy drift closer. I was shooting tighter and tighter with a long lens, but I wanted to show the whole setting, to put him in the context of the landscape. I saw the picture in my mind's eye. All the elements were there: a powerfully built alpha male polar bear standing atop a pristine iceberg, surrounded by low mountains and framed beneath a flawless sky. That image of him adrift on a lone piece of melting ice captured so much of what I wanted to say and show about these animals, this place.

But first, I had to change my lens.

I've done it so many times the movements should have been instinctive, but I had to take my eyes off the bear for just a second to make sure the lens was lined up correctly. I could not miss this shot. When I looked back up, the dinghy had drifted to within ten feet of the bear. He eyed me with heightened curiosity. Hell, from where he was, he wouldn't even have to get his feet wet; it was a straight jump from his iceberg into my lap. His hips and leg muscles shifted and tensed, but I could see a hint of indecision in him—leap, or turn and run? I was already raising the camera with my right hand and blindly firing off frames before the camera even reached my eye. With my other hand, I shifted the idling outboard into reverse.

The bear stood his ground for a moment, glaring, then turned and climbed up and over the berg. When I finally got the camera to my eye, I saw it.

Nothing but lens cap.

CHAPTER 17

A SINKING FEELING

The sound of faint but persistent crunching against the hull woke me from deep sleep. The thinnest sheet of new ice was sliding past, pulled by the tide into my protected bay. It was five a.m. and cold, both inside and out. The thermometer showed thirty degrees and there was not a breath of wind. The sky was half lit and the surrounding hills doubled back on themselves in the water's perfect mirror. It was utterly serene, and almost surreal.

As I made my way slowly out toward Frozen Strait, panes of clear ice broke away and skated across the frozen surface. The sky overhead remained a cerulean blue, and sunlight danced off the water. The storms and my troubles were all forgotten. This peace, this beauty—it seemed like the natural order of being, like the coda of my old Sunday School lessons, "as it was in the beginning, is now, and ever shall be."

I puttered happily along the shore, repeating saccharine affirmations to myself as I pushed through the drifting and encircling ice. When one door closes, another opens.

The rational half of my brain shot back, That's what Hudson thought.

I've long imagined that if I were a captain, a proper ship's master and commander, and not some know-nothing powerboat jockey, I'd have been like Henry Hudson. He was obsessed and reckless, moody and unreliable, the guy who took whatever boat was at his disposal, sailed it wherever the hell he wanted, blew the budget, screwed the schedule, and returned home

months late looking considerably worse for the wear and tear, but with a story to tell.

This would also be the man voted most likely to be set adrift on the ice and left to starve and freeze and die.

Hudson led four Arctic expeditions in as many years between 1607 and 1611. The man sailed farther north than anyone is known to have before him, and was driven past the point of reason in his search for the fabled shortcut between the trading hubs of London and Amsterdam and the riches of distant Cathay. He was hardly the first man to allow hope, greed, and wishful thinking to overcome common sense, bitter experience, and the hundreds of miles of ice-choked oceans arrayed before him. He was in good company. Geographers since Pliny the Elder in the first century BC knew—just *knew*—there had to be a passage across the top of the world between Europe and Asia.

In 1609, the Dutch East India Company bankrolled Master Hudson's wanderings, and he sailed his ship, the *Half Moon*, from Holland toward the North*east* Passage, searching for a trade route across the top of Russia. This was already his third bite at the apple; his previous trips had ended in bitter failure and threats of mutiny. Hudson made it as far as Norway and the White Sea and discovered, to no one's great surprise, that there was "much wind and snow, and very cold." Rather than following his orders to either forge an eastern route through the ice or cut his losses and return home, he turned the ship west. He sailed more than three thousand miles in the wrong direction, against prevailing winds and current, toward the New World.

That is my kind of crazy.

Once there, his ships took a scenic cruise along the salubrious North American coastline from Nova Scotia and Maine down to the Chesapeake Bay and North Carolina. The coming of winter finally sent him scurrying home. There was talk of another mutiny on the return trip across the Atlantic, and Hudson sailed the *Half Moon* back to London, avoiding the chilly reception and hard questions that surely awaited him in Amsterdam.

Finally, after three summers stymied along the far northeast corners of the Arctic, Hudson got his wish: an expedition to explore the American continent's northern shores. He knew in his bones that this was the way—this was the Northwest Passage and the shortcut to the Orient. A group of

well-heeled investors footed the bill, and he was given command of a newer and larger ship, the *Discovery*. He sailed her across the North Atlantic past Iceland and Greenland, toward what the maps of the day called the "Furious Overfall," a huge inlet with massive currents that earlier explorers had seen beyond the tip of Labrador. They hammered against ice and storm for six hundred miles through what later became known as Hudson Strait.

Hudson struggled for three long months through vile weather and against monstrous tides amid the pack ice. He was plagued by bad navigation, and by the end of it, he faced another mutinous crew. In exasperation, he flung the charts in front of the men and said, "If you're so bloody smart, you sail the goddamn ship."

Or words to that effect.

Finally, late in the summer, they arrived at a wide-open sea. It sure looked like the Pacific. They sailed south along its coast thinking, "China's got to be around here somewhere." Sadly, for all concerned, it was not. When the ship arrived at the Bay's southern reaches, it was already October and the crew faced a winter unlike anything they had anticipated. Though their position wasn't any farther north than London's, they discovered a climate more like Siberia's. The *Discovery*'s men faced scurvy and frostbite and slow starvation through a long and dismal winter.

Dissension boiled over, and as the grumbling grew worse, many openly questioned Hudson's judgment and sanity. He seemed reckless and untethered, uncompromising yet directionless. Provisions ran low. When it was time to sail in spring, Hudson readied the ship for another season of quixotic wandering. But there remained food enough for just two more weeks, and some of the crew began to think it better to risk mutiny charges and the gallows back home than endure certain starvation in this cold hell.

The mutineers dragged Hudson from his cabin, bound his arms in heavy ropes, then shoved him into a rowboat. They threw Hudson's young son in after him, then dragged seven of the weakest and sickest crewmen from their bunks and tipped them in, as well. *Discovery* sailed away from shore with the small skiff in tow, then the cold-hearted bastards cut the towline and set the desperate men adrift amidst the ice. The mutineers raised all sail and left Hudson and his men to their grim fate.

Discovery sailed for home with the mutineers in command. In the end, not a one of them faced the hangman's noose. They had plenty of time on the long voyage to get their stories straight. A battle with local Inuit had left several of the ringleaders dead, and all blame for the mutiny shifted, not surprisingly, onto them. The survivors claimed the mutiny a bloodless thing, more a cordial parting of the ways, really. But, when they arrived back in London, months at sea and thousands of miles of soaking waves and cold rain had still not washed the bloodstains from the ship's wooden decks.

None of the abandoned were seen again. But Hudson did get the Bay named after him. I guess that's something.

A flapping and squabbling knot of seagulls caught my eye as they circled above a gnawed-over ribcage and a pool of crimson blood on the ice. A hundred yards off, I could see the author of this small bit of carnage: a big male polar bear swimming, lazy and full, through the icy water. Not wanting to spook him, I left *C-Sick* to drift and again set out in the inflatable dinghy. The polar bear saw me, took one deep dive, then another. I felt that familiar adrenaline surge.

Taking deep, steadying breaths, I ran the Zodiac parallel to the bear at dead-slow speed. In my head, I could already see the picture: the bear swimming beneath the surface, floating in blue, fur trailing behind with each powerful stroke of his paws. I had tried to get that shot with my underwater camera, but it required a very special bear and very steady nerves. I had never been able to get it right.

I kept one eye on the bear while I fiddled with my cumbersome underwater housing. He, in turn, had both eyes squarely on me as he swam across the still water. I extended the pole to its full length, lowered the camera to the surface, and let the breeze carry me toward him. He gave out a low growl, clearly irritated, and opened his mouth wide. I instinctively held the shutter switch down as he snapped down angrily, fangs cracking at the dome. Momentum carried me forward, and as I pulled the camera up, the Zodiac

Polar bear bites at underwater camera, Frozen Strait.

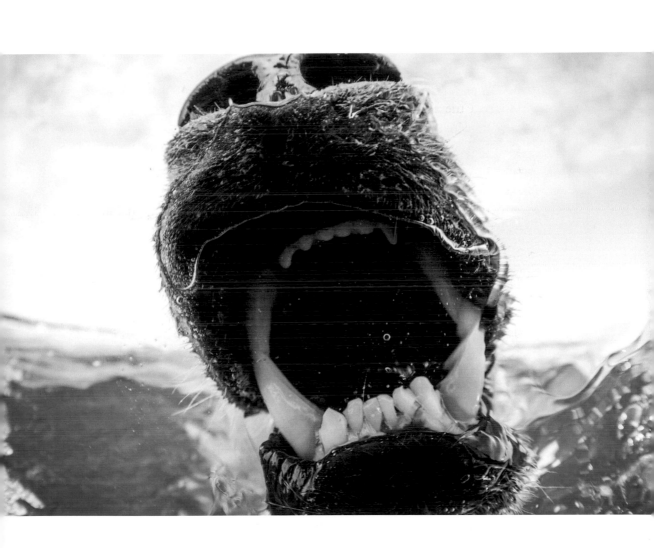

continued to drift closer. While I fumbled the gear back onboard, the polar bear lashed out again. His head seemed as big as a horse's, supposing that horses came equipped with four-inch incisors. When he lunged forward, he clamped his teeth into the inflatable's thin, synthetic rubber skin, and bit down. Hard.

At the sudden *whoosh* of compressed air, I knew I'd stepped over the line from incautious, stumbled past stupid, and careened into the realm of suicidal.

The bear was as startled as I was, and turned to swim away. Taking on water, the boat began to sink out from under me. I looked frantically for *C-Sick* but saw nothing except ice all the way to the horizon. Then, amidst the jumble of white shapes, I spotted the unmistakable outline of home. I snapped the outboard into gear and began to limp the Zodiac, slowly and soggily, back toward *C-Sick*. Inflatable boats contain two or three separate tubes, shaped like cylindrical balloons and welded together to form a single U-shaped hull. Pierce one and the boat should still float. Mine did, but it sure wasn't pretty.

The bear's teeth had torn a six-inch hole right at the waterline, and my heavy outboard motor pulled the tube even lower into the water. I shifted my weight onto the good tube as far as I could. Water still splashed into the boat, slowing me further, and the steering turned sluggish. Not only had the air gone out, but the wounded tube began to fill with seawater. It felt like driving a half-full kiddie pool across the water.

When I finally got back to *C-Sick*, I started hauling my heavy gear cases out of the sinking craft. When I stopped to look at my underwater camera, I found deep scratches left by the polar bear's fangs, scarring the housing's hard acrylic dome. But that seemed the least of my worries. I stared miserably at the sodden dinghy. Without it, this little adventure was over. I couldn't do any serious underwater work, couldn't even turn tail and run for home. I had no way to reach dry land and buy the fuel I needed to get back.

This was something altogether different from last summer's pinprick leak. All the same, I dug my repair kit out of a rat's nest of tools, then read and re-read the instructions. Clean, glue, patch, wait. They made it sound so simple.

In a repeat of the awkward dance we'd done last summer, I had to wrestle the cumbersome Zodiac up on one side. It took an hour of straining and swearing, but I finally got it lashed to *C-Sick*'s gunwales. Gallons of water drained from the torn tube. But eventually I was able to get to work on the actual repair.

It took another hour, three patches arranged end to end, and nearly all of my glue to cover the rip. Somewhere in the middle of all this, as I drifted in the middle of Frozen Strait, Janet sent me a satellite text. It was the latest weather update.

"Gale warning. East thirty, building to forty. Batten her down, sailor boy," she wrote.

I took a look around me—blue skies, warm sun, calm seas—and thought, "This is not the time for jokes." But when I checked the barometer, I saw it had started to fall and thin wisps of horsetail clouds drifted in on the western horizon. I was more than halfway across the strait now, with the Zodiac on its side still trussed up like a Thanksgiving turkey.

I headed slowly east toward the shelter of Vansittart Island. But after running for an hour, I found my passage was blocked by a hundred-yard-wide tendril of ice. I was just a few miles from shore, but the ice stretched out before me like an impassable border fence. I looked north and south, then dug around and found a loonie, the Canadian dollar coin, buried deep in a pocket. I flipped the dinged-up coin and Elizabeth II stared coolly, regally back at me. Heads. North it was. I motored for another hour, searching for an opening, but the barricade only grew thicker. I had no desire to find myself sitting miles offshore when the weather blew up. Already, the wind had begun to stir, and all I could do was scuttle back toward the protection of last night's dogleg cove. Even if the east wind blew for days, and shoved every piece of ice in Hudson Bay against the shore, I should still be safe in there.

By nightfall, rain slashed against the windows and the wind gusted past twenty knots. The dinghy's patch was still there, but after four hours of soggy towing, it might fall off if I looked at it funny. I didn't dare test it with air pressure until the glue had time to cure overnight. For now, there was

nothing to do but curl up on my bunk and hope my nightmares weren't any scarier than the day I'd just endured.

Tucked in aboard *C-Sick*, I could sleep through almost any rain shower. The patter of raindrops on the roof always left me with a warm feeling of smug satisfaction. I cheered myself with the happy thought that, no matter how bad it got, at least I wasn't camping out in some water-logged tent. But when the first gale winds hit, I was up in an instant. *C-Sick* didn't have much room to drift before she'd be on the rocks, so I dressed and kept watch throughout the night. Seated at the helm, steam rising from my coffee mug, I stared out as the view swung back and forth, back and forth, like a tennis match through my cabin window. My orange sleeping bag seemed the only note of color left in the world. Outside, the surrounding low hills were blanketed with a thin layer of tundra; a gray-green skin covering gray-brown rock, with gray-gray clouds scudding over the gray-blue sea.

The Zodiac repairs produced, at best, mixed results. The first layer of PVC patching seemed to be holding, but the second layer, which I'd slathered on in an effort to cover the bulging seams, lay curled and pitiful in the rain, a trail of gray epoxy ooze sliming everything.

That morning marked the halfway point of my trip. And as I stared out at the dismal landscape, it seemed like I'd been here half a lifetime and had accomplished, approximately, fuck all. And it might well take the other half of my life for the ice to clear out after this latest blow. All day, I alternated naps with short bursts of activity. Desperate to break the day's suffocating silence, I finally got out the shotgun, loaded it with heavy lead slugs, and racked one into the chamber. Up on deck, I spied a perfectly blameless patch of ice, sighted down the metal bead, and fired. There was a deafening bang, and the gun recoiled hard against my shoulder. The slug sent up a harmless spray of water. Missed by five feet. I racked in another shell and fired again. And again. And again, until the magazine was empty.

The bears need not lose any sleep over my marksmanship.

I turned my attention to something more productive: repairing the Zodiac. Shooting it was out of the question, but I sure thought about it. A few dozen strokes with the air pump rewarded me with the all-too-familiar sound of

air hissing back out of the dinghy. My original patch was still leaking, and I discovered a new bite mark that I'd missed first time around. During a lull in the wind, I heaved the dinghy back on deck and smeared around more goo and cut up more patches. Inside, the barometer continued its fall, and soon the wind veered to the south and began to blow like it meant business this time. I had tucked *C-Sick* in close behind the near shore, but my anchor refused to bite into the seagrass-covered bottom. It would hold just long enough for me to step back inside and imagine all was well. Then, we would begin to imperceptibly drag across the narrow bay. Without the GPS, I'd never have noticed, but I could see our slow drift across the screen. An hour later, I would have to climb back up to the bow, haul in the anchor chain, and start hacking away at a hundred pounds of knotted grass.

As darkness fell, a moment of unexpected beauty interrupted my exertions. While I was cutting the anchor free, green specks of bioluminescence glowed among the tangled grass and mud, tiny jewels amidst all the cold and dark and muck.

Staring into the slowly gyrating chartplotter screen provided, at best, limited entertainment, but I sat there all the same. Through the night, *C-Sick* spun around its anchor like a hypnotist's cheap, dangled watch, back and forth, back and forth. By morning I had logged an additional four miles on the GPS without having moved from this windswept spot.

When I woke, it was raining inside, and so cold I half expected snowflakes to come drifting down from the ceiling. Instead, a fat cold drop landed on my face and drove me out of the sleeping bag. To my surprise, the sun was shining, the gulls were singing, and it was, in fact, a brand-new day.

I pumped up the Zodiac and while some escaping air continued to hiss, it seemed marginally improved: now I had nearly ten minutes, rather than ten seconds, before the tube went completely flat. Baby steps. I hauled the dinghy up on its side again, gooped on more silicone, and wondered momentarily who the patron saint of leaking boats might be. If I was to guess, it would fall to Saint Jude, the guy in charge of all the other lost causes.

When I poked *C-Sick*'s nose around the corner of my little cove, I was surprised to find nearly all the ice was gone. Vanished. Rather than relief,

this set off a new round of concern in my worry-filled head. Where did it go? Did it take the polar bears with it? Are they just around the corner, ready to jump me?

After nearly five hundred miles of motoring, I was now running perilously low on fuel. I had enough of a reserve to make it back to Repulse Bay, but there wouldn't be much left over for sightseeing. I pushed north toward Cape Frigid, across the top end of Frozen Strait, and headed due north into a deep fjord-like channel along the edge of Melville Peninsula. I made slow progress against the tide, and I was still at least forty miles from town. The sun was setting before I found a decent spot to spend the night. At my new anchorage, still water mirrored the twilight sky, and a flock of Canada geese flew over in a perfectly symmetrical V. They were already heading south, away from summer's end.

I peered out the window at the continuing ribbons of snow geese and Canada geese flying overhead and wondered if I shouldn't take the hint. August 20. It was hard to imagine I had only ten more working days before I needed to turn south. Where had the time gone? I distinctly remembered at least a few moments of diverting terror, which I guessed was something.

I began a long, slow putter back through the Harbour Islands toward town, then saw two polar bears poke their heads up from behind some rocks.

The gas station would have to wait. I let out the anchor chain as quietly as I could, then settled in. I stared up at their napping forms on a low ridge, half a mile away, through my binoculars. The novelty of that wore surprisingly thin after an hour or two, so I rowed the Zodiac over to shore and then stared up at them from there instead. The bears were still a quarter mile away. It was only when I bent over, out of their line of sight, to pump more air into my drooping dinghy that one of the bears roused himself for a closer look. I carefully loaded everything back into the boat at the water's edge, got cameras ready, and kept one boot on the shoreline rocks, ready to push myself back if he came uncomfortably close.

For once, I felt in control of the encounter, but there was still something deeply primal in the way this apex predator was evaluating my suitability for dinner. The bear came close, my nerve faltered, and I rowed a few strokes back. Puzzled by all this, he sniffed at the spot where my boots had just

been, then stared quizzically out at me as I clicked away. I could almost see the wheels turning behind his eyes as he struggled to figure out what the hell was going on. He walked past a stranded iceberg just long enough for me to get a few quick frames, then headed back uphill to rejoin his companion in summer slumber.

Not a great shot, but one of the summer's best.

It didn't take long to figure out where all the polar bears had been hiding. It wasn't out on all those miles of virgin icy wilderness, either. Rather, it was practically within sight of town, where they were mooching off beluga scraps and narwhal carcasses. In all, I counted eleven polar bears on August 21, more than I'd seen in nearly three weeks of concerted ice bashing.

The morning had brought an unpromising mix of pissing rain, low gray clouds, and cold wind, so I watched the veritable parade of polar bears from the relative warmth of my boat cabin before finally turning for town. I arrived just as an armada of freighter canoes roared out of the harbor, each with a man standing in the bow, harpoon in hand. For just a second, I thought they were an armed and angry rabble coming for me, but they roared right past *C-Sick* and headed off into the mist. Someone had spotted a pod of beluga whales swimming into the bay.

For a moment, my journalistic roots urged me to race out and join the fray with my cameras. And just as quickly, I knew that neither my interest nor my pictures would be welcome. I practically said it out loud, "Not my town. Not my place. Leave it."

At the pump, as he filled my eleven jerry cans with sixty-six gallons of gas, a local guy asked me, yet again, if I worked for Greenpeace.

"No," was all I said. By now I'd learned that neither humor nor sarcasm got me anywhere, so I stuck to a flat denial. It was simple, and had the advantage of being true. I am, at best, a half-hearted tree hugger. While I carry my load of precious, West-Coast-liberal beliefs around in a bespoke, organic hemp messenger bag, I also eat meat, own a gun, drive a boat, and have a carbon footprint that is melting my share of the polar ice caps and then some. I even flatter myself that I have some understanding of the central role of traditional hunting in these indigenous societies.

The guy at the gas pump shrugged, topping off my last can. "I believe you, but you'd be doing yourself a favor if you went on the local radio for an interview."

I shook my head, anxious to get my three hundred dollars' worth of gas and get back out on the water. "No time," I said. "Got to head toward home soon."

"You know," he finished, "to talk about your work?"

In hindsight, I see how badly I misunderstood his intentions. I thought he was giving me a hard time, but he was trying to save me from myself. I had never stopped to think how my comings and goings must have looked to everyone here—a stranger arriving to town uninvited, lurking around, seeming a little too friendly, taking snapshots of the kids and the dogs, then vanishing.

But I remained on mission that day, stopping just long enough to play with some roaming sled dog pups on my way out of town. Then I rowed out with my fuel, pulled anchor, and put Repulse behind me.

Christ, they must have thought, he's even after our dogs.

ROUND TWO

I saw three more polar bears as soon as I arrived back at the Harbour Islands. It didn't take long for the mother bear with her two young cubs, standing on a high ridge, to see me as well, and they all took off at a dead run. Cresting a low hill, they nearly plowed through a local Inuit family's picnic on the rocks. Two of the men stood up fast, grabbing for their rifles, but the bears kept right on going, vanishing over the far shore.

I waved to the family in what I hoped would be seen as an apology, then motored slowly on, navigating through the cluster of small islands. Orange sunset light beamed from beneath the dark clouds, setting the landscape aflame. But no more bears, and no pictures.

I anchored on the south side of the archipelago in shallow water, which offered some protection against the gusting northern wind. Dusk fell quickly beneath thick clouds, and suddenly it felt altogether dark and cold and forbidding. A lonesome fog settled over me. I belatedly remembered, after only seven seasons of dark nights aboard *C-Sick*, the simple joy of candlelight. I located an enormous, three-wick survival candle amidst all the other crap I'd brought along, lit it, and took what cheer I could in its warm glow.

I saw six polar bears the next morning before my first cup of coffee had gone cold. Things were looking up. But as the morning wore on, they all seemed to go quiet, and soon I was back to the old routine of driving and searching and seeing not much at all. It was a busy day out on the water all

the same. Paul, Repulse Bay's lone taxi driver, barreled up alongside me in a green freighter canoe. "I'm running a little low on gas," he called over, while his cheerful, gray-haired passenger waved. "Probably don't have enough for the return trip back," he said. "Can I borrow some?"

The last thing I needed on my conscience was some poor, stranded tourist—especially one who reminded me so much of my own spunky grandmother. I heaved one of my six-gallon jerry cans onto his boat and waved as they roared off across the water at full throttle.

After they left, a convoy of four or five more boats buzzed past. It was an overnight high school field trip, of all things. I mentally recalibrated any future claims I might make regarding these epic solo adventures across the Arctic wilds.

Heavy clouds rolled back in late in the day, but toward evening the sun emerged into another band of clear sky, and the barren landscape began to glow. I found a polar bear sleeping soundly on a rocky hilltop and paddled the still-leaking dinghy to shore. I tried photographing the bear from the beach as he rested 150 yards above me on a rocky crest. My biggest telephoto still wasn't long enough, so I walked in a little closer, tripod and lens over one shoulder, twelve-gauge slung on its strap over the other. He sat up briefly, and I got a few precious frames of him illuminated by the last glimmer of sunlight before the light, and the moment, vanished.

The bear rolled on his back in a long stretch like a shaggy, white dog. Then he gave a little shake to settle his fur, and began walking down the hill, right toward me. I knew enough not to turn and run, but I wasn't about to try talking sense to him either. I checked my shotgun for the third time, making sure I had a banger shell in the chamber, clicked the safety off, and began my retreat. I walked backwards and sideways, oh-so-careful not to slip or stumble on the rocks.

The polar bear followed in desultory fashion. Even after I reached the relative safety of my Zodiac, he kept right on strolling along the shore, shadowing me as I rowed just out of reach. I finally saw what had drawn his

Digital camera's viewfinder and sleeping polar bear, Harbour Islands

attention: a carcass of some kind, gone putrid and stinky. It was food during the leanest of months, and I suppose he couldn't afford to be picky. I left the bear munching away at the gray and smelly mess.

In the morning, the distant sound of my approaching outboard sent three polar bears fleeing from that same carcass. Two of them ambled toward another hunters' kill that was still partly submerged beneath the tideline. Working together, the pair struggled to pull the remains out of the water and up onto the rocks.

I quietly idled the dinghy's outboard, and drifted closer toward shore, all but inviting the bears to come investigate. They ignored me, focused as they were on the gruesome prize at hand. The bears had to bite down hard, then twist their heads to tear away mouthfuls of stringy muscle and flesh. Only once did a bear curiously approach the dinghy as I floated nearby, and I reversed to stay out of reach.

The engine suddenly stalled, and a breeze carried me right back toward the polar bear. I'd been sitting on *C-Sick* for ages, and felt woefully out of shape. But it's funny just how quickly an old guy like me can unlock a set of oars and start rowing when his life depends on it.

After eating their fill, the polar bears drifted uphill, found a soft patch of tundra, and went to sleep in the warm sun. I motored the Zodiac around in a slow tour of the archipelago's islands, stopping every few minutes to pump air back into the still-leaking tube. I saw a hunter's boat off one of the islands. Remembering the gas-pump guy's words about allaying suspicions, I called out hello and introduced myself. Billy, a heavyset Inuit from Repulse Bay, was out with a couple other guys and his young son. The first thing he asked me was, "You aren't working for Greenpeace, are you?"

It had been a long day, and I started to make a wisecrack, but he cut me off.

"Well, are you?" He was ass-kicking serious.

"I'm just out here taking pictures of the bears, man," I held up my camera like some sort of talisman. "I'm a wildlife photographer. This is my job."

Visibly unimpressed, Billy stonily told me, "You can take plenty good polar bear pictures at the Winnipeg Zoo."

"What, and miss out on all this?" I muttered beneath my breath. But to my new friends, I merely lifted my hand in a wave and slunk off, tail between my legs.

The next day broke completely still, the water calm and flat. I set off in the Zodiac just as the sun rose, and, rounding a corner, startled a polar bear near the shore. The bear broke into a trot. I stopped. He stopped. I held my breath. He relaxed. I ghosted in closer. He forgot I was even there. Breathing again, I opened my waterproof case and got to work. I pulled out the big telephoto zoom, checked the settings, and began to frame. The bear, likewise, went back to his own morning rounds. The first order of business was tracking down some breakfast.

He held his nose aloft, took in small sips of air, and began sifting through them on an almost molecular level. The polar bear's sense of smell is the stuff of legends, and would put the sniffiest sommelier to shame. Scientists have observed them picking up the scent of a ringed seal from nearly twenty miles away, following that smell on shifting winds, and using it to hone in on pupping dens buried beneath three feet of wind-hardened snow and ice.

This bear knew there was food nearby, and slowly tried to locate the source. "I'm getting a whiff of seaweed here, big notes of unwashed socks from Mr. Stinky over there. But there's something else, too. Is that narwhal? Two weeks dead, somewhere close in a foot or two of water, aged to perfection . . ."

He walked up and down the rocky shoreline, stopping again and again to raise his nose to the breeze. He moved to the water's edge and sniffed at the surface, then waded into the icy water and finally submerged his head, eyes open, looking for any sign of the remains.

In the years I have spent around polar bears, this was the first time I had been able to quietly sit and watch a bear so completely relaxed in my presence that he continued to go about his bear business without a second thought. I sat on the edge of the Zodiac, camera in hand, and tried to get it down in pictures.

I had all the time I needed to unfold my tripod and balance each leg on the half-submerged shoreline rocks, then mount my camera and heavy lens.

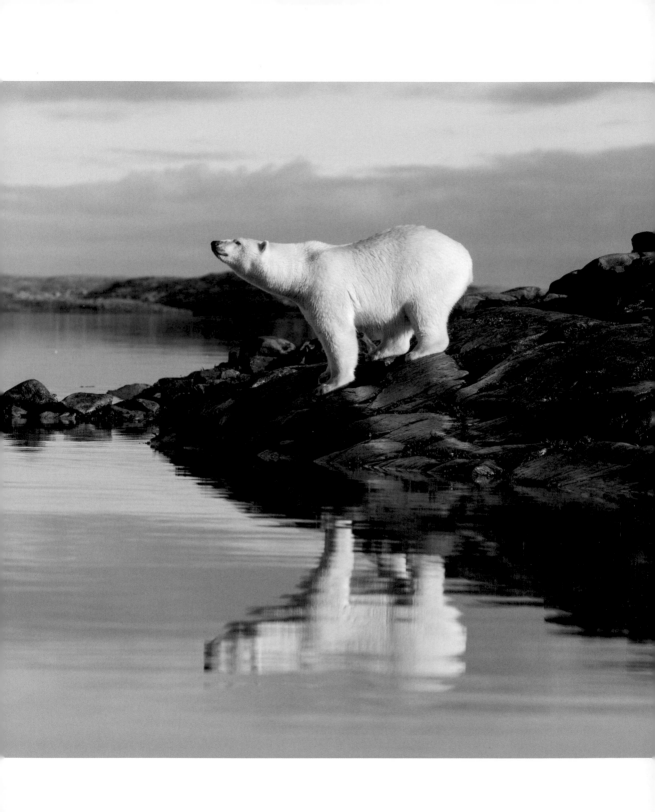

Most polar bears in summer look a bit scruffy from their time onshore, but this bear positively glowed in the morning sunlight. Through the lens, I watched healthy muscle and fat roll beneath his fur as he walked. He was close enough that I could see and hear each breath he took.

After a time, he seemed to abandon thoughts of food and sauntered uphill. He settled on a sunny outcrop less than twenty yards away from me, lay down, and drifted off to sleep. I could see he was dreaming; his nose twitched, his mouth moved slightly, and his eyes flitted back and forth behind closed lids. What was he dreaming of? Fat seals and lady bears, I hoped.

The high mechanical whine of hunters' boats pierced the morning silence. The polar bear roused suddenly, clearly startled, and stared out toward the horizon as the hunters slowly passed, miles away. I kept my eyes on the bear, trying to hold onto this moment. All my weeks of searching had finally yielded, if not great photographs, then at least a few hours of silent witness.

Patience is underrated in a world of perpetual motion and constant distraction. To sit in the warm sun, breathe air crisp and tangy with salt, and watch the secret life of a wild animal—maybe this is what I should have been striving for all along. Skip the operatic lighting and predatory theatrics and be content to simply watch a polar bear at peace in his domain.

When the mosquito buzz of the hunters' outboards faded to silence, the bear gave a little stretch, then set off over the hill. The spell was broken.

I thought about next steps. While the Harbour Islands were certainly the most productive place I had visited this summer, the pictures were always going to be the same: "Polar Bears on Rocks." No ice. No prey. And lots of boat traffic. I had set up shop in the very center of the hamlet's prime hunting grounds, and the hunters eyed me with irritation. Taking advantage of the calm winds, I headed twenty miles east, back to Cape Clarke, and then south toward White Island.

But all the to-ing and fro-ing proved fruitless; nothing but hours of motoring against the tide, no pictures, crap light.

Polar bear standing along shoreline, Harbour Islands

The only redeeming hour came at day's end. Big chunks of sea ice drifted past on the hurrying current. The setting sun, hidden behind a smothering layer of low cloud, pierced the gloom with a brilliant beam of light that spread out and turned the sky crimson. The drifting icebergs, still in shadow, seemed to glow cobalt blue from within. At these high latitudes, the sun descended with almost aching slowness, and it was a full hour before the light finally faded from the northernmost clouds.

Through it all, I maneuvered *C-Sick* past icebergs that were taller than her, trying to arrange the perfect composition of sky and sea and ice, almost humming with rare cheer. Pretty sunsets? I could practically shoot this kind of stuff with my eyes closed, at least if I remembered to take the lens cap off. It was a good moment, but beneath the workmanlike happiness I could feel weariness and a growing sense of defeat in my bones.

Janet could hear it in my voice. "Baby, you sound like you've been dragged through a bush backwards," she said.

CHASING LIGHTS

The ice had an answer for all my puny attempts to push farther east into unexplored territory: "Dream on." I turned south instead, toward Vansittart Island. When I passed the gravel beach where I had run *C-Sick* aground last summer, there was hardly any ice in sight. Nearby, I spotted three polar bears sprawled in slumber high in the black rock hills. A fourth bear nearby seemed just as sleepy. With a bit more looking, I spotted dozing bears five and six, and then spied number seven walking along the shore ice a few miles later. All remained far out of photographic range.

After that, my day began to go decidedly pear-shaped. I found a walrus mother and calf resting in picturesque fashion on an iceberg floating nearby, and prepared the Zodiac like I'd done dozens of times before. I tied it up alongside *C-Sick*, then secured a safety rope to the heavy outboard before transferring it from *C-Sick* over to the inflatable. That way, if I did lose my grip, I could retrieve the sodden motor without resorting to scuba gear. Next was the awkward and cumbersome process of struggling to lift the unwieldy outboard, balance it on one thigh slung over *C-Sick*'s yard-high gunwale, and then gingerly pivot into the bobbing Zodiac. I had to lower the outboard onto the inflatable floor before mounting it onto my dinghy's wooden transom. The walrus were all sound asleep, so it's not like I was rushing. But somehow, I lost my balance and the engine slipped. A sharp propeller blade sliced the inflatable floor open with a sickening *whoosh*.

The walrus would have to wait. After I worked my way through my extensive dictionary of nautically themed profanities, all I could do was dig out the patch kit and see if I could fix this fresh, steaming mess. And swear some more.

In the midst of all this, an enormous storm front began to spill over the southern horizon. All I wanted was just one more polar bear to brighten the mood.

Then, like I had ordered him off the menu, a bear appeared. I spotted him swimming between icebergs, sunlight glowing off his fur, looming clouds darkening the Wagnerian sky. But by the time I'd managed to load everything back into my leaking dinghy, the bear had vanished, clouds had blotted out the sun, and the wind had started to build. I knew it was time to stop worrying about bears and start thinking about where I might find shelter.

But just as quick, the promise of a picture to salvage my disastrous morning lured me right back out. Another polar bear appeared less than two hundred yards away. He dove, paddled underwater for ten seconds at a go, then surfaced, and continued on his way. If I ever wanted an underwater bear, this was the one.

The Zodiac's new patch came off as soon as I set out, and with the floor soft and rolling beneath me, the dinghy felt horribly unstable in building seas. But I let the wind carry me close enough to the bear to plunge my domed camera into the water and click a few frames as he dove again. With the camera five feet underwater at the end of a pole, there was no looking through the viewfinder. I was left to shoot blindly, trying to angle my camera toward the bear. As I peered into the water below, I could see him paddling almost effortlessly, ten feet below the surface. The camera housing and its eight-inch-wide dome dragged in the water and pulled my boat to the left, nearly on top of the swimming bear. He let out a burst of bubbles in surprise when he almost surfaced underneath me.

I was close, so very close to getting an image that I had dreamed of for so long. But I'd crossed a line: there was no mistaking the bear's alarm. Wind

Polar bear blows bubbles while swimming beneath surface of Hudson Bay, Vansittart Island.

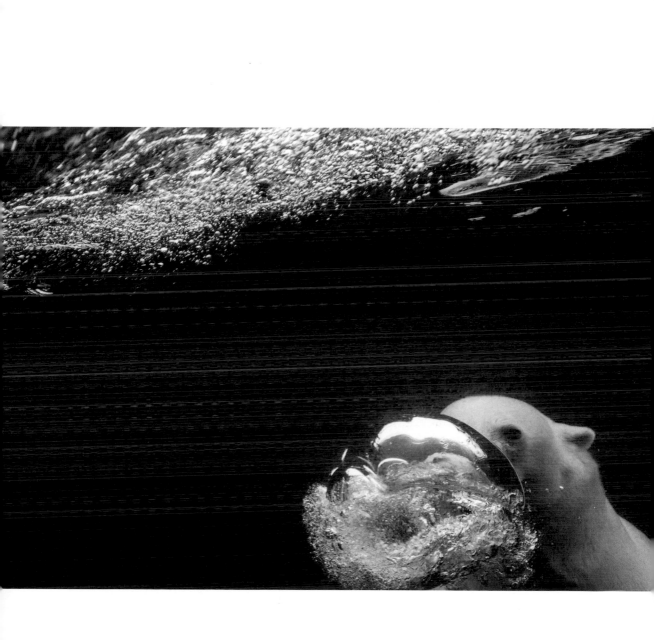

buffeted my Zodiac and waves began to slop over the bow. I knew *C-Sick* was out there somewhere, adrift in the ice, but I could no longer see her. Everything was going wrong. I knew if I kept recklessly pushing on like this, I would die out here, just like that old bush pilot had warned me all those years ago, cold and alone.

The polar bear swam away, and I headed slowly back in the direction I imagined I had come. Half a foot of water sloshed on the dinghy's floor. As I nosed through the jumble of ice, frantically searching for *C-Sick*, I saw a menacing gray wall approach across the water. Just then, *C-Sick*'s antenna appeared up in the distance, swaying back and forth in the chop, as if waving to attract my attention. "Yoo-hoo, silly . . . over here . . . "

I turned my heading forty-five degrees and arrived just as the squall or fog—I couldn't tell what it was—dropped visibility down to almost nothing.

Shaken, I rushed to the helm and, steering almost blind, used the GPS to head back toward shore and shelter. The chart showed the outline of a cove, but it was two long hours before I could find a path around the narrow entrance, past the accumulating windblown ice, and into the shallow bay.

I had never been here before, and my chart offered no depth soundings. I inched in, relying now on my depth-finder's sonar. The bottom shallowed from twenty feet to ten, and the alarm bleated again and again. I watched the screen intently as it dropped to eight, then six. I hit the switch and raised *C-Sick*'s propellers, looking out the cabin door until I could see them half-submerged and spinning up a spray of water. I ghosted over a rocky bar and into the protected cove. It was almost free of ice, but very shallow. The surrounding coastline rose no more than ten feet above the cove, even at low tide. The high tide wasn't due until two a.m., and I had no idea what shelter, if any, I would have left by then.

I settled in, listening to the rain and wind buffet my precarious new home.

I woke at six, tiptoed out onto the windswept back deck to relieve a full bladder, then put on the kettle for my morning coffee before I woke up enough to ask, "Why?" I wasn't going anywhere in this weather. I turned off the kettle, curled back into my sleeping bag, and pulled a black watch cap over my eyes. I slept for hours more.

Later, I rallied long enough to go out and collect some drinking water from the rocky shore, using a small cooking pot to ladle rainwater from the deepest and least gull-spattered pools. It was slow going. The boat cabin's temperature hovered around forty degrees, and I returned wet and cold from my excursion. I broke down and turned on the rusting Heater Buddy, then returned to straining out the floating lichens and debris swirling in my drinking water tank.

All I could do was wait out the storm. It had been blowing from the south-east for twenty-four hours, and the forecast Janet sent called for thirty-knot easterlies. I settled in to enjoy another healthy dose of schadenfreude, savoring the sufferings of long-dead men who were far tougher than me. I read page after page from Anthony Brandt's *The Man Who Ate His Boots*, a history of the search for the Northwest Passage, and caught up on the final chapters of John Franklin's saga.

When I left him, Sir John was the toast of London, the man declared a hero for surviving a disaster of his own making. How the tough and savvy Hudson's Bay Company's men must have mocked Franklin, a man so pious that he couldn't bring himself to swat at mosquitoes even as they descended in clouds to drain his blood. George Simpson, who ran the HBC's vast empire from York Factory, was particularly scathing in his appraisal: "[Franklin] has not the physical powers required for the labor of moderate Voyaging in this country; he must have three meals *per diem*, Tea is indispensable, and with the utmost exertion he cannot walk above Eight miles in one day . . ." Those seemed like harsh words to describe a man who had traveled across nearly 5,500 miles of wilderness and mapped five hundred miles of unexplored coast-line. And the Admiralty chose not to see it that way: they saw an officer who demonstrated that uniquely British mixture of grit and pluck and moral supe-riority. He survived while so many other, weaker men had died around him.

He returned to the Arctic in 1825, leading a second overland expedition. This time, he took no chances, meticulously planning for any contingency. Perhaps wisely, he gave Hudson Bay a miss. The expedition, a proper British Navy affair, arrived with ample provisions and stout Navy boats and a strong Navy crew to carry it all. They struggled against the ice and mapped hundreds more miles of

inhospitable northern coastline. They didn't find the Northwest Passage, but at least they returned with their footwear intact and uneaten.

In comparative terms: a triumph.

He returned home after two years away and got on with his life. His first wife had died from tuberculosis while he was off sailing for Canada in 1825, and he married her friend, Jane Griffen, a year after his return. He was knighted, and returned to naval command in the warmer waters of the Mediterranean and Caribbean. He eventually went on to serve as Lieutenant Governor of what is now Tasmania. Back then, it was a dismal prison colony called Van Diemen's Land. He arrived bearing all of the responsibility but with little real political power. Things ended badly. After he was humiliatingly sacked and shipped home, the frozen Arctic wastes must have looked pretty good.

Great Britain in 1845 was ascendant. The Royal Navy hatched a plan to outfit two of their strongest ships with everything a modern expedition could ask for, then send it north to sort out this Northwest Passage business once and for all. There would dispatch their best officers, a hand-picked crew, the most modern scientific instruments. They would be plenty of food and nice monogrammed silver cutlery and plates for the officers' dining pleasure. What could possibly go wrong?

Everything, as it turned out.

Sir John Franklin, his reputation sullied after the unpleasantness in Tasmania, was determined to salvage his place in history. At 58, he had gone to fat, hadn't sailed a big ship through the ice in nearly thirty years, and was nobody's first pick to lead Britain's big push north. But he was persistent, to the point of desperation, to restore his good name, and he got the job.

Like his first disastrous expedition to the Arctic, this was a rush job. Franklin won command of the expedition in February and the Admiralty scheduled their departure for May, in just four months' time. Everything had to be done quickly: preparing the ships, selecting officers and crew, provisioning her with three years' worth of food that included eight thousand hand-soldered tins of canned soup, meat, and vegetables. HMS *Terror*, brought back from the dead after Back's disastrous journey, sported a new twenty-horsepower steam engine. That was half the power of one of *C-Sick*'s

outboards for a ship weighing more than three hundred tons. They brought along an organ and sheet music, a library of more than a thousand books, and costumes for theatrical productions during the long winter months. They even brought a pet monkey named Jacko.

The expedition departed filled with the confidence of that early Victorian era; success seemed assured. Arriving in Greenland, they anchored briefly alongside some whaling ships. As they waited for the ice to clear, they sent home letters and reports, and set sail with 129 men and officers aboard. Then, they vanished.

They might as well have sailed off the edge of the earth and, truth be told, they would have saved themselves a good deal of trouble if they had. A year passed: 1846. Then 1847. Not a word, not a glimpse.

The Admiralty refused to acknowledge that anything had gone awry. It wasn't until three years had passed, in 1848, that the first of a string of relief missions was organized and dispatched. The rescue parties found not a trace amidst the icy labyrinth. More years passed. The search expanded. Some of the rescuers' ships, beset in ice forty feet thick, were trapped, and required rescues of their own. Men sledged across hundreds of miles of ice and suffered the torments of the damned. They slowly filled in the blank spaces on the map, but of Franklin's fate, or poor Jacko's for that matter, they learned nothing at all. The search, prodded not a little by Lady Jane Franklin's driving will, personal charm, and substantial fortune, dragged on for nearly a decade.

Brandt's book described it as "the largest, most expensive and lengthiest search-and-rescue operation in the nineteenth century." Along the way, the Northwest Passage was found, almost as an afterthought. It was, to no one's surprise by then, an almost impassable nightmare of ice.

Dr. John Rae, who was an HBC surgeon at York Factory and the Company's de facto explorer-in-residence, had been traveling and mapping the Arctic coastline north of Repulse Bay for years. Unlike Franklin and his earliest expedition, Rae didn't go in for half-baked death marches. According to Brandt, "he was the first Arctic explorer in all of Great Britain's history in the Arctic to learn how to live like an Inuit, off the land, building snow shelters as he needed them and traveling light and fast."

In 1854, Rae returned North, not to look for Franklin, but to fill in some of the remaining blank spots on the map. He wintered over in Repulse Bay and then traveled north to the coast.

There he encountered Inuit who had heard stories of dozens of white men starving to death, years before. On his way home, Rae purchased a handful of grisly souvenirs from the Inuit: a gold officer's cap band, monogrammed fork and spoon, one of Franklin's engraved silver plates. And he learned of the expedition's agonizing last stand. Their ships trapped in the ice, the men had tried to march south, dying in their tracks. The last starving survivors, reduced to cannibalism, met their end just south of King William Island.

Of all the journals and letters and charts that the great expedition surely produced, nothing remains. A single sheet of paper was discovered in a cairn on King William Island, years later. It explained everything, and almost nothing. The ships had been beset by the ice in September 1846, and spent two winters trapped before they were abandoned in April 1848. The survivors were marching south toward the Barren Lands without their commander. Sir John Franklin had died on June 11, 1847. He avoided the worst sufferings of the catastrophe, but the cause of his death was never explained, and his grave was never found.

Nearly 170 years of research and debate have gone into determining how and why the expedition unraveled. Some combination of scurvy and lead poisoning from poorly soldered canned food seem the likeliest cause. The fate of the ships themselves was a mystery until 2014, when Canadian research vessels discovered the wreck of the HMS *Erebus*. Two years later, her sister ship HMS *Terror* was found south of King William Island in eighty feet of water, nearly intact.

Sitting here dry, well-fed, reasonably warm, and momentarily safe, I eyed *C-Sick*'s stocks of canned soups in a new and more suspect light. I felt a pang of sympathy for all those poor souls who came so far, only to suffer and die in futility, their words and deeds lost forever.

Sometime after two a.m., *C-Sick* began to buck and rock, waking me from fitful sleep. The wind had swung northeast, and an incoming tide had submerged nearly all of the rocky shoreline that had protected me from the

open sea. I was left peering into the dim gray haze out my cabin windows, anxiously searching for signs of incoming ice.

The wind. The dark. The cold. The sheeting rain. I didn't like any of this. But there was nothing to be done but put the kettle back on, make some tea, and wait it out. I sat down at the helm and stared through rain-smeared glass. I could just make out a line of big icebergs grounded on the submerged reef less than a quarter mile out. If they drifted into my little bay, I would be in a spot. By five a.m., there was just enough light to go up on deck, haul in the anchor, and move to a more protected corner of the cove. I didn't feel safe until the tide fell and my sheltering island reappeared from beneath the sea.

By daybreak, it was soupy inside, too. Water dropped from the cabin roof, gathered on my sleeping bag and on the floor, clung to the windows. The temperature outside was thirty-six degrees; inside it was a balmy thirty-seven with ninety-eight percent humidity. I pulled out my little shaving mirror and studied the reflection, wondering if I had started to mildew like everything else onboard.

By noon, the clouds and fog had begun to break and the sun peeked out for about eight seconds. I decided to fire up the engines and stick my head out. I was surprised to find the two-mile channel leading out was navigable; the north wind had blown just enough ice clear to open a winding pathway through. Once I was in open water, a four-foot ocean swell greeted me, crashing in spectacular waves and showers of spray on the shore.

I wanted away from here, badly. So, I kept right on going.

I covered the twenty-eight miles around Vansittart Island's southern shore in about five hours, grateful to be moving. The closest shelter was ahead at Petersen Bay, and I declared victory for the day when I arrived there, just as the wind began to pick up again.

All along the way, I'd had plenty of time to think back to those early explorers, to the hard men of the Hudson's Bay Company, and to a hundred generations of Inuit hunters who crossed this land and these waters. Those men knew how to suffer.

I tucked into my heavy down sleeping bag wearing thick wool socks, two layers of long johns, fleece bibs, two layers of polypropylene zip-neck shirts, a

fleece vest, a fleece jacket, and a heavy fleece watch cap. Then I draped Page's parka over top, confirming yet again that I was nothing but a spoiled baby.

I covered seventy-seven miles in fourteen hours in one long slog during my gray retreat back to the Harbour Islands. I spent the next day zipping around in the Zodiac, alternating spells of motoring in search of polar bears with pit stops of awkward air-pump grappling as part of my ongoing struggle to stay afloat. At day's end, I returned to *C-Sick* and headed back toward my anchorage.

A boatload of local hunters pulled up alongside to say hello. As soon as we got Greenpeace out of the way, we chatted amicably for half an hour, and I belatedly began to see that a subtle social etiquette existed here on the water. I had been sorely remiss. Someone mentioned coffee, and it dawned on me that I had tons of extra food, and it had been the height of rudeness not to share. I put on the kettle and started handing out granola bars. The guys mowed through three of them, each, before the water had boiled.

They spoke of the hunt, and one of the guys told me, "I heard there was a narwhal with two horns. It's worth some big money. If I got that narwhal, I could buy a new boat. I could buy *your* boat," he laughed, looking at *C-Sick* with an acquisitive eye. The others chimed in with talk of the fortune such a kill would bring.

"But we don't waste anything," one hunter remembered to add, before they went back to talking among themselves, glorying in their summer's days out on the water.

After they departed, I saw a mother bear and her second-year cub resting on a rocky hillside to the south. The mum kept a wary eye on me, but they stayed put, and soon settled back to sleep. Toward evening, I slowly rowed into their tiny lagoon and drifted in silence to a spot twenty or thirty yards below the sleeping pair. They filled my camera's viewfinder frame, snuggled together in the day's dying light. I spent a quiet hour in the company of

Inuit stone cairns at sunset, Harbour Islands

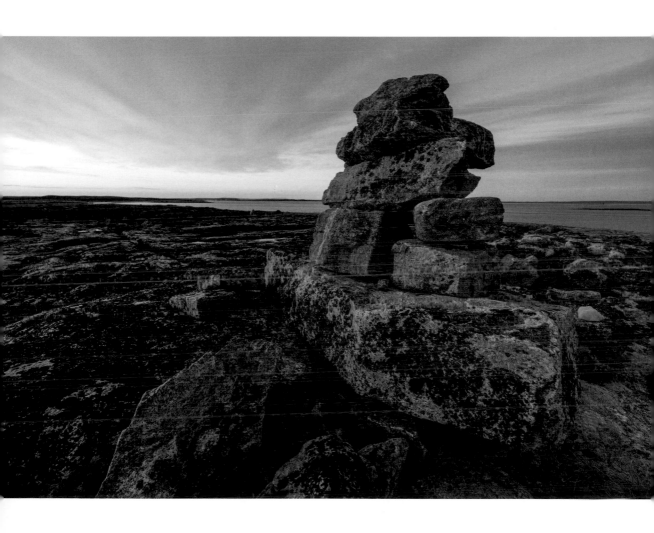

mother and child. After a frustrating trip with little to show for it, it was a lovely moment of grace to end on.

I followed the tide back out just before sunset, then motored to one of the nearby islands. Sunset light burnished the ancient granite of Inuit cairns and tent rings until they glowed like warm embers. Finally, as the sun skimmed the horizon, I put down my cameras. Photography has always pushed me to look more closely at the world, but could also make it harder to feel. I was constantly working to frame and shoot these images, but in my rush, the fleeting reality of each scene slipped away. Another day reduced to pixels on a screen.

I remained still for a while longer, wanting to hold onto the moment; the fading light, the glowing clouds, the quiet of an Arctic evening.

For days, the north wind chased *C-Sick* down the coast. Hour after hour, the boat struggled up the back of big waves, then caromed down at the edge of control. It was harrowing, but it made for a fast trip south. At the last minute, I took a detour on my way back to Rankin Inlet, out to Marble Island. I hoped that one last night in the wilderness might soften the shock of re-entry.

A handful of local hunting boats whizzed around the island, and I stopped to talk with a family that had just butchered a beluga whale along the shore. Their skiff was filled with neatly stacked wedges of blood-streaked *muktuk*. The beluga's remains lay along the shore at the tideline, a trickle of blood pooling in the rocks. The whale's head was untouched, and after the family departed, I pulled my dinghy up onto the shore and hopped out onto the rocks to photograph the scene. Without warning I found myself on all fours. The warm afternoon sun had rendered some of the beluga fat into a slick of oil. Mixed with the whale's blood, the pungent stew turned the rocks slick as ice. I scuttled across the ground, digging my fingers into any crevice I could find to avoid sliding down into the water.

The blank, black slits of the whale's eyes stared skyward; its mouth was curled into an enigmatic Mona Lisa half smile. Even in death, it looked faintly bemused—an expression that did not much match the butchery all around. I grew up among hunters, and I'd spent enough time around farm animals and butcher shops to know that meat doesn't come into this world

wrapped in plastic on Styrofoam trays. All the same, I felt a keen sadness at this animal's unhappy, undignified end.

As I gingerly made my way back to the Zodiac, I slipped again and landed flat on my ass, making doubly sure I would smell like easy pickings to any passing polar bear. I rowed the dinghy solemnly away. In the shallow water, I was distracted by another whale floating below the surface; it was just as butchered and every bit as dead as the beluga on shore. When I turned to go, a young polar bear was staring at me from thirty feet away, nose twitching at all the appetizing smells so close at hand. I had never heard a sound—he wasn't there, and then he was. I cursed myself for such carelessness. My last polar bear of the season could have easily been my last polar bear . . . ever.

But the bear had even easier pickings: a small pile of beluga skin and *muktuk* stacked along the shore. He looked like a dog stealing pork chops off the kitchen counter as he slurped up the scraps one by one. I sat nearly motionless in the Zodiac, shooting pictures whenever the bear looked up to make sure I wasn't going to try to steal any of those whale chops. The moment hung in the air like the chime of a bell. Then someone in a distant skiff spotted the bear and came racing over. I don't know all that much about polar bears, but experience has taught me that roaring straight toward a wild animal at full throttle accomplishes little more than scaring the bejesus out of it—and pissing off any photographer who happens to be sitting nearby.

But I just waved a greeting, offered a shrug at the perfidy of bears, and headed back to *C-Sick*.

I anchored for the night inside Marble Island's protected cove. It was dead calm, and as darkness fell, a fat gibbous moon glowed over the encircling white stone hills. Before calling it a night, I pumped up the dinghy one more time and motored quietly back to the beluga kill. Under the light of the rising moon, I could dimly see a polar bear with her plump young cub, licking at the pools of blood and oil and taking bites of the beluga's carcass. They sensed my approach, and I kept my distance. I simply watched their ghostly shapes, and listened to the sound of blood and death passing back into life.

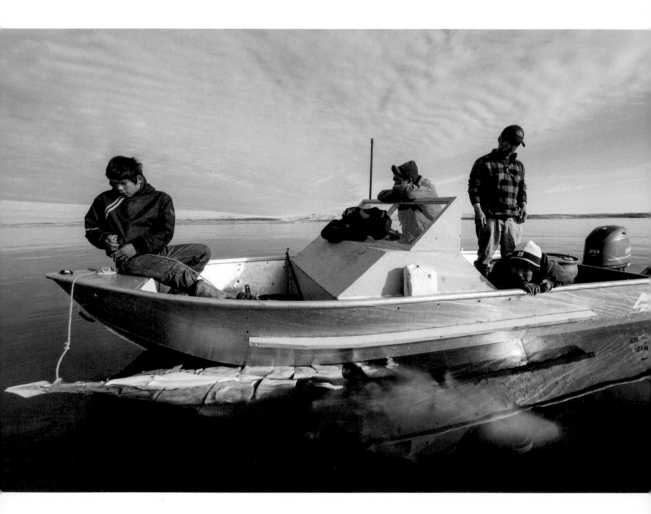

FOREBODING

The trouble landed in the form of an email, out of the blue, in early spring. It took me a moment to sort through the garbled spelling and punctuation.

Hello Paul, we seen you down in Hudson bay one summer, now we asked you before Are you green peace or what so ever, you said no and you lied, now we see picture that you said you would never post, but why is it posted now?

I'm willing to sue you for posting it lying to us and lots of people seing it now on face book etc.

I know you are a good lied, some people told me about you in repulse bay too.

So I will sue sue for the picture you took and said you would not post , but it is now, I will give it to our government and our nunavut president that some people like you come in through Manitoba, into our Hudson bay, I will asked them to watch and for theses kind of people who lie, and that they need permit to go boating on our Hudson bay and keep track of where you guys are, you ran away from repulse bay hunters, heard that I will get more info from them they will help me too to give to our nunavut leaders.

My first thought was, What the hell?

Inuit hunters towing remains of beluga whale kill, Marble Island

But then all I could think was, "This is going to be trouble."

After not a little digging, I tracked down the photograph in question. It was on the *National Geographic* website, where it appeared under the headline, "How Brain-Damaging Mercury Puts Arctic Kids at Risk." The article began, "Inuit children, exposed in the womb, have lower IQs because their mothers eat whale meat and other foods tainted with contaminants that drift north." The piece highlighted how traditional hunters like the Inuit of Hudson Bay had been harmed by decades of reckless industrial pollution far to the south.

Spread across the entire web page was one of my photographs of the Inuit hunters who had greeted me on Marble Island, near Rankin Inlet. They stood in their aluminum skiff, slowly towing the bloody carcass of a beluga whale to deep water. It was not a bad shot—evocative even—as the hunters and their sons looked off in four different directions, hinting at an uncertain future.

To be honest, I don't remember what I did or did not say when I took those photographs. I had unthinkingly submitted them to my picture editor when I returned home, and months later the nice folks at *National Geographic* licensed it to illustrate their news story.

I wrote a long and apologetic email back to the aggrieved hunter, trying to highlight my respect for the people, the land, and the traditions of Inuit subsistence culture. I even ladled in stories of my father's lifelong love of hunting in the Pennsylvania woods. But I knew it would mean less than nothing. I had made an enemy. All my self-justifications mattered not one jot.

All the same, I knew that I would be going back north. *C-Sick* was hibernating through another Arctic winter out behind the sled dog lot in Rankin, and the long months away had only made my heart grow fonder. I knew I'd done her wrong; I'd pushed my boat too hard, demanded too much. But if we could have just one more summer in the Arctic, I solemnly promised to make things right. New spark plugs, oil change, the full mani-pedi, facial, and massage package back at the boat spa. Whatever she wanted.

So long as I got one last shot.

I'd done it this time. Misjudging the tides, I was dragged out into the Bay by a cascade of water ten miles wide. The offshore winds caught every ripple and splash of water, and pushed back relentlessly, forming steep standing waves. I jammed

the throttle down to motor up each face, punching through the crest before C-Sick *launched into the air. I saw nothing but sky, and then the bow plunged nose down with a sickening crash into cold, green water.*

The next wave battered us, and the next, until a breaker caught the boat side-ways and suddenly rolled her upside down into the surf. Gear, clothing, and food flew everywhere as icy water poured into the cabin. I kicked at the door, fighting my way outside, but found nothing except miles of windswept ocean. C-Sick *was sinking beneath my feet. Ice water was taking me down into darkness. I whimpered the beginnings of a prayer. "Please . . . God . . . "*

I woke gasping and sweaty with panic, my heart pounding. It was two-thirty a.m. and the summer night was warm and still outside our bedroom window. In the long moments it took for the fear and cold of my dream to clear, I rolled over and looked at Janet. She was sleeping quietly, peacefully next to me.

I was so not ready for this.

And yet for the last three months I'd done nothing *but* prepare—methodically, obsessively, expensively—for *C-Sick*'s final Arctic expedition. I had created spreadsheets and packing lists and provisioning tables so I could get it right this time. Of course, I had tried the exact same thing last year, and wound up buying food enough to feed the whole Franklin expedition, with leftovers for Shackleton's guys.

I sometimes looked back on the days when I used to work as a photographer. Get up in the morning. Go out and take some pictures. Go to bed a happy man. It seemed a long time ago. Now, I was a man obsessed, less a wildlife photographer and more like a twitchy and compulsive survivalist. I packed five hundred pounds of gear into a dozen different cases, and stowed the boxes and duffels in my aging and dented SUV. This time, I planned to drive out and retrieve my old boat trailer in Gillam, then portage *C-Sick* all the way home to Seattle at summer's end.

The evening before my departure, I went to bed half hoping some local hooligan might hot-wire the truck and drive off into the night, saving me from myself. I barely slept as my mind hamster-wheeled in the darkness, running through packing lists and all the near-misses and almost-catastrophes of last summer. Last year, I continually struggled against massive ice floes and

howling winds and my own reckless desperation. How this summer might be different I couldn't really say. The ice charts for Hudson Bay showed more of the same. A bitterly cold Canadian winter meant there was still lots of ice up north: good news for polar bears but less so for polar bear photographers.

At home in Seattle, I lay in the darkness until the stars faded into the first blush of dawn. The distance, the expense, the raw, stupid danger of going so far and getting so close—how could it possibly be worth it?

Foreboding followed me down the stairs, and I couldn't help but wonder, "Is this the trip when my luck runs out?" Would this be the last sunrise I watched through the branches of our old backyard cedar, our last home-cooked breakfast, my final embrace? I knew I was being maudlin, but by the time I walked out to the driveway and held Janet in my arms, tears welled in my eyes.

My wife kept her own reservations tightly under wraps. Dry-eyed, she reassured me, "You'll be fine. Get going before you wind up stuck in traffic."

I made it halfway down the driveway before I slammed on the brakes, hurried back, and kissed her one last time.

Then I was gone.

As I put miles behind me—one hundred, then two, then four—my nerves settled and I started to look forward. *C-Sick* wasn't going to sink. The polar bears would again refrain from devouring me. The ice wouldn't crush us. It would all be just fine.

Somehow, three long days of driving passed in a mind-numbing blink of highway monotony and the steady background drone of audiobooks. I always imagine that these long road trips through the heartland will give me time to think big thoughts. But no epiphanies appeared across the thousands of miles, just the cloying brain lint of cheap aphorisms.

If it was easy, everyone would do it.

Sitting on the couch is free, but where does that get you?

When I thought about it, sitting on the couch with a cold martini in hand, watching *Mad Men* reruns sounded better than anything that might lie ahead.

In the scruffy mining town of Thompson, I unloaded four hundred pounds of boxed gear and provisions at the air cargo office. Half a dozen guys stood

around and watched as I staggered beneath the weight of my heavy cases. Only the shortest of them, a wiry Indian kid, made any move to help. We piled the load onto two wooden pallets. They were quickly shrouded in layers of plastic wrap before disappearing into the void, balanced on the tines of a racing forklift. I trudged next door to the office and paid a small fortune to send it all ahead of me to Rankin Inlet. The agent shrugged and left my parcels' arrival time vague and not altogether certain.

Two hundred more miles of bumping over dusty roads brought me back to the tidy grid-pattern streets of Gillam. Two summers ago, I had backed *C-Sick* on her trailer down a rocky slope and into the Nelson River, then drifted away on the current toward Hudson Bay. If all went according to plan this year, I would haul the trailer back to the train depot in Thompson, then park and catch my flight north. At summer's end, I planned to run *C-Sick* all the way from the Arctic Circle back down to the rail cargo terminal at Churchill, and then load her onto a freight car for the six-hundred-mile southbound trip. I'd follow on the next passenger train and once we were reunited in Thompson, I'd hoist her back on the trailer and retrace my long drive home to Seattle.

Written like that, it sounded like a lot of moving parts. But, really, what could go wrong?

As it turned out, quite a lot. When I drove up to the launch site outside Gillam, my heart sank. In the two years since I'd left my trailer, someone had run over it with what, a snowplow? An army surplus tank? The trailer, built to carry two tons of boat in a cradle of heavy-gauge steel, was far from flimsy. It now lay bent and mangled, its lights smashed, and the tie-downs and spare tire had been stolen. Even the license plate was gone. I guess I should have counted myself lucky that the whole thing hadn't been cut up for scrap metal and the earth beneath it sown with salt.

I hooked the disfigured trailer up behind my truck. Skewed at an awkward angle, it sent up curtains of muck as two hundred miles of gravel road turned to mud in a cold, steady rain. Ten minutes before Saturday afternoon closing time, I found the only motorhead garage in Thompson, parked my trailer out front, and advanced the shop's owners a thousand bucks to get the thing roadworthy enough to limp back home.

Still, I made it to the dismal Thompson airport, with its low ceiling, crumbling acoustic tile, blaring television, and flickering fluorescent lights, with plenty of time to spare. The Calm Air agent greeted me with more bad news: Churchill and Rankin Inlet were both socked in. Have a seat. The coffee machine's over there. Enjoy the wait. And so I did, for hours, until the announcement came: no flight tonight. I went through the motions of arguing, more out of reflex than any hope of improving matters. My complaints accomplished nothing, but I took meager consolation in ruining someone else's night, too.

INTO THE WATER

I made it from my crappy hotel back to the airport in time to watch the sun rise and was greeted with news that the skies above Churchill had cleared. The passengers gathered, boarded, and departed as if nothing untoward had happened. If anyone had noticed my low-grade tantrum the night before, they were too polite to mention it. As we flew north and east, we left the road system behind and flew toward Hudson Bay under skies full of promise and over miles of mosquito-plagued tundra.

When we landed for a stopover in Churchill, I stood out on the tarmac, bathed in sunlight. I held out my hands and spread my arms wide, trying to soak it all in, like some pale lizard sunning itself on the blacktop. Quick enough, a cold breeze sent me scurrying into the terminal. Inside, a massive polar bear towered over me, fearsome claws raised in attack or protest or surrender. It was hard to say. Whatever his posture, he was dead, stuffed and imprisoned behind panes of tempered glass. Still, it wasn't hard to imagine those glass eyes following me accusingly down the arrivals hall, like he'd caught wind of what I'd been up to, and was not amused.

I glanced out the window to make sure the plane hadn't left without me and was pleasantly surprised to see my cargo pallets sitting just outside. They looked a little worse for the wear since I had seen them last, but were seemingly intact. While I stood with my nose pressed against the glass, a small front-end loader hustled over, scooped them up, and popped them into the

cargo hold. Now, should the plane and I both fall from the sky, I would at least enter the hereafter like the pharaohs of old, with my worldly possessions scattered all around me.

Only a few passengers re-boarded for the connecting flight that would take us the final three hundred miles north to Rankin Inlet. It was just three stout Inuit women, the flight attendant, and me. We took off, propellers howling, into a cold wind blowing off the Bay. In a few minutes, we flew effortlessly over the same coastline that had, a few summers ago, taken me weeks of boat-slamming misery to cross. I took a long gulp when I thought of retracing my way back down that same long, empty coast when I brought *C-Sick* home at summer's end. I remembered no landmarks, just a barren, stony shore dotted with reefs and rocks, a few pinprick Inuit outposts, and hundreds of miles of open, windswept sea that stretched all the way east to Quebec and Ontario.

By the time the plane circled down toward Rankin Inlet an hour later, glowering clouds had consumed the blue skies and were busy working their way down the scales toward creepy minor chords of low scud and cold rain. Not to go all Robert Falcon Scott, but I was reminded of that doomed Antarctic explorer's famous words as he approached the end of his frozen trail: "Great God, this is an awful place."

It was a five-dollar, five-minute ride in Fluffy's Taxi that delivered me unannounced to John Hickes's doorstep at the Nanuq Lodge. It felt like coming home. John gave me a warm handshake, a big smile, and the keys to my old room, along with a key to one of his half dozen half-running Chevy Suburban trucks.

Outside, a cold wind lashed rain down in sheets that reduced the gravel streets to gritty mud. John's sled dogs huddled soggily inside their kennels.

He got right to the point. "I've got some bad news about your boat," he started. *C-Sick* had spent the last ten months wrapped in more layers of blue tarp—protection against the long winter, but not, as it turned out, from the

Reading glasses on nautical chart

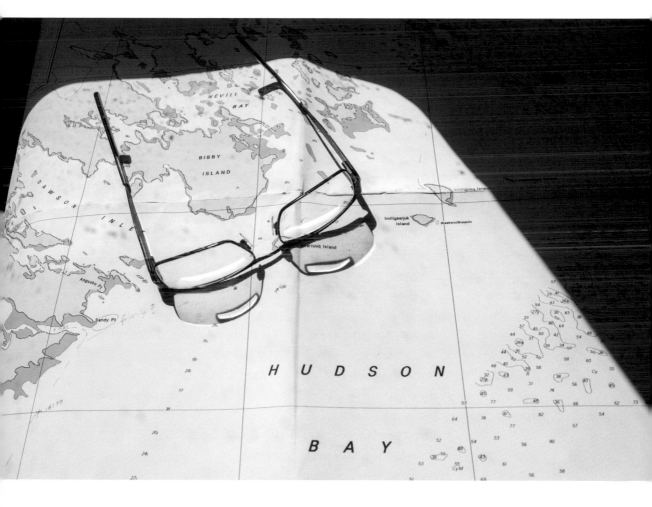

roaming bands of ever-curious kids. "I found a bunch of them in your boat, had to chase 'em the hell out. They didn't steal anything, but they busted some stuff."

Out behind the dog lot, where the kids had been using *C-Sick* as their private playhouse, I discovered that they'd managed to break off my radio aerial, as well as part of the depth-sounder. From the outside, if you squinted and didn't know any better, the boat still didn't look half bad. Blizzard winds had again shredded the tarps to ribbons, which now flapped in the afternoon's soggy wind. I counted myself lucky that the damage wasn't any worse.

I cut away the rat's nest of rope and cord that I'd cobbled together to secure the tarps, and peeled back layer after layer of blue plastic. Finally, I reached that familiar, faded and scratched fiberglass hull. I gave her an affectionate pat and said, "There's my girl." I cut away the last half acre of tarp with a muddy, windy flourish. There she was, flogged half to death but ready, I hoped, for more. Neither the years nor my uneven seamanship had been kind to her, but she still looked good to me, like an old friend.

I got right to work, wiring in an old fish-finder I'd kept as a backup. I possessed only the faintest working knowledge of electrical wiring. The panel and the fuses were still a mystery to me. My new finder had a red wire and a black wire. I dug out my pliers, cut another set of wires from the panel, and matched them up. I spliced them together with a twirl of finger and thumb followed with a quick wrap of black electrical tape. I pushed its power button and the new LCD display flickered to life.

Pleased as I was, it all seemed a little too easy. I reckoned it was only a matter of time before I would find myself back in that cramped cabin, curled on one side and staring in mute bewilderment at the pretzeled wiring of *C-Sick*'s electrical panel, wondering who blew out all the candles.

In the morning, I headed back to John's overstuffed garage to excavate my old Zodiac and its outboard motor. I wouldn't go so far as to call John a hoarder; let's just say he's an enthusiastic collector of the random and obscure. Both the dinghy and motor were more or less where I had left them, but were buried beneath a fresh layer of caribou skins, old tires, red plastic gas cans, and car parts. It was easy enough to dust the reindeer bristles off my dinghy, but, for the second year in a row, I found my outboard had spent

the long winter soaking in a pool of its own motor oil. Boat motors prefer to sleep on one side only. Flip them over and they turn fussy and prone to wet the bed.

Anywhere else, I would have run the thing down to the shop and let them deal with it. This in spite of having learned through hard and costly experience that boat mechanics generally charge twice the original estimate to fix half the problems, while creating a slew of new and potentially life-threatening issues that are revealed only after payment has cleared the bank. But up here, if a problem needed fixing, I was going to have to do it myself.

I heaved the motor out of its oil pool and stared at it for a long while. My father was handy with tools and equipped with the practical knowledge, confidence, and skill needed to resurrect the most mangled of machines and motors. He would have made short work of this project and the rest of my litany of marine and mechanical woe, finished it all up before lunchtime, then gone for a satisfyingly grueling hundred-mile bicycle ride. Sadly, I was more than a decade late to start asking for pointers, and I was left to my own devices.

I closed my eyes and tried to channel decades-old lessons from shop class. I unbolted parts until I got to what I was pretty sure was the carburetor. This was probably the most delicate part of my engine, an intricate assembly where gasoline and air were mixed in exact proportion, then sent into the cylinders and . . . well, I didn't really know what happened after that, except that I wasn't going anywhere until I got it working again.

The particulars were dull and hardly the stuff of rocket science. I loosened four bolts, six screws, and a couple small, critical linkages that I tried like hell not to lose. Viscous oil had leaked out and fouled the carburetor. I found an old steel mixing bowl in the garage, and filled it with a flammable pool of gasoline. Then I dumped the parts in and swirled them around to wash away the oil. Fumes billowed as I pulled them out piece by piece and let them air dry as one of the locals watched me curiously, cigarette in hand.

Then I reversed my steps like backtracking out of a minefield, re-bolting and screwing the parts back into place.

Offering a silent prayer, I yanked on the starter cord once, twice . . . and suddenly the engine caught, snorted, and sprung smokily to life. A thick gray

plume of burning oil filled the garage. Now I knew how Jesus felt when he brought Lazarus back from the dead.

That small miracle aside, this entire enterprise had begun to feel like it was held together with baling wire and wishful thinking.

I mentioned to John's handyman, Chesley, that this seemed as good a time as any to put *C-Sick* back in the water. He nodded, and wordlessly headed off to find an air pump for the boat trailer's soft tires, a jack to lift up the hitch, and his brother, Norman, for moral support. Norman helped latch the trailer onto Chesley's old pickup truck and together they set off. I followed, trotting behind, video camera in hand, to document the momentous occasion. I smelled something burning and watched with growing alarm as one of the ancient trailer's axle bearings began to smoke. Soon the wheel began wobbling ominously.

Chesley drove slowly on, unperturbed. "It's nothing but junk anyway," he called out of the pickup window. Norman sat beside him in the passenger seat, silent and serene as the Buddha himself. We made a slow and strange parade, driving the half mile through town to the marina at walking speed. When we arrived at the waterfront, Chesley reversed the trailer down a gravel incline, and I scrambled over the gunwale, tracking mud all through *C-Sick*'s cabin.

He backed up into the water, and as *C-Sick* floated off the trailer, I fired up both her port and starboard outboard motors. I tried to come alongside the makeshift wooden dock so I could tie up, but I misjudged the approach, and soon found myself with one foot on the dock and the other on *C-Sick*, my legs spreading into classic pratfall pose. I was seconds away from a cartoon-punchline fate when I jumped back on the boat and took her around for another pass.

I devoted the afternoon to driving back and forth, back and forth across town in my borrowed truck. Up to the Umingmak Building Supply store and back down to the dock. New starter battery. More tools. Random pieces of overpriced hardware. Each time I arrived back to the dock, I smacked my head, remembering something else I needed, and set off again. It was nearly sunset before I finally felt confident enough to take *C-Sick* out for a short test run.

Just as I motored out onto the Bay, a beam of golden light shone down like a spotlight through dark banks of cloud. Though the land was bathed in almost biblical light, it didn't feel like much of a benediction. The low islands, rocky and trash-strewn, seemed dead and barren to me. The sea was a lifeless gray, the color of dirty bathwater. But the boat floated and the engines ran, and I knew I would have to pull the trigger and go.

CHAPTER 22

AWAY WE GO

Real men, when they departed for the Arctic, kissed their wives goodbye and sailed off the edge of the earth. Maybe they came back, maybe they didn't. What they didn't do was blog about it, upload Facebook updates, and call home to piss and moan about every step of every single day.

I am cut from different cloth than the men of that heroic age. I'm not ashamed to say that technology is my friend. Some days, it feels like the only one I have.

I wouldn't dream of leaving Rankin Inlet without a working satellite phone. So, when my trusty Iridium refused any and all entreaties to connect with the satellites above, I spent twenty-seven minutes on hold, listening to old Frank Sinatra tunes crackling across the ionosphere, in order to reach technical support in Tempe, Arizona. That was followed by eight full hours of firmware updates, internal time function reboots, and repeated entry and re-entry of randomly generated thirty-two-digit magic-decoder-ring sequences. Each time I tried something new, I had to trudge outside in the rain with phone antenna pointed heavenwards. It must have looked like some arcane and futile religious ceremony. It's not that my prayers went unanswered, just that Heaven's response was always the same: "Searching for network . . ."

Under any other circumstances, I would have thrown a proper tantrum and hurled the balky phone into the sea. But, as I did not want to die alone,

unheard, and unheeded in the cold and fearsome wilderness, I saved that for another time. Instead, I took a different tack and tried to locate a rental phone that I could airlift in. No sooner had I approved a payment equivalent to round-trip plane tickets bound for the land of umbrella drinks and warm sand than my old satellite phone pinged. I had a text message. It was Janet's daily weather haiku. Somehow, I now had a working phone.

This was good news, even if Janet's news was not good. The weather forecast called for easterly winds, building to twenty knots. The wind had already begun to kick up. Out in the harbor *C-Sick* wallowed on the swell, and fog and drizzle began to spit before finally turning to cold, steady, horizontal rain.

Even though it was well past time to leave, I had to give the weather and the water one more day to settle. I must have seemed the guest from hell; I was forever saying goodbye, but I never actually left. Every night since I'd landed, John and Page had set a place for me at their dinner table. As evening rolled around after one final day of waiting, I announced it was my treat, and showed up at suppertime with a stack of frozen pizzas from the Kissarvik Co-op. After three slices of pepperoni and two more of freezer-burned veggie, I walked down to the dock. The wind had stilled, replaced by a thick pall of fog.

Page and her pup, Frosty, who somehow retained a snow-white coat in spite of the surrounding muck, walked with me down the muddy streets. There wasn't much to say, really. She mothered me a little, sending me off with a bag of cupcakes, a hug, and, "Be careful."

"See you in a couple months," was all I could muster as Page took a few more snapshots of me that she again emailed on to Janet. I dropped my last-minute groceries into the inflatable and climbed in. I yanked on the starter cord and the outboard coughed to life, then I motored across the harbor toward *C-Sick*. I felt a familiar pang as I cut these last remaining strings to my world.

Following pages: Midnight sun lights Marble Island, Hudson Bay

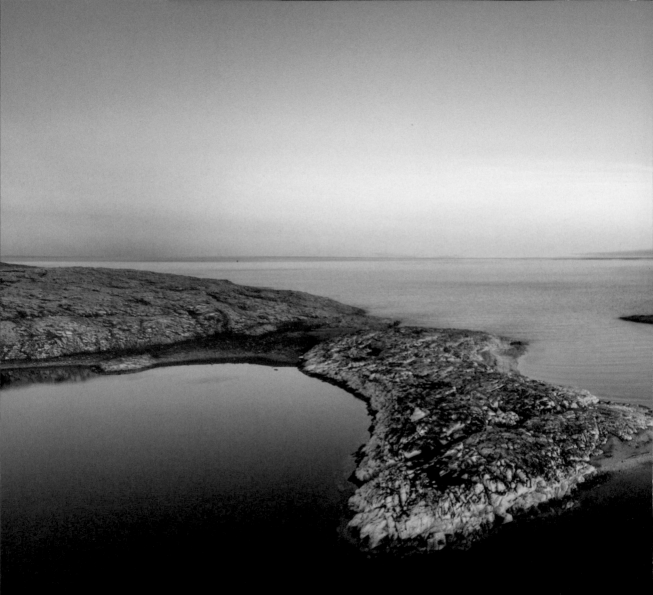

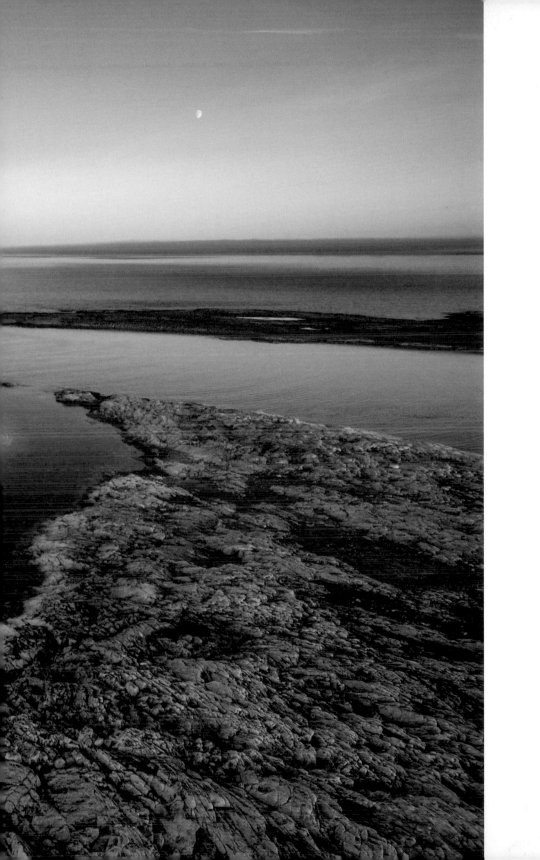

As it was, I barely made it out of sight from town. I took *C-Sick* just two or three miles before dropping anchor on the sheltered side of nearby Thompson Island. The fog enveloped us, hiding all trace of land. There was nothing but the slap of water on the hull and the slow back-and-forth drift of my boat on the sea.

It occurred to me that one of these days I might have to go out and actually take some pictures. But as I looked out from the helm into a world of fog and cold rain, I decided that this was not that day. I steered by the GPS's compass, and listened to the motors' steady drone, and it all came back to me. Ten months faded and it was like I had stepped away from *C-Sick* for only a moment.

It was time to stop moping, put on my big boy pants, and get to work. This was my last bite at the apple, my final chance to take *C-Sick* north and come home with some trophy shots. The images I'd taken last summer were nearly all forgettable. Okay, I'd never photographed the inside of a polar bear's mouth before, and I'd only sacrificed a camera dome and my Zodiac's good health to get it.

Eight uneventful hours brought me back to Marble Island, right where I left off with the polar bears last fall. Unlike last year, when that young polar bear had snuck up to within thirty feet of me, there were no surprises. No epiphanies, either; it was just a pleasant afternoon of motoring as the fog burned off and revealed the warm summer's day it had been hiding. Steering with binoculars in hand and my knee wedged against the wheel, I scanned the buff-colored shoreline for buff-colored bears.

When I took *C-Sick* through the island's narrow passage, I was returning to my favorite anchorage in all of Hudson Bay. Here, I settled in, surrounded by high rock walls on all sides, to an evening that felt almost tender. Wisps of fog rolled gently across the setting midnight sun, and the still water folded the world back on itself in perfect reflections.

I had started to grow a little wary of showing up unannounced in these small hunting villages. As I tied the Zodiac to the rocky breakwater at Chesterfield Inlet the next day, two grizzled-looking white guys rolled up in a

pickup truck and badgered me in Quebecois French. I took the bait, *je suis americain*-ing and smiling like a monkey.

"We're just fucking with you, man," one of them laughed. "Hop in." He said, "I'm Ralph," by way of introduction—as if that was all I needed to know on the subject, then crushed my hand with a mighty shake of his callused paw.

We sped through town to his house and he handed me the keys to a quad bike so I could haul my fuel cans up to the gas station. Sensing my uncertainty in the finer arts of ATV-ridership, he offered a quick lesson before sending me off helmetless and heedless through town. Outside the Co-op store, I heard someone call out, "Hey . . . Paul." It was one of the Inuit women from my flight, surprised but happy to see me all the way up here.

"What are you doing in Chester?" she asked.

"I'm heading north toward Repulse for those bears of mine—maybe stop in Wager Bay and see how things look," I said.

She raised an eyebrow. "You know about the ice, right? It's still pretty bad up there."

I nodded and smiled like I knew what I was doing. She introduced her husband and, as we exchanged pleasantries in the afternoon sun, I felt another small pang. "What's the hurry?" I wondered. But for me, the clock was always ticking.

That wasn't the first warning I'd had about ice farther up the coast. Repulse Bay had struggled through a brutally cold winter and was still surrounded by more than twenty miles of ice. No one could get in or out by boat. There was talk of fuel shortages. For all I knew, reports of Franklin-esque cannibalism would shortly follow. The North was one big small town; gossip and rumor were the mainstays of conversation. I figured the late July sun would have taken care of all that ice by the time I got up there. But I *was* a little worried about what else the rumor mill might have spawned over the long winter's months.

Arctic loons cried mournfully through the night around my anchorage up the coast at Rockhouse Island, and in the morning sandhill cranes squabbled with a sound like wet sneakers on a gymnasium floor. It was a perfect day for travel, the wind completely still, and all around me Hudson Bay mirrored a sky filled with wisps of summer cloud. Without a hint of ocean

swell, the water's surface offered no clues about what might lie beneath, and I struggled to find my way through a maze of submerged reefs and shallows through sheer persistence. The depth-sounder beeped out its warnings, and for more than an hour I kept my head out the window while I steered, trying to judge the gray stones and kelp waving beneath me.

Out in deeper water, I saw a flash of white. A beluga whale surfaced, breathed, and disappeared. When she re-appeared, she was joined by a tiny gray calf. I was no hunter, no threat to her, but she swam away from me all the same.

I unfolded one of my paper charts and scoured the maze of islands ahead, looking for the night's destination. Fullerton Harbour sounded promising, the only spot in a hundred miles to hold out the prospect of shelter in its name. Sometime after noon, a cold fog ghosted in off the Bay, and I was left staring at the GPS's compass again, struggling to hold a course. Every time my attention wavered, *C-Sick* charted her own path, like she was writing her name across the water.

Amid a maze of islands, I spotted the summer's first polar bears; one was sitting up to watch my arrival, and another was sprawled out on the gray rocks, sound asleep. Their island was ringed by shallows like some medieval moat, and in the dismal flat light I decided, meh, no picture here. But as I distractedly looked back, I drove *C-Sick* onto a flat rock shelf. We slid in like a pizza going into the oven, and *C-Sick* ground to a halt. At least I managed to get the engines up in time before destroying the propellers. Practice makes perfect, apparently.

I decided not to panic and, thinking I might be able to muscle her off, leapt over the gunwales down to the shallow rocks. Ice water immediately spilled into my boots, and I scrambled back aboard, socks soaked. I was worried less about cold, wet feet than the vision I'd had of what would transpire if I did successfully shove *C-Sick* off the ledge. I could just see myself standing there, watching helplessly as she drifted away toward deep water in almost picturesque fashion.

Maybe this was a stay-on-the-boat job, after all. I grabbed the boat hook and shoved with all my might, first from one side, then the other. The cheap pole bent double under my weight. Next, I gingerly lowered the propellers

back into the water, careful to remain clear of the rocks. I dropped *C-Sick* in reverse, and slowly rolled on the throttle. This resulted in long minutes of the propellers spinning in wild futility, then finally, oh so slowly, *C-Sick* ground her way off the rocks and into deeper water.

Pushing on through the thickening soup of fog, it felt like I was walking barefoot over a barroom floor after the fighting was done and the beer bottles had all been busted. I navigated around pinpoint rocks with my head stuck out the window, cursing heartily as I tried to eyeball the depth. I could see granite shoals spreading out around me for hundreds of yards. I passed a seagull standing knee-deep in water. Either the bird was levitating or there was a rock under there, too. I corkscrewed in helpless circles for an hour, struggling to find a way out.

As darkness descended and visibility dropped to nothing, I stopped at the first spot I found that showed ten feet of water. I anchored there for the night, out in the open water, hoping the wind would hold off long enough for me to crawl into my sleeping bag for a few short hours.

Come morning, the dismal view from my cabin windows was unchanged. Rain. Fog. Repeat.

I pointed *C-Sick*'s bow east, past Cape Fullerton, then commenced a slow trudge up the coast through Ne Ultra Strait, where Hudson Bay narrowed into Roes Welcome Sound. Southampton Island was a dozen miles to the east. It wasn't far from here that Captain George Lyon drove his ship, the HMS *Griper*, onto the rocks in 1824. He was also on his way to Repulse Bay and similarly lost as hell in the fog. Like me, he struck rock, but he possessed more dramatic flair, doing it in the midst of a howling gale. The *Griper*, a stout wooden ship, was pounded for hours through a long night of screaming winds and frigid rain as waves broke over her. Lyon finally called his officers and crew up on deck and, as the lifeboats were readied, offered what must have been some exceedingly heartfelt prayers. They knew they'd have to abandon ship any minute.

Lyon wrote without illusion in his journal, "If any of us should have lived to reach the shore, the most wretched death by starvation would have been inevitable." He lost three of his four anchors, but somehow the ship held

together, and by dawn the winds abated. Not without reason, he bestowed the name "Bay of God's Mercy" on this otherwise barren stretch of coast.

Content with my relative good fortune and oddly cheered at the thought of someone else having his ass handed to him, I doddered along at five knots for hours, listening to the gentle slap of waves on my bow, with a constant eye on the electronic chart and depth displays. Suddenly, there was a total blackout. Both GPS displays went dark, the depth-sounder was out, and the radar up and died. The engines were still running, but otherwise my prospects suddenly felt decidedly nineteenth century.

I dove behind the helm into the V-berth, uncovered the electronical panel, and started checking fuses. I had foreseen it all: me, lying on my side, and peering dumbly into this rat's nest of wiring and fuses. Not wanting to drift on the tide, I ran up onto the bow and let out the anchor chain, hand over hand. Then I went back inside to light my gas cooker and put on the kettle. A warm cup of tea suddenly seemed like an excellent idea.

I did not suffer from a lack of choices. Between Chinese green tea, English black tea, and a red-leaf *rooibos* tea from South Africa, I had brought half the UN along with me. Whichever I chose, I knew eventually I'd have to go back to that tangled rainbow of wires. So much of *C-Sick*'s electrical work had been added on piecemeal, over the years. The most recent additions, including my mission-critical GPS, were wired by a guy who normally installed car stereos. The stuff I had done last week looked like work by the guys who stole your car stereo.

I began again at the fuse box and traced each set of wires between the power source and its respective device, tugging and squeezing at each of the electrical connections. In the end, I found the problem to be nothing more complicated than a loose wing nut back at the battery terminal. One good twist and the lights came back on, though it took another cork-bobbing, stomach-churning hour before I re-assembled and tidied up all the loose wires and gear cases I'd torn apart in my panic.

I traveled north past Whale Point. After that, it would be a long run along empty coastline to Kamarvik Harbour—more than sixty more miles all told. I set off. The fog dissipated not long after noon, and the sun showed its face for the first time in days. As if on cue, the wind picked up as well, and before

long *C-Sick* was bashing through steep swells and sending up curtains of spray. Slowed by the waves to four knots, I knew I couldn't reach the closest anchorage until well after midnight. I pored over the paper charts, then my marine GPS display, and finally at the topographical map I'd loaded into my backup GPS. Hell, I even looked out the window with my own two eyes hoping to find some haven where I might stop and anchor for the night.

Before me stretched miles of rugged coastline, all of it completely exposed.

In the end, I had to turn tail and go back the way I came, retreating to Whale Point. I had never anchored there before, and could only hope to find shelter for the night. On the following seas, my return trip was twice as fast and half as miserable, but it was still nearly sunset before I turned the corner and began looking for an anchorage. Though it wasn't obvious on the charts, *C-Sick* and I discovered a small, secret cove tucked behind the point. It felt almost enchanted, this perfect little hiding spot, appearing out of nowhere. I carefully probed a mile or more into the channel and found water consistently twenty feet deep. Though the channel was narrow, barely 150 yards wide at spots, it seemed to offer protection from every direction. But should *C-Sick*'s anchor lose hold, we'd find ourselves on the rocks in short order.

I looked around satisfied, dropped the anchor, and called the place home for the night.

Janet read me the weather forecast over the satellite phone, and it made for a grim bedtime story. She said, "Tonight it's ten knots out the north. That's good, right? Then tomorrow they're saying it will be forty knots. Gale force. And it's like that for three days. That's not so good, is it . . . "

That wasn't a question, of course. By now she knew all too well that forty-knot gales were the stuff of my nightmares.

Outside, dark clouds were already sweeping in from the northeast, snuffing out the sun like a guttering match.

Following pages: Overcast skies reflected in calm waters, Chesterfield Inlet

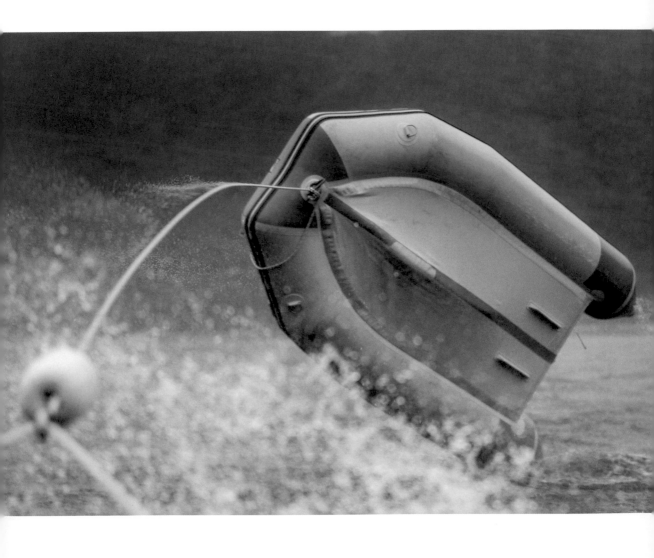

PRISONER OF THE WIND

The wind returned like a jilted lover in some bad country song: howling with rage, waving a pistol, and busting up the furniture.

By morning, the easterly gale had whipped my once-quiet cove into a lather. With the high tide, nearly all the rocks that had sheltered me were gone, vanished beneath the waves, and *C-Sick* bucked and rolled in a lake more than a mile wide. There was just a thin crescent of rock protecting us from the big, bad Bay.

One look at the open ocean's maelstrom of breakers and seething water told me I should count my blessings to have found this spot, and that I better make myself at home. I was going to be here awhile.

It would soon become an art form, this waiting. I started each day with a heart-healthy breakfast of fried eggs, fried potatoes, and fried bacon. After that, I stepped outside and resumed my obsessive quest to gauge the strongest wind gusts. I had only a small, handheld anemometer, and out on the bow I squinted into horizontal rain, holding it up like a lighter at an AC/DC concert. To my surprise and mild disappointment, it was only blowing twenty-five knots, occasionally gusting into the low thirties.

Zodiac flips in storm winds

I could hear the words forming in my head: "Is that all you've got?" Like the Stay Puft Marshmallow Man in *Ghostbusters*, I had conjured the demon and it could not be undone. I scurried back inside as a shuddering gust sent up stinging sheets of spray.

My old Heater Buddy was slowly giving up the ghost, and the temperature inside my boat matched that of the great outdoors. Cave-like humidity built up inside *C-Sick* from my cooking and breathing, and soon condensation dripped down from the ceiling and windows. My puffy down jacket and sleeping bag seemed to gain weight and lose warmth with each passing hour.

I was stuck halfway between Rankin Inlet and Repulse Bay, roughly 150 miles in either direction. The good news was that I had made it halfway to my destination. The bad news was that any help, while not impossible, was certainly a long way off and no sure thing. Self-sufficiency, always good in principle, took on new urgency. I began to think through every task to make certain both *C-Sick* and I remained safe and above sea level. Mortal peril has a tendency to focus even the most scattered of minds.

I repeated the magic words once again, "You fuck up, you die."

Through a long muddle of storm-bound days, I cooked warm soups and curries, read my books, watched some movies, and even tried to grind through a few hours of Rosetta Stone Spanish lessons. Memories of salt-rimmed tequila drinks under the hot Baja sun tormented me. From time to time, I stared out the window, listened to the wind, and hoped against hope that this storm might someday pass.

It was difficult to relax, let alone sleep, when *C-Sick* was whipping back and forth. Her anchor line was drawn taut and fairly vibrated under the enormous strain of wind and waves. I knew I'd gotten both of us into this pickle, and I had to count on her toughness to get us out. Gray evenings gave way to near darkness as thick clouds raced overhead. I lowered the table and spread my sleeping bag out on the settee, but I spent most nights sitting bolt upright in my seat at the wheel, gauging my crescent-shaped digital path on the GPS's dimly lit display. If the anchor let go and we started to drift, the GPS would, I hope, give me some warning. I'd have only a minute or two before we struck rock.

I stayed awake through each high tide as the sheltering rocks disappeared from view and the beating began in earnest. *C-Sick* tossed wildly on the

waves, and I had to brace my feet against a bulkhead to stay put in my seat. Finally, around five a.m., when the tide ebbed and my rocky fortress walls emerged from the sea, I could curl up to sleep.

By the third day of this, the storm had only grown stronger. Outside, my seventy-five-pound Zodiac performed dramatic aerial gymnastics, flipping over and back on the wind. Longing for diversion, I watched it perform for half an hour before finally venturing outside to tie it off more securely.

I was no stranger to solitude. No one who isn't inured to the voices in their head would voluntarily spend six weeks alone on a boat. Yet it was one thing to push forward each day, moving however slowly across the land and sea, putting miles behind me. The art of stillness—remaining patient and calm in the face of storm and wind—was something else entirely. After a while, it began to feel as if there was a small, sharp-toothed animal burrowing in my gut, gnawing away at my confidence and courage. Still, I did not have a lot of options. There was no calling "time-out" and no surrendering to the lurking fear and panic that I kept tightly leashed. I walked into this fight, and now I had to take my beating.

There's rarely a situation that is so bad that I can't, with a little nudge, make much, much worse. I looked out through the storm and noticed the anchor had started to drag. Just twenty feet or so, but worrying.

As soon as I began to motor *C-Sick* forward to take up enough slack to haul up the anchor, the dinghy began to pirouette again in the wind. Hung up on its short tether, it acted as a huge sail, nearly pulling me over the side as I struggled to right it. In desperation, I started opening valves to deflate the thing, then hauled its unwieldy and sodden bulk into the cockpit. I ran back to the cabin and switched on the electric windlass, which slowly pulled up the last fifty feet of anchor chain, and finally the anchor itself, now weighed down by an extra hundred pounds of kelp. I scrambled up to the bow, knife in hand, and began to hack away at the slimy ball, trying not to slice off my thumb in the process. I had a lot of balls in the air, continually looking over my shoulder, then scurrying down below to motor forward away from the rocks, before running back up top to slash away more kelp. When it was finally clear, I dropped the anchor, but it refused to grab and *C-Sick* dragged

backwards toward shore and disaster. I tried six times before it finally held, tentatively, in the gathering darkness of a storm still gaining strength.

It did not make for a restful evening. I spent another long night watching the little electronic boat icon on my glowing GPS screen arc back and forth, like the world's most boring video game. I started thinking, I'm the wrong man for this, in the wrong boat, in the wrong place, and definitely at the wrong fucking time.

Exhausted, I set a drag alarm on the GPS and crawled into my bunk. If *C-Sick* moved more than one hundred feet, the chartplotter should let me know. Somewhere in the depths of sleep, I heard a beeping sound, just annoying enough that burying my head under a sodden pillow didn't help. It took a second or two, but then I shot out of bed. One nice thing about waking to catastrophe is that there's no time to panic.

C-Sick had already drifted a hundred yards, into the shallows, and was nearly on the rocks. Moments from grounding, I started the engines and motored off with one finger on the windlass switch to bring up my fouled anchor. *C-Sick* struggled to keep her nose into the swirling gale. If we got turned sideways, we'd be blown ashore in seconds.

Again, I motored across the narrow inlet, and again I crawled up onto the bow to hack angrily at the kelp wrapped around my anchor. And again, I strained half a dozen times to get the anchor to properly set. I finally drove forward until I could almost touch the sheltering rocks, where I finally found purchase in dangerously shallow water.

I shared none of this with my wife, of course, when I made precious contact with the outside world. I was eager to change the channel in my head, and I hoped desperately to hear about a change in the weather.

"How's your Spanish coming along? Should I buy those tickets to Cabo?" she chirped, trying to cheer me up. Then she shared the forecast. "You've got at least two more days of this wind. I hope you brought along less depressing music this time."

In the light of day, my situation didn't seem all that dire. I had a roof over my head, no shortage of food or fuel, shelter from the storm. It was only at night that my imagination took wing toward all manner of outcomes

dark and terrible. Mostly, I worried about that half-inch piece of nylon rope strung tight as piano wire, tied off on fifty feet of chain, and, at the end, an undersized anchor, buried uncertainly in the muck below. Outside on the Bay, huge waves corrugated the seascape. Whitecaps smashed against the shoreline.

The tide rose. The tide fell. But the wind remained my constant companion.

By day four, lethargy descended on me. Years of experience taught me that patience and failure go hand in glove with a career in the arts. But this futility? It was starting to piss me off. I hadn't even had a chance to properly fail. I was just sitting here watching the hours spin past in a thick fog, my short time in the North ticking away.

The only real signs of life here were the flights of Arctic terns nesting on the rocky shoreline behind me. They skimmed across the water's surface, diving for small fish, then returning to young chicks waiting expectantly on exposed nests. How the hell did they survive here? I was wrapped in four layers of fleece and a down jacket, safely sheltered from wind and rain, cooking warm food and drink. Yet I was feeling quite put upon. These terns were exposed to the weather's full force, yet thrived under the most dire conditions. And when they were done up here, they'd head down to Antarctica and start up all over again.

I knew I should get my sorry ass off of *C-Sick* and out to explore the islands and shoreline here. I had certainly spent enough time staring at them. But it was crap light and I didn't want to fight with the Zodiac, wrestle the outboard, and risk losing both. I idly wondered at what point prudence slipped into torpor and cowardice.

Feeling a little ashamed, I pulled out the hand pump and inflated the Zodiac back to life. It slowly unfurled after twenty minutes of concerted effort, then I tied it off, heaved it overboard, and prepared to row ashore with cameras, telephoto lens, and the old Remington. It felt like it had been a year since I'd used any of them, particularly my shotgun. Before heading out, I loaded the magazine with rusty bear-banger shells from the previous summer, and tried racking a round into the chamber. It jammed halfway on

the shell's corroded brass base. Better to know that now, I supposed, and dug around for a new box—there must be at least one I hadn't dunked in salt water. In five days here, I hadn't seen a single polar bear, but life was full of surprises.

I rowed to shore, helped along by the wind. Once there, I buried the dinghy's small anchor under a cairn of rocks, just to make sure it didn't wander off without me. The querulous screeching of a thousand alarmed terns greeted me when I stepped ashore. Mindful of their nearby nests, I steered a wide berth; I had ample experience with their marksmanship. I set up my tripod, attached the big lens, and started shooting pictures. Even if there wasn't much market for even the most inspired renderings of distant white birds against gray clouds, I wanted to see if I could still remember how all this stuff worked.

A couple thousand poorly focused and badly composed exposures later, I had all the proof I needed that my reflexes had gone a little rusty during the long days stormbound.

As I rowed back across the narrow bay, I noticed a strange sound: silence. The wind had vanished. When I hiked to higher ground and looked out across Roes Welcome Sound, it might have been a different ocean. The whitecaps were gone, the angry seas now nothing but a gently rolling swell.

I hustled back to *C-Sick*, stowed my gear, hauled up the anchor one more time, and set out. It was after four p.m. when I cleared the entrance and started heading northeast again. Sweet Jesus, it felt good to be moving. There was just the lightest of winds, and riding the storm's leftover swell felt like driving down a rolling farm road. As opposed to the roller coaster run by meth-crazed carnies that I'd been stuck on for nearly a week.

I still managed to wring all the anxiety I could out of my six-hour journey north. I wondered if it was all a trap, worried about the sudden exposure, the uncertain forecast, the empty coastline, the melting ice caps, the fate of the dinosaurs, and the futility of all human endeavor. But somehow both *C-Sick* and I arrived in one piece up at Kamarvik Harbour. A patch of blue sky opened to the northwest just as a fat cheddar moon appeared over the horizon.

The forecast still called for shifting winds, but I planned to push north come what may. There was also a special warning, cautioning of unusually dense ice in the waters ahead. As I settled in for the night, I convinced myself that this was actually good news. Where there's ice, there are polar bears.

LATITUDE 65

After yet another six hours of steady, uneventful motoring, *C-Sick* crossed the sixty-fifth parallel. I knew it was just an imaginary line on the globe, but in my head, it denoted The North. *Arrival.*

I looked around with my binoculars and wondered where I might find all that ice I'd been hearing so much about. In the time since I had left home, I'd studied the online charts, read the forecasts, and listened to all manner of hearsay and rumors. They had all said pretty much the same thing: a vast wall of impenetrable frozen sea awaited me. Abandon hope, and turn that wee boat around, lest ye be crushed, and your bones be scattered.

Well, maybe not exactly, and definitely not in a pirate accent. But I'd been spending a lot of time in my own head lately. And yes, finally, I spied a wall of white stretching across the horizon.

As I approached the wide mouth of Wager Bay, the frozen blockade resolved itself into nothing more than a series of narrow ice bands, distorted by distance and strange inversions. I passed through the barricade without breaking enough ice to fill a martini shaker. Just as I cleared Cape Dobbs at

Aerial view of melting sea ice, Wager Bay

the south end of Wager Bay, the sun broke through for the first time in ages and it seemed like a sign. I slid open a window and held my hands up to the light, feeling like an animal emerging from its dank and dismal cave. The coastline curved almost due west into Wager, and soon the sun shone directly in my eyes, half blinding me. I grumbled a bit and started digging around for long-misplaced sunglasses. You simply cannot please some people.

I had been warned in no uncertain terms to steer clear of Ukkusiksalik National Park, which included Wager Bay, unless and until I registered and filled out the proper paperwork with Parks Canada up in Repulse. Still, the park's precise boundaries did not appear on my nautical charts, nor on my topographical maps, nor even on my all-knowing, all-seeing GPS. And it wasn't like there was a gate and some park ranger standing around to collect admission and hand out brochures. So, I obeyed what I took to be the spirit of the law, and set not one foot on dry land anywhere near where I thought the park might have been. All the same, a low-grade worry that I might run afoul of the local authorities gnawed at me.

The incoming tide hauled me along, adding three, then four, knots to my speed. I dug out my cameras and went to work, slowly cruising along the shifting threads of broken pack ice in a hunt for some decent photographs. I spotted plenty of seals basking in the evening sun, and even a pair of walrus were whisked past on the tide. All looked nearly as pleased as I was with the return of fine weather. I kept my long telephoto propped up on the seat nearest me while I continued moving, searching. I was loath to admit it, but I was really after one thing only. Yet for long hours, my evening remained disappointingly free of polar bears.

As the light mellowed and turned golden, I resolved not to obsess about all the pictures I wasn't seeing and make some small effort to simply enjoy the place and take what I could get. If all I saw were floating icebergs, then I guess I'd be an ice photographer. If there were nothing but seals, I'd be your pinniped picture man.

And the seals were a delight. Ringed seals are quiet, elusive ghosts on the water. They come by their suspicions of human intent through hard experience: the local Inuit hunt them as enthusiastically as the bears do. I would usually see these seals in the water only for an instant, soulful eyes peering

out at me, heads wavering in disquiet and curiosity, before they vanished again beneath the surface.

Their larger cousins, bearded seals, were easier to spot as they stretched out to sun themselves on slabs of ice. Getting close to them was another matter. I would motor at dead slow speeds upwind, then let the current and breeze carry me slowly toward them, saying in my most reassuring voice, "Nobody here but us icebergs."

Their faces were a contradiction of curiosity and suspicion. With huge liquid eyes that seemed to peer into my soul, these seals were the essence of anthropomorphic adorableness. And those whiskers; I could think of nothing but fat men and handlebar mustaches. I took what few photographs I could before my little barbershop quartet flashed a look of comprehension and flippered back into the sea.

I drifted for hours, until the sun finally passed behind the rocky hills, and a gibbous moon took its place in the evening sky.

Icebergs forty times the size of *C-Sick* zipped past on the tidal current outside my helm station window. House-sized bergs fetched up in the shallows, and the incoming tide churned the ocean into whitewater rapids. Ninety miles of water was trying to pour past me all at once, and it sounded like a waterfall's roar, impossible to ignore even from miles away. The surface boiled with eddies and whirlpools that swirled ice chunks in circles, sucked them down, and then spat them back out. I felt, not for the first time, very small indeed.

The tide pushed *C-Sick* along at nearly ten knots, like she was just one more iceberg, as the engine quietly idled. I told an imagined pursuing park ranger that I couldn't slow down even if I wanted to. But I did want to stop long enough to test out one of my new toys. Like a vast river, the current ran strongest right down the middle, but within a few yards of shore it eddied and turned back on itself. In the shallows, I slipped into a nook in the rocks, dropped anchor, and prepared to take to the sky.

Like most boys, I often dreamt of flying. And like most grown-ups, I couldn't be bothered to set foot in flight school, much less get a real pilot's license. These days, most of my dreams of flight were set in some faraway

airport where I'm arriving late, on the wrong day, in the wrong country, and missing my luggage—not unlike my real life. My once fiery love for flight has, after years stuck back in steerage class, waned considerably.

But show me a camera that flies? Now we're talking.

Days before I left on this trip, I spent a thousand dollars I didn't have on an updated version of the Dà-Jiāng Innovations Phantom remote-controlled aerial quadcopter, designed and built in Shenzhen. Read: I bought a new drone. On previous trips, I had used earlier versions that, at the time at least, had seemed like a technological miracle. But I was never able to match what I could see from the air with what I actually captured through the drone's tiny camera and lens. I had great fun flying the thing in Africa, hovering over Botswana's Okavango Delta, and photographing elephant herds that I could have reached in no other way. But the camera was primitive, and repeatedly flying the poor thing into acacia trees didn't help.

I gave the rocky coast a sweep for sleeping polar bears before I headed for shore. The drone fit into a waterproof case the size of an overnight bag, and I carefully lowered it, along with my safety gear bag, into the dinghy. Once ashore, I commenced my simple routine. Turn on the remote control. Plug in my iPhone as a display monitor. Fire up the Phantom.

The drone came to life with a cheerful tweet and happily waggled its tiny gimbaled camera. The miniature internal gyroscopes whirred, and tiny GPS receivers pinged the heavens. If all went according to plan, the Phantom would be ready to fly in minutes.

When it worked, it was a gift from the gods. When it didn't, I was left in agony, going through an endless string of system alerts and error messages, IMU calibrations, and MC data errors. I wasted hours starting and restarting the thing, swearing strenuously, trying to coax it back into the skies.

I took a perfunctory last look behind me for approaching bears, then got to work. With the white plastic control box hanging from a thin strap around my neck, I was the very picture of post-modern man-child dorkdom. I already had the mad-scientist reading glasses; all I needed now was a polyester flight suit and pocket protectors.

To take off, I pulled down on the two control sticks, which started the drone's four plastic blades whirring in unison. A slight upwards nudge on the

left stick added throttle, and it lifted ten feet off the ground. If I took both hands off the controls, the Phantom would hover there until the batteries ran low, and then it would automatically land itself.

The screen of my phone showed me the view through the drone's camera lens. I could swivel it up and down, pan left and right to frame my picture. For the first time, I could remotely see exactly what I was trying to photograph, and I was practically hopping up and down with excitement. This was the best camera *ever*. Because it *flew*. As I sent it up and out over the drifting ice, it felt for a moment like I was on even footing with all the *Planet Earth* BBC types I had so long envied, only without the posh accent, the army of production assistants, or the extravagant budgets.

From four hundred feet up, the drifting ice looked like a slowly moving chain of tropical islands, fringed by lagoons of vivid turquoise and a sea gone black and cold. The height only emphasized the vastness of this place. Flying above me, the drone revealed a brown granite landscape scoured smooth during the last ice age. Boulders had long ago gouged telltale parallel lines into the bedrock beneath millions of tons of advancing glaciers. For twenty minutes, I had a God's-eye view of creation, like I was seeing the world for the first time. In my head, I could hear Sir Richard Attenborough's plummy voice intoning, "These images, what you see here, have never before been seen by Man . . ."

The drone's battery alarm broke the spell and I called my little bird back home. Only now did I realize how dangerously distracted I'd been. A polar bear could have walked up behind me, stolen my wallet, and shaved my head before I even looked up.

Afterwards, I spent my day back aboard *C-Sick*, slowly drifting with the ice, following the tide in and back out past the wide mouth of Wager Bay. For that one day, I had it all—calm seas, blue skies, miles of ice, and the blessed warm rays of the sun—everything, in fact, except critters. I couldn't even find a seal to save my sorry soul. Still, after all this time on the water, I finally had a picture or two to show for my day's labors.

The next few days were filled with eighteen hours of sunlight and glassy seas as I lingered along the coast. A warm breeze sometimes flowed out from the

hinterlands, like the tundra itself had sighed in contentment. Spooky, but a welcome contrast to the water's constant chill. To save on fuel, I ran only one of *C-Sick*'s two outboards. When I shut it down, too, we drifted in silence, and I climbed on top of the pilothouse to listen. At first there was just the absence of noise, the engine's *thrum* still echoing in my ears. But in the stillness, I was able to hear a symphony of subtle sounds. The gentle lapping of water against my hull, the constant crunch and splash of sea ice breaking apart, the distant call of loons carrying across miles of water, the breathy *paaaaah* of a narwhal exhaling as it swam somewhere nearby, unseen.

But I wasn't kidding anyone. I was here for the King of the North, the biggest predator to walk the earth, Mister Polar Bear. And he was nowhere to be found.

When I first traveled to the Arctic aboard a sailboat chartered in Svalbard, I would stand on deck and stare at the horizon for long hours, unmoving except to make sure that everyone saw me playing Captain Ahab. Out here, all alone, with no one to impress but my iPhone, I toned down the theatrics. Still, after ten or twelve hours of staring out at the blank wilderness, I started to get a little punchy. I began calling out the sightings just to amuse myself: "Oh look, there's a polar bear's ass . . . a foot . . . ears! I see a fluffy little ear."

Actually, there *was* an ear. Attached to a head. Resting atop an enormous paw, belonging to a polar bear—an adult male, I guessed—sound asleep on the ice a hundred yards away.

He kept right on sleeping even as I fought the breeze and bounced *C-Sick* off an iceberg. Finally, the bear opened his eyes to see what the commotion was about. He didn't seem stressed or annoyed, just mildly curious about the ruckus. As soon as he stood up, I could see that he was frightfully thin, with an oversized and sagging suit of fur hanging loosely where fat and muscle had been. He sniffed the air, trying to sort out the mixed scents of unwashed human, leaking oil, and moldering long underwear.

Apparently, none of it smelled much like dinner. Bears, even hungry ones, have some dignity and, after a moment, he settled back down to rest. It was only later that I realized he must have been exhausted, and likely starving; he was conserving what little energy he had left. The setting sun gleamed in his eyes and turned his coat a shimmering orange. I made my pictures as

quietly as possible, trying to get it all down; the light and the majesty and the essential struggle for survival. I wanted to translate it into pixels, light and form within a frame, as if I might stop the river of time.

Late one afternoon, a large lenticular cloud formed over the Bay—just above me, and seemingly nowhere else. All around its edges there was blue sky and sunlight. I had been riding the ebbing tide fifteen miles out into Roes Welcome Sound, ignoring the building southwest wind until a single thought rang in my head: Time to go. Between the thinning ice, the potential bad juju with Parks Canada, my ebbing fuel reserves, and the pressing calendar, it suddenly felt like the perfect moment to continue on my way.

As soon as the words took form in my head, the wind veered southeast and kicked the exposed sea all around me into a sloppy mess. Three-foot waves rolled *C-Sick* on her side with hard slaps. I headed north, making for the coast and trying to find some shelter from the wind before the tide turned and began to run with force. I crested a wave and without warning a wall of water nearly swamped me from behind. I was caught in a tidal rip, a series of steep, standing waves that were barely more than a boat length apart. I throttled my one good engine up to full power and climbed up the back of one wave, careful not to pitch forward and bury my bow in the next. The propeller lost purchase and spun wildly on air within a breaking wave. *C-Sick* lurched sideways and nearly rolled in the surf. Steering with one hand, with the other I lowered the second outboard and then struggled to get it started. It had spent the past three weeks cold and idle, and it caught only reluctantly. Finally the combined power of the two outboards was enough for me to regain control.

The danger zone extended just a few hundred yards, and I warily pushed through one wave at a time until I reached calmer water. Stunned and shaken, I was surprised by how the Bay had lulled me into cheerful carelessness over the last three days, then turned around and tried to kill me. If I'd been thrown crossways in those waves, *C-Sick* could have easily flipped. I motored three or four miles farther up the coast to Bury Cove, feeling a heightened awareness and newfound respect for the sea. A man-sized *inukshuk* rock cairn marked the natural harbor's entrance.

Storm winds continued to build and I spent a night and a day and then another night anchored in the cove. When the skies again cleared, the wind dropped just enough to lure me out of hiding. I told myself I would just stick my head out and take a quick peek beyond the protection of my anchorage. Out on the open water, a stiff breeze blew against the tide, making for uncomfortably rough seas, but the going was not impossible. After an hour of cautious travel, I knew I was on my way.

C-Sick took a beating, sending big gouts of sunlit spray against my windows. I pounded up the coast for hours. By sunset I was anchored in a small cove just twenty miles from Repulse Bay.

Before going to sleep, I consulted the calendar. I had a week, maybe ten days at most, to find my polar bears, get my pictures, and turn *C-Sick* south toward home. But my next step was to simply push the final miles into town, buy gas, and reacquaint myself with the Repulse Bay's gritty charms.

CHAPTER 25

UNWELCOME

The excitement of making it all this way, finding a path through the final twenty-mile maze of ice, overwhelmed any qualms I might have felt about returning to the rough-and-tumble hamlet of Repulse Bay. Since my last visit and unbeknownst to me, they'd changed the name. Now, it was officially dubbed Naujaat, "the nesting place of seagulls" in the local Inuktitut language. But otherwise, it was pretty much as I left it. I motored up the narrow channel toward town, and in truth, I was feeling modestly triumphant. Was I the first boat to brave the ice this season? Would I be greeted warmly like some minor conquering hero from the South?

The answers were no, and hell no.

My visit to this insular Inuit hunting village on the Arctic Circle soon brimmed with all the dramatic trappings of blockbuster cinema. I'm still trying to figure what kind of story it was, or even who were the good guys and who were the villains.

Was this your standard *Into the Wild* drama featuring one more dissolute urbanite on a quest for adventure who gets more than he bargained for, confronted on all sides by foul weather, hostile wildlife, irate locals, and persistent debt collectors?

Or was it a romantic comedy? A clumsy outsider arriving from the sea greeted with wariness until he wins the heart of a feisty CBC reporter (I'm thinking Drew Barrymore here). He might gain love and acceptance, but at

the price of a contentious off-screen divorce settlement from his loyal and long-suffering wife.

What about an anti-colonial indigenous production, where noble Inuit hunters face off against an undercover eco-terrorist who infiltrates their community to sabotage their centuries-old traditions with his anti-hunting sonar warning beacons? His nefarious plans foiled, the villain would be chased, cowering and naked, into the unforgiving wilderness that would surely consume him in the final reel.

Here in real life, things were short on special effects, but long on melodrama.

I knew I'd stepped in it when a big local guy started giving me shit in the middle of the Co-op store. It was hard to follow his line of reasoning, but the gist of it was, "You're Greenpeace. You can tell all the pretty lies you want, I don't care. You scared off all the seals with sonar. You better get out of town. Now. And you better hope we don't find you out on the water."

None of my attempts at charm, humor, or bluff got me anywhere, and I had the unmistakable feeling any further conversation would involve an ass-kicking out in the parking lot. I moved double-quick to get my provisions, get my gasoline, and get the hell out of town. But double-quick was not fast enough. As I rowed back to *C-Sick*, I smelled trouble before I even saw it. Someone had spattered her cockpit with a bagful of *muktuk*. The small hand-cut strips of pink flesh were backed by the gray skin of a young beluga whale, and were already melting into a vile-smelling oil in the afternoon sun. The bucketful of rotting fish carcasses was a nice finishing touch, in case I'd missed the point.

If there was ever a moment for me to set up my cameras and roll video, this was it. Instead, I just felt a burning shame. I was mortified that it had come to this, and I was more than a little scared, suddenly aware that I was a long way from home without many friends.

My earlier arrivals here had been met with warmth and hospitality and curiosity. I liked to think that I reciprocated these gestures. Over the past two summers of travel, I'd done all I could to build goodwill, chatting with

Walrus head, Repulse Bay

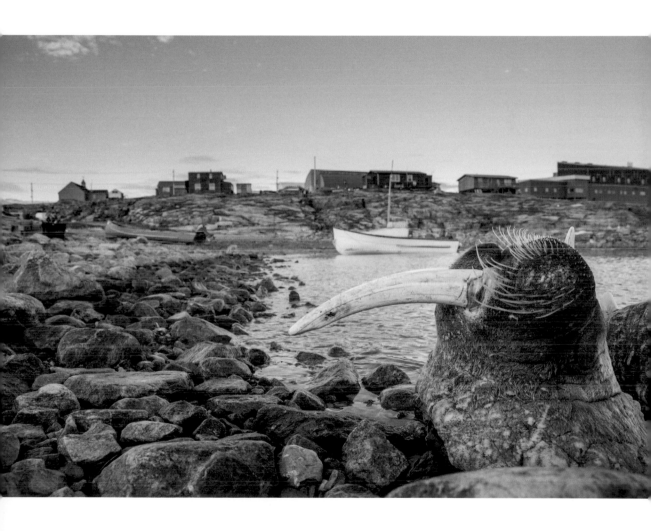

anyone I met in town or who stopped by *C-Sick*, handing out postcards of my photographs, waving to other boats out on the water. But working solo and on a shoestring, I have always preferred to fly under the radar. Partly, it's a residual Lutheran reticence about drawing attention to myself, but it's also a habit from my old newspaper days. I'd learned early on it was generally easier to ask for forgiveness than permission. In broadcasting your plans and asking for some official stamp of approval, you give other people the power to say no. On reflection, I realized that my reluctance to announce my presence to anyone at the hamlet government or to the influential Arviq Hunters & Trappers Association was a mistake.

In the absence of any authoritative knowledge about what I was doing up here, folks had drawn their own inventive conclusions.

I dug out a pair of rubber kitchen gloves, and cleaned up the stinking mess in my boat, dumping bucket after bucket of seawater into the cockpit. Fish and whale oil spread everywhere, and I slipped repeatedly, nearly tumbling overboard. My bilge pump spat out gallon after gallon of putrid water. Thinking I might cut the oil slick, I squirted half a bottle of dish soap into the mess, creating a nasty, bubbling yet pleasantly lemon-scented stew.

I looked for a bright side. They didn't get my sleeping bag. And the polar bears would sure know where to find me now.

A few hours later, a new pickup truck drove down the gravel frontage road and parked at water's edge. I rowed to shore and met Clayton Croucher, the hamlet's interim Special Administrative Officer, an outsider with a kind manner and tired eyes. I told him the welcome committee had already stopped by. He did his best to reassure me, explaining, "The people here are afraid, afraid of the outside world, afraid of pictures from their hunt getting out, afraid of the changes they see all around them." He shook my hand, apologized, then invited me to come speak in front of the hamlet's council meeting the next afternoon. "It might help if you explained for yourself what you're doing up here."

After that, I set off on a one-man charm offensive. I started with the receptionist at the hamlet office, followed by the mayor, the office staff at the

Rotting scraps of beluga whale *muktuk* dumped into *C-Sick*, Repulse Bay

Arviq Hunters & Trappers Association, the kid pumping gas, and anyone else who crossed my path. Looking back, I probably didn't help my cause by starting out each conversation with, "Just so there's no misunderstandings, I have a gun, too."

Two RCMP constables, following rumors of trouble, came looking for me. They were professional and cordial, and made every attempt to be reassuring. But any conversation that starts with "You're certainly within your legal right to be here," and ends with "Can I guarantee your personal safety? No . . ." was unlikely to put my mind at ease.

My head was spinning. I tried to figure out how things had gone so terribly wrong since my last visit ten months ago. That crazy email story I'd received in the spring had grown wings and a consensus had been reached: my motoring around the Bay these last few years was clearly part of a secret anti-hunting campaign to frighten off the seals, belugas, and narwhals with underwater sonar.

I am not making this up.

For years I had listened to dockside stories that blamed bad hunts on Greenpeace secret agents. I had nodded indulgently and chuckled to myself, chalking it up to the natural antagonism between hunters and environmentalists, to the ongoing conflict between tradition and the outside world, and to local folks with a lot of spare time on their hands during the long winter nights. All that suspicion had now found more tangible suspects: *C-Sick* and me.

The next afternoon, I shaved, washed up as best I could, and traded my filthy waterproof Gore-Tex for the only clean trousers and shirt I had on board. I walked uphill to the Repulse Bay hamlet's office building, a modern pre-fab structure, corrugated white with orange and yellow stripes. Inside, eight council members sat around a circle of tables. Clayton Croucher and the young mayor, Solomon Malliki, were at the center. I found a chair off to one side, beside the RCMP officers. All of a sudden, I was a rebel no longer, and more than happy to hitch my cart to law enforcement's pony. Juice, coffee, and cookies were on offer, and the meeting began with an hour or more of the town's business, conducted in a mix of English and Inuktitut and in loose accordance with Robert's Rules of Order. RCMP Constable Michael Fortier

delivered the month's crime statistics, a report dominated by alcohol-related domestic abuse and disorder, leavened with a dash of petty theft and random mischief. After that, he was on the receiving end of ten minutes of sustained criticism from several of the council members, recounting perceived slights and shortcomings in police service.

I was up next. I made my way to the front of the room and, using my best public speaking voice, introduced myself. One councilman visibly winced at my volume, waving his hand for me to tone it down. I did my shtick. "I've traveled up to the Arctic to photograph the polar bears and wildlife here, and show the world what a beautiful place you live in," I explained. Simeon, a local man with handlebar mustache and ample belly, translated my words into Inuktitut. The council's questions and my responses volleyed back and forth between the local dialect and English. It made for slow going.

A man from the Arviq Hunters & Trappers Association interrupted, scowling at me, and began to deliver a litany of accusations about the now-familiar sonar beacons. He added new layers of grievance about my repeated disruptions of the hunt and the disrespect I'd shown. For starters, I hadn't even bothered to ask his organization's permission to travel in their Bay.

"We saw you," he said. "You deliberately drove your boat between the hunters and a narwhal."

I was baffled. "I've never seen a narwhal in my life," I said, leaving out the one I had watched get shot to pieces the previous summer.

"No, you lie," he spat back.

I conveyed as best I could my respect for the people and my love for their land.

Someone interrupted. "I don't believe you. I think you are working for a large company with a lot of money."

Without thinking, I let a snort of laughter escape. Hard stares from around the table wiped the smirk off my face. "I'm new at this, and I'm sure I've made mistakes," I said. "If I have, it wasn't intentional, and I would appreciate it if people would let me know, help me learn." I wanted to add something about the times local boats had bee-lined toward me as I photographed a polar bear, sending the animal running, but for once I kept my mouth shut.

Switching tacks, I offered that, if I was trying to sabotage and disrupt the hunt, it wouldn't be hard, and it wouldn't be subtle, and I sure wouldn't be up here all alone.

The Hunters & Trappers Association man asked me acidly, "Are you going to hide behind the RCMP all the time you're here?"

All I could think was, "Is that a threat?" But what I said was, "I hope that we can treat each other with respect, and that we'll all respect the law," or some similar twaddle.

We went around and around for an hour or more. I listened to the elders' concerns and did what little I could to assuage them. But being calmly threatened and repeatedly called a liar felt surreal. As we wrapped up, I invited everyone to come down to the boat for guided tours of *C-Sick*. While the council took a break for more coffee and cookies, I shuffled out.

A little while later, Mayor Malliki, Constable Fortier, and a couple other guys joined me down at the water's edge, and we all crowded into the dinghy. I rowed us out, and when we all climbed aboard, I opened up my equipment cases. Camera gear. Drone. Satellite phone. Shotgun. No sonar. No beacons. No Greenpeace bumper stickers. One of the younger councilmen went up to *C-Sick*'s bow and pretended to hurl harpoons at an imaginary narwhal, laughing with delight.

I offered coffee and cookies of my own. I don't know what they made of me, but folks sure seemed to like *C-Sick* a lot.

I wish I could say I gave a rousing oration, won over the council, and was greeted with newfound respect and, yes, even love, in the community. At that point, I would have been happy with grudging acceptance for another week or two, followed by mutual relief when we parted ways. But life isn't like the movies.

When I went slinking away into the morning fog, there was no cinematic scene of departure. Still, I couldn't help seeing it through a camera lens: my plucky little boat motoring off through the ice, an aging but still ruggedly handsome man (Wait, is that George Clooney? Maybe a younger Ed Harris?) looking back over his shoulder just once before his boat disappears into a veil of mist.

THE GIFT

I couldn't get out of town fast enough.

With the return of wind and fog off the Bay, it wasn't easy. I tried to ignore the potent bouquet of whale oil and lemon dish soap wafting in from my cockpit while I motored out of town and back toward the Harbour Islands. It was only ten miles, but it felt like a good start. Southerly winds had packed the shoreline with a dense curtain of sea ice again, and for two days I traveled in circles around the archipelago. During the day, I slowly crunched my way through the now-familiar patterns of ice and rock, always searching for polar bears. When darkness fell, I dropped anchor in the lee of whatever island promised some protection from the drifting ice.

I woke once to the sound of loud scraping against *C-Sick*'s fiberglass hull. I sat up and stared in confusion out the window. I couldn't see a damn thing. It took me a moment to realize I was inches away from the featureless white wall of a garage-sized iceberg. Up on deck, in boots and long underwear, I used my bent boat hook to push clear. I wasn't going to move that berg, but at least I could hold *C-Sick* a few feet off until it drifted past on the current. Then I went back inside and crawled into my still-warm sleeping bag, thinking, "Did that just happen?"

There were polar bears around, to be sure, drawn to the carcasses that became the gory touchstones along my daily rounds. Day by day, I watched their slow-motion dismemberment and decay. Seagulls and ravens pecked

away at the remains, and the polar bears drifted through silently, tearing off mouthfuls of rotting meat before vanishing again into the ice and fog. The dense ice made it easy for the bears to keep their distance or avoid me altogether. Once or twice a day, our paths crossed, and the results were as predictable as a play in four short acts:

Act 1. Boat encounters bear.

Act 2. Bear sees boat.

Act 3. Bear recalls pressing business engagement and makes hurried departure.

Act 4. Photographer makes sad frowny face.

I managed to take a few pictures, but they were yet more snapshots. I longed to travel farther from Repulse Bay, but the winds would not let up. The good news, at least for me, was that the winds kept any hunting parties in town. The sea was too rough to risk travel by open skiff or freighter canoe. The bad news was that I was left to drive in circles among the same handful of wary polar bears. Dark clouds, both literal and metaphorical, seemed to hang about three feet above my head.

Toward evening, a break appeared in the sky to the northwest, and sunlight streamed through *C-Sick*'s windows. As the wind swung around from the north, spray flew off my bow and caught the light, as if the sea itself were sending up sparks. I told myself, Tomorrow.

Come morning, I headed south toward Frozen Strait, eager to put more miles between me and town and hoping to avoid any further potential unpleasantness. The lumpy seas made for slow going, and it was hours before I approached the north side of White Island. I imagined that this was the place, and today was the day that I would find my promised land, a place of friendly walrus, perky seals, and curious polar bears.

What I discovered instead was one more wall of tightly packed ice, blocking any progress. The tide swirled and small leads opened up, tempting me in, but just as quickly they squeezed shut with boat-crushing force. I'd been down this road before. At one point, the idea of spending a week or two trapped in some desolate cove, menaced by an ever-tightening circle of ice, might have seemed the height of adventure.

Now it just sounded like a pain in the ass.

The next day, on my way over to Beach Point, I anchored in the lee of a massive berg that had grounded in the shallows. I rowed ashore and flew my Phantom drone up and out over the rocky shoreline, then pointed the lens straight down. The view looked like a jumbled puzzle of identical white, each piece one more wind-compacted ice floe. Through the camera's distant lens, I could see half a hundred miles of sun-soaked, windswept bay, with a ribbon of ice packed tight all along its shore.

Though neither prudent nor strictly legal, in those early, unregulated days of drone flying, I occasionally flew my little bird out at the very limits of sight, sound, or common sense. As there wasn't a town, airport, or human being within twenty miles, the only real risk was kissing my new favorite flying companion goodbye. I was nervous about this at first, but with each flight I pushed her limits a little further—first to five hundred feet, then one thousand, and beyond. I had to squint hard to make out the dwindling white dot, but as long as I could pick up the video signal, I could tell where my drone was flying. And even if we lost contact entirely, the Phantom had a built-in fail-safe feature that should send her winging home to the launch site.

When I started flying the Phantom, I treated the thing like a particularly expensive video game, where you only got to die once, and it cost $1,000 to start over. But, like any number of my relationships, things grew more complicated. When everything worked, flying her felt like we were dancing across the sky. I needed a cigarette by the time we were finished. But she could turn moody and high-strung, and her little head sometimes filled with *ennui*. She became possessed by an urge to flee and dash herself upon the rocks, and a little of me died, too.

I gave her a nickname: *Petite Mort*. It was about as clever as I will ever get in French, and Édith Piaf was already taken.

As I stared excitedly at my control screen, we flew over the sea ice and the camera showed sunlight sparkling off the Bay, a vision of cold heaven. While her parts might have been built in China, her heart beat with a distinctly Gallic flare for the dramatic. Suddenly, *Petite Mort* set her sights on some far

and distant shore and zoomed away, flying fifty knots downwind on a course only she knew, flinging herself toward a watery grave.

I hit the emergency "Come Home" button, trying to convince my little drone that suicide was not the answer, but she only laughed, hysterical now, and hit the gas. I had seconds before she would fly out of range and beyond all control. If she fell into the water, she'd be lost to me. Dead drones don't float. I thought to turn her camera until I could see land receding in the distance, and steered *Petite Mort* back toward the rocky shore. She was still flying far too fast, but if she was going to crash, I wanted to find the pieces and give her a decent burial. The distance numbers on my display began to wind down as I steered her, kicking and screaming, back toward me. At a thousand feet, I saw *C-Sick* as a speck on the screen, then I could make out the beached Zodiac, and finally the top of my own head, bowed as if in prayer over the controller. She was still unstable, hurling herself off-kilter through the air. I could almost hear her cries of "*non . . . s'il vous plaît . . .* let me die . . ." as she lurched wildly back and forth above me. I finally grabbed her as she flew past with my shaking hand.

No, *mon amour*, I can never let you go. I put her back in her dark box. Sometimes, we all need a little quiet time to come to our senses.

Only later did I come across these words in the instruction manual: "The Phantom 3 will not work in polar regions." And so we learn.

With only a handful of days left, I felt like I'd run out of ideas. There was nothing to do but turn *C-Sick* back to the Harbour Islands, back to within ten miles of town. I had hoped to steer clear of any more conflict—any more contact, really—with the locals, but I was heading back to the middle of Repulse Bay's hunting grounds.

In the days since my unwelcome arrival, I had run the story through my head over and over. Of course, the people had every right to be mistrustful of me. If I looked at it through their eyes, everything I did looked suspicious.

When I lowered the anchor, didn't it look like I was sending down a sonar beacon? Flying the drone? Aerial reconnaissance. My underwater camera? Subaqueous seal surveillance. All that motoring *C-Sick* around in endless slow laps made me seem like the creepy guy loitering just outside the playground fence. Now *I* was the one feeling paranoid.

With the calm weather, the hunters' boats returned to the islands. Each time one passed, I waved and forced a smile. Some waved back, some simply ignored me, and a few roared at full speed just a few yards from *C-Sick* and offered nothing but a hard, flat stare in return.

One evening, a big freighter canoe with three Inuit hunters aboard pulled up alongside to have a chat. We got the usual "You don't work for Greenpeace, do you?" thing out of the way, and then I put on the kettle, made some coffee, and dug out a bag of beef jerky to share. Sitting exposed to the elements in their open boat, the men were all well-bundled in thick coats and coveralls. Though *C-Sick*'s heater was all but worthless, I was at least sheltered from the constant wind and the night's spitting rain. I had flattered myself that I was roughing it out there, but these guys knew better. One of the young Inuit men told me, "If I had that boat, I'd never go back to town."

The oldest of the group, a burly guy named Michel, sat on the canoe's gunwale and spoke quietly without a hint of rancor in his voice. He told me, "My grandfather is buried on one of these islands." Looking out at the barren coastline surrounding us, Michel told me, "There are no factories here, no forests, no mines. We take our living from the sea and from the land. That's what God has given us."

After we drained our coffee mugs, Michel pulled their big outboard motor to life and slowly headed out, leaving me to chew on those simple words for a long, long time.

Once in a great while, the universe conspires to make me look like I know what I'm doing.

It had been another overcast and unproductive day, but toward evening the sun dropped beneath the cloud deck and the light upon the land suddenly turned sublime. The northwest wind was still blowing hard, and I didn't want to tempt my drone with any more thoughts of a watery grave. So I clambered into the Zodiac and headed out with a bare minimum of gear: just a couple camera bodies, and three lenses tucked into my waterproof Pelican case.

After days of futile searching, the prospect of finding a polar bear within the next ten minutes, under this amazing light, seemed laughable. But it

couldn't hurt to take a look, so I headed out toward a nearby row of massive icebergs that were glowing in the sunset's ochre light.

I hadn't gone a quarter mile before I spotted the polar bear and her cub. If I had stayed onboard five minutes more and finished my hot cocoa, the bears would have found me first, likely following *C-Sick*'s heady bouquet of fish guts and beluga oil. A tiny first-year cub trailed right behind her, struggling to keep up on the rocky shoreline. When the mother bear spotted my Zodiac among drifting ice floes, she stood on her hind legs for a moment and peered down uncertainly at me. Then she shifted directions and headed up and over the small islet. Her cub followed, taking three steps for every one of hers across the uneven surface.

Bears will often head to water when they're surprised or uncertain or simply of a mind to. That's how they get to these islands, and how they move on. By the time I spotted the pair again, they were swimming across open water. Young bear cubs learn to swim short distances soon after they leave the den in springtime, but their small bodies lack the insulating fat reserves needed to keep them warm for hours of exposure to ice-cold water. The cub paddled a few yards back, and his mother waited for him to catch up, then allowed him to crawl onto her back for a lift.

Struggling to move my small dinghy upwind against the chop, I opened my waterproof camera case just in time for a splashing wave to cover me and my telephoto lens in a shower of ice water.

I can't say how it got there, but inside the case I found a large, brand-new lens cloth, still in its plastic wrapper. So, instead of hopelessly smearing the lens with my filthy fleece sleeve, I was able to get right to work, almost as if I hadn't just fallen off some passing turnip truck. The next few moments were the stuff of dreams. The sun, glowing orange beneath dark storm clouds, illuminated mother and cub like Renaissance saints touched by holy light as they swam across the water. When they climbed onto an ice floe, they both gave a vigorous wet-dog shake that sent up a spray of backlit drops. The

Polar cub nestled beneath mother on sea ice, Harbour Islands

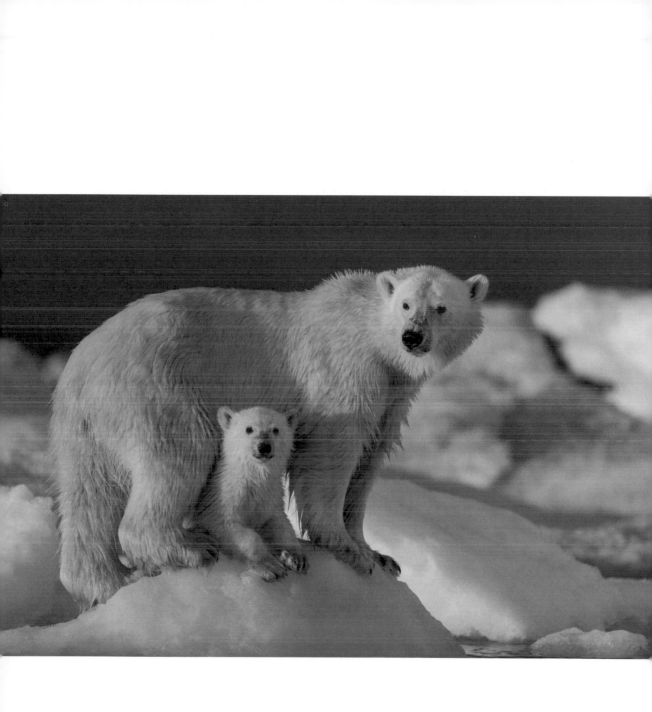

young cub tucked himself under the mother's belly, and the two looked back at me with curiosity.

As the sun fell below the horizon, the sky itself seemed to catch fire, lit from below in swirling flames of color. I knew it was crazy, but I dropped the engine into neutral and let the dinghy drift on the wind, slowly pushing me closer to the bears. Standing protectively in front of her cub, the mother bear loomed above me with deadly intent as I floated silently thirty, then twenty, then less than ten feet away. I leaned down and held out the wide-angle in one hand, stretching my arm as far as I could until my camera almost touched the water's surface. I was shooting blind again, but I desperately wanted to show her framed beneath that expanse of incandescent sky.

She was close enough to leap; I was completely at her mercy. She gave one short *huff* of warning as I squeezed off five or six frames. Then, moving as quietly as I could, I shifted the outboard into gear and backed quietly away to safety.

When the bears again took to the water, the young cub clung to his mother's back as she slowly swam toward another island nearby. The light fading, I stopped taking pictures and simply watched them grow smaller until they were lost in the distance.

You cannot anticipate these moments. You can't plan for them. I had decided long ago that I could only spend the years I had with both eyes opened wide, hoping that life's majesty and drama might not pass me by. For these few fleeting moments, I had been given a chance to witness a scene of rare beauty. Those minutes were the rarest of gifts. If they happened every day, you couldn't help but begin taking them for granted, or stop noticing at all.

Bobbing in the Zodiac, I quickly scrolled through the frames on my camera display. It was all there, almost everything I hoped for this trip. I turned the dinghy around and headed back toward *C-Sick*. In my head, I made the turn for home. After so much time on the water, so much effort and disappointment, this day felt like a parting gift, as if all of the last month's suffering had been washed away. As I rounded the point and tucked back into my cove, a surge of joy burst out of me, and I let loose with one loud, long, and entirely uncharacteristic rebel yell.

CHAPTER 27

CAPE FEAR

A cold fog had rolled in from the north, blotting out the sun and the nearby islands as I finally packed up to leave. I called Janet to let her know I was heading out and her reply melted my heart: "Baby, come back to me. You've been gone too long."

My eyes edged with tears as I hung up the phone. I gave *C Sick* a gentle pat and said the words out loud, "Thanks for taking care of me. I'll ask just one more thing. Take me home."

I had been looking at the charts over and over, and the numbers did not change: it was still six hundred nautical miles south to the railroad terminus in Churchill. I already had my train ticket and an appointment to haul *C-Sick* onto a freight car for the start of our long overland journey toward home. Running both outboards, under perfect conditions, the trip should take a week or so. But both engines were struggling, trailing a thin sheen of oil across the water. *C-Sick* looked battered beyond recognition. Pastor Kirby should be administering her the last rites, but we still had a long ways to go.

I had worked out a schedule that would get me back on time. In order to save fuel and avoid completely burning out my engines, I wanted to run her gently, at displacement speeds of five or six knots. Though the weather was sunny and the seas momentarily calm, I had the very real sense that I was hobbling in on my last legs. As I arrived at Bury Cove, I thought I saw smoke in the distance, but it turned out to be the glowing mist of a small waterfall,

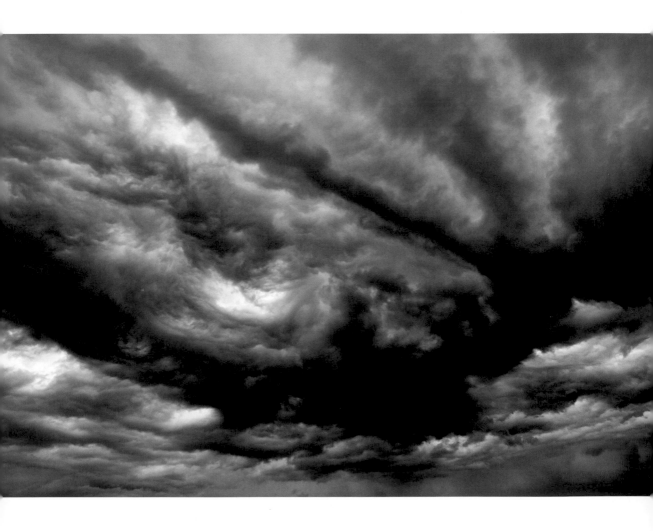

tucked in behind a low highland. I hopped into the Zodiac and raced the setting sun to get one last picture. To my surprise, there was a young polar bear sitting on the rocky shore, staring fixedly back at me. He seemed genuinely curious, even a little perplexed, about this intrusion upon his solitude. I could hear him sniffing the air for a clue, and each exhaled breath glowed in the golden light.

As my camera fired, something clicked behind those black eyes, like the tumblers of a lock dropping into place. That shutter's small *click* seemed to answer whatever question was puzzling him, and he sprinted away, running full bore uphill and over the horizon. I was left alone, staring up at the distant waterfall and empty riverbank.

As soon as I woke up, I knew this would not be a repeat of the previous day's sun-dappled trip across calm waters. Janet texted me a weather forecast that promised rising winds and building seas. Sure enough, easterlies began to bluster across my protected anchorage. Fog rolled in as I set out, and a nasty three- or four-foot beam sea began to hammer *C-Sick*, rocking the boat from side to side. The closer I got to Wager Bay, the uglier the conditions grew. If I ventured past the mouth of the bay, I would be looking at twenty-five miles of open water and rough going. I opted instead for the shelter of nearby Berthie Harbour, a long nap, and a leisurely lunch.

I didn't have any tide charts for Wager Bay, but I could tell that ninety miles of water were flushing out in swirling currents against twenty knots of east wind. It was a mess out there, and I would be smart to stay tucked into my safe little harbor and wait it out.

For all the endless pages of writing I scrawled into my journals during these summer trips, all I have from that day is a single sentence written in a shaky hand: "I don't ever need to do that again."

When an outgoing tide meets an incoming gale, the strong winds catch every small imperfection in the water's surface and push back, magnifying

Storm clouds, Hudson Bay

them until they grow into ugly, stacked waves that can turn steep and violent. I knew all this in the back of my mind. All the same, sitting in the protection of my sheltered anchorage just a few miles north of Wager, I felt a burning urge to get moving. It was such a simple thing: grow impatient, then cut a few corners, get sloppy, decide to go before the time is right.

An old Inuit hunter once told me that before you cross Wager Bay, you should confess in a loud voice all your sins. I've never been particularly super-stitious, but wanting to get into the spirit of things, I worked my way down the list: pride, lust, greed, and vanity. . . . There might be some others, but I didn't have all day. I must have overlooked something, or maybe I mumbled a bit, because pretty much as soon as I left the safety of my little cove, I could see the gods were angry.

And then their anger turned to rage.

Almost immediately, big waves came at my boat from every direction in a confused and vicious sea. *C-Sick* wallowed and pitched sickeningly. The tide was still running plenty strong, and shore quickly drifted from view. There was no turning back, not against the surging tide, and not in these waves. If I got turned sideways in this mess, the boat could roll, and then the fun would really start. None of this was new to me—I had taken *C-Sick* through plenty of rough water and, however inexplicably, made it back in one piece each time—but this felt different, almost sinister. The low gray skies had a sickly, greenish tint, like tornado weather. The water stormed gray and vio-lent and, with each wave, sheets of spray were flung into the air before gusts whipped them away.

In the distance, I could make out a line of breaking waves and, before I even fully formed the words, "I better stay out of that mess," the current grabbed *C-Sick* and dragged us relentlessly into the maelstrom.

I feared steering directly into the waves, so at the last second, I turned the wheel over hard to angle away for a more glancing blow. Still, if I turned too far and showed too much beam, I risked getting rolled. With each wave, *C-Sick* suffered another terrible blow. No matter what I tried, huge waves lifted her bow until I could see nothing but sky out the front windows, fol-lowed by a second of near-weightlessness as the breaking curl dumped us off, then a neck-snapping, deafening crash when the hull slammed down an

instant later. Dishes and loose gear went flying. Overhead, I heard my cargo roof rack, mounted with four heavy steel clamps, begin to break apart. It was almost a relief when it gave a loud crack and slid away. There wasn't a chance in hell I could turn around, let alone try to haul it back aboard. All I could do was look back once as it floated away, upside down, with my empty gas cans, extra stove fuel, and spare sleeping bag inside.

I can always tell when I'm scared: I start talking to myself. I began to murmur over and over, "The boat wants to float, the boat wants to float." But as I got sucked further in, each wave sent me pitching forward, and I had to brace against the wheel. I felt a spasm of pain as the impact whiplashed my neck. *C-Sick*'s bow disappeared underwater, then bobbed back up. Waves of green water exploded against the windshield. I felt my heart begin to race, and my already grim game face gave way to gritted teeth, ragged breaths, and the beginning of a new and deeper kind of fear.

It was only a few small steps to panic, but I was determined not to go there unless and until this thing turned turtle on me. At that point, I figured I would have earned the right to flap my arms and scream like a little girl for however long I had left.

These were surely worse seas than anything I'd ever encountered—steeper, angrier, more violent. In the back of my head, I knew that the Zodiac trailing behind me wasn't going to sink. At the very worst, I could scramble into my drysuit, hit the panic button on my EPIRB, then sit around for an indeterminate number of hours in cold, wet misery while hoping that the helicopter pilots hadn't been out drinking.

The ugliest wave I'd seen yet rose before me. I jammed the throttle forward to accelerate and climb its steep face, praying I wouldn't lose momentum and slide backward into the trough. I held my breath as *C-Sick* crawled up through the crest, then suddenly pitched forward into thin air, as if we were falling out a window, and slammed back into a concrete sea.

The early twentieth-century Arctic explorer Knud Rasmussen once asked his guide and friend, Aua, an *angakkuq* or shaman, about religious beliefs among the Inuit peoples. He responded: "We don't believe. We fear." I had nothing I believed in beyond my precious self-regard, papered over with a veneer of yoga-class spirituality. It seemed pretty thin soup to face the

prospects of dying alone and cold in this forsaken place. Fear began to consume me, and somewhere from the depths of memory half a century old, a scared little boy at Lutheran Sunday School whispered, "Please, God . . ."

There was no heavenly response, no blinding beam of light. It seemed no one was listening, after all. There was only the sound of the wind and the crashing waves. I was alone, a beaten and frightened man waiting for the end of the world.

Yet, little by little, the pounding lessened, and after an hour I could tell we were through the worst. I looked around the boat's small cabin. Glass shards from my beloved French press. Scattered cutlery, plates, and utensils. A pile of half-read books. Everything was soaked in six inches of seawater. But the twin outboards still pushed us forward, even as *C-Sick* rolled and weaved like a punch-drunk boxer. She'd taken a pounding all right, but we were both still standing.

Passing Cape Dobbs at Wager's southern edge, I picked up a following sea that sent us racing along as if pushed, gliding down each wave with a splash. I remained a sitting duck out here on the empty coast, with more than twenty miles to go before the nearest shelter, and I was grateful for any helping hand.

The sun was long gone and darkness had settled over Kamarvik Harbour by the time I motored into the evening's anchorage. The wind had backed to the north and was still blowing twenty knots, so I was eager to find shelter. I followed the narrow inlet for miles, staring at my charts in the half-light, cursing the depth-sounder as it shallowed out again and again. I ran nearly five miles to the very end of the bay but couldn't find a place that offered any protection from the wind and chop. Drifting back toward deeper water in the darkness, I finally said, "The hell with it," and dropped anchor behind a thin outcrop of shadowy cover. I was too wrung out to do anything more than collapse into merciful, dreamless sleep.

It was five hours from my anchorage near the mouth of Kamarvik Creek back to Whale Point. The seas were manageable, almost boring, until the occasional big roller swept in behind me, lifting *C-Sick* a good ten feet above the running seas, then sending us bobsledding down again. That woke me

right the hell up. Then the wind caught my dinghy and flipped it over and *C-Sick* stopped with a lurch. I looked back and saw one of the D-rings had torn away. Before I could haul in the lines, the dinghy righted itself on the next gust. It felt like the wheels were coming off left and right. I jury-rigged a shortened towline and kept right on going.

I took a break in the all-too-familiar shelter of Whale Point just long enough to make some instant coffee and instant noodles for lunch, leading to instant culinary remorse. A polar bear was spread-eagle and sleeping soundly on shore. This land seemed to funnel the wind, now twenty-five or thirty knots out of the northeast. I set off again, feeling harried.

Less than a mile south, *C-Sick*'s starboard engine began to cough, then it up and died. I pumped the fuel line's rubber priming bulb by hand, like it was an animal's small heart. The motor fluttered back to life, then stumbled, and expired for good. Feigning competence, I unhooked the silver cowling and climbed atop the engine, then began poking and prodding at its guts. My mental checklist of possible repairs was short. I stared at the mysterious hoses and clamps and wires. I tried willing the engine back to life. I raised the fuel filter to my lips and tried to blow it clear, and got a mouthful of gas. It might have been the fuel pump. It might have been evil spirits. All I knew was that it refused all efforts at resuscitation.

I was down to one engine, the balky port outboard. I fought back a wave of impending doom. There comes a point where I just get tired of worrying, and I had reached it. My remaining motor would go until it stopped. Then, and only then, would I allow myself to worry more.

The wind and following seas pushed us all the way past Cape Fullerton and I called it a day by the century-old police and trading post. There was a decent anchorage tucked in close to shore. Nearby, I could see the collapsed remains of an old cabin, a low circle of piled stones, some scattered century-old rubbish. For years, I had heard stories about this place. The land felt barren, lonesome, haunted.

Following pages: Ruins of abandoned trading post, Fullerton Harbour

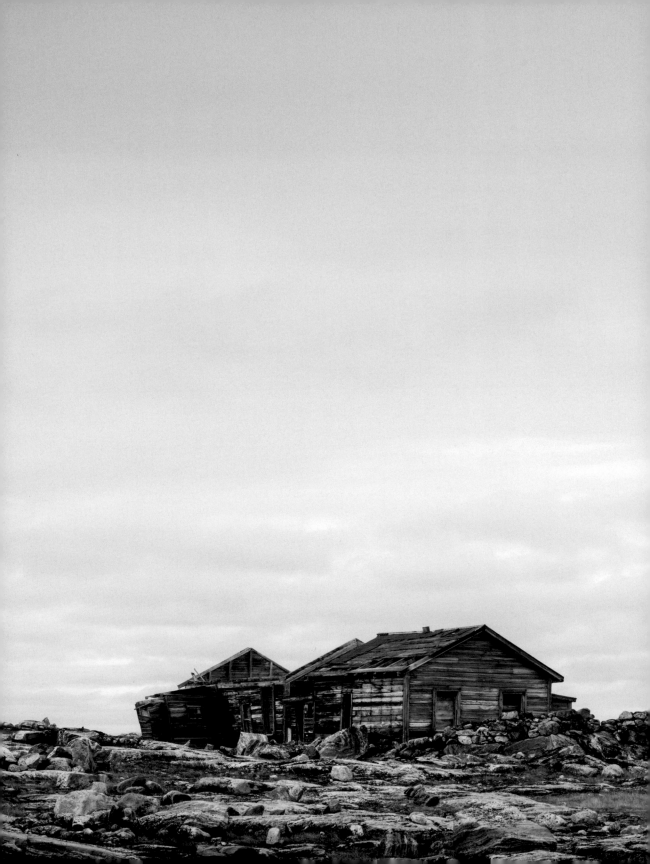

In the morning, I ventured a few miles farther, over to the abandoned trading post. Two wood-frame cabins were still standing but leaned over hard to one side, as if bucking a strong wind. A century's worth of long winters had taken their toll. The roof was mostly gone, the window glass was broken out, and the walls were toppling in upon themselves. Whatever paint the wooden boards once had was scoured off long ago by blizzard snows. They had weathered to the color of landscape and sky, a dull and lifeless gray.

A stone wall surrounded the cabin. It was lower in front of the southern windows to let in what winter light there was and perhaps to offer better sight lines on uninvited guests. I tried to imagine the mix of ambition, grit, and desperation that would drive a man to come to this place, even to drag his wife along, for a year or more. I had spent just a few months here, and faced a tiny fraction of the hardships, and it had all but broken me in two.

When the summer's last ship sailed, it must have marked the end of whatever life these men had once known, and the beginning of a much leaner, harder existence—a life unforgiving of misstep or misfortune.

A mournful air hung over the scene. For years, I had heard the story of a constable who went out on patrol, leaving his wife behind to feed the sled dogs. She slipped, lost her footing, and the dogs were upon her. There was no one close enough to help.

The tundra was only inches thick here, and low stone mounds all along the coast marked the final resting spot for those who did not survive their northern trials. But near the cabin, there was a grave that showed more care than the others. A foundation ring of large rocks filled with fine gravel created a platform, away from the cold ground, for a casket. Then a tall mound of stones covered it.

I stood there for a long time, staring at the grave and turning the story over in my head. Could you ever build a tomb big enough to bury that kind of loss?

I felt myself the worst sort of fool. I had left behind everything I loved to come up here and court death and disaster; I had practically begged them to come calling. I tried to imagine the depths of that man's long winter of sorrow, staring out the cabin window at her grave. There are some things that

no one should have to bear, not so far from home, not in such a lonesome land. I could feel the cold wind keening through my bones.

The legend I'd been told had it that some nights you could hear the ghosts. But I'd heard no music, no woman's cries. For me, there was nothing but the desolate wind carrying the first hints of fall. I looked around the Bay, trying to feel something other than a terrible sadness, but there was nothing for me here. Overhead, flocks of snow geese were carried on the wind on their long migration south. I pulled in the anchor chain hand over hand and, under a low gray sky, turned my boat to follow.

UNWINDING

I traveled along a coastline that had grown low and indistinct, barely visible from a mile offshore. I might as well have been in the middle of the ocean. The charts showed fingers of rock like an outstretched hand, reaching out from the vast granite plains of Canadian shield formation, some of the oldest stone on the North American continent.

It was another long day's slog, forty-some miles on one engine from Fullerton Harbour down to Cape Silumiut. After circling and circling again, I found a deep pool where I could anchor, hundreds of yards offshore. Some stupid inner voice told me that now would be the perfect time to change the engine oil. On land, this had become a routine project for me: unscrew one bolt, drain out the old oil, then pour in four quarts of new through a cap atop the motor's cylinder head. With *C-Sick* afloat in the Bay, the process was fraught with peril. I tilted the outboard engine up and out of the water, paddled the dinghy around to the stern, and gingerly used a wrench to unbolt the drain plug for which I possessed no spare. If I fumbled the plug and dropped it in the water, my troubles would grow legion. I lined my five-gallon toilet bucket with a heavy garbage bag, held the loosened plug between my thumb and two fingers, and gave it one more turn. It tumbled into my hand amid a geyser of warm, streaming—what the fuck?

I didn't know what was coming out of my engine, but it sure as hell wasn't oil. A vile gray river of syrupy sludge erupted over me and over the dinghy, and nearly overflowed the bucket. The irreplaceable bolt and my wrench slipped through my oil-slicked fingers while I clutched desperately at the outboard's cowling. I held on with both hands, grim-faced and clenching the bucket between my thighs to catch the outpouring filth, as if engaged in the worst form of barnyard bestial congress. In the end, I was left panting, slime-smeared, and utterly defiled. I didn't think I'd ever feel clean again after what I'd just done.

But half a roll of paper towels and a large, medicinal belt from that last, precious bottle of Irish whiskey sanded the edge off my shame. I bagged and re-bagged the evidence, and stowed it out of sight. I didn't know much about engines—hell, I didn't know *anything* about engines—but I knew that this was *so* not right. Seawater was still leaking in and had turned the motor oil from slippery petroleum goodness to a viscous gray muck. I had more than three hundred miles to go down a barely inhabited shore with one dead engine, and the other a sick puppy indeed.

I was going to need more whiskey for this.

At the last second, I remembered to replace the drain plug before I started pouring in my final four quarts of new oil. Then I latched down the cowling, wiped away the fingerprints, and offered one more silent prayer to the gnomic gods of marine engineering to guide me over those remaining miles.

A day later, back in Rankin Inlet, I packed up whatever I couldn't leave behind, said my goodbyes, and quickly cut the cord. John was out of town on some sort of local government business, but Page and Frosty walked me back to the dock like they'd done for three summers. It felt ungracious to abruptly leave these people who had helped me so much, but with a window of calm weather threatening to slam closed, I was running out of time.

I made it sixty miles from Rankin Inlet almost to Whale Cove, but I stopped just short of the village. I now felt wary of what reception might await me in these small settlements. I anchored just around the corner, by the portentously named Hell's Gate. The smell of burning plastic lingered in

the air. Most likely someone had set the town dump alight—a not infrequent summer diversion in these parts.

Come morning, I continued my slow passage south and west. Clouds built along the horizon, but these were warm weather clouds, puffs of cottony cumulus, casting shadows of rain miles off. Each day, I ticked off another degree of latitude on my ride south and sloughed off another layer of clothing as the air warmed. I was down to a base layer of polypropylene tops and bottoms, a fleece jacket, and cotton cargo pants. At this pace, I would be down to a wife-beater and boxers before I reached Churchill.

The rain clouds dissipated as the day wound down, then vanished altogether as I pulled alongside Sentry Island, a few miles out from the hamlet of Arviat. I arrived just as the sun covered the low rocky shore in golden light. There was no time left to go out searching for polar bears; I still had another hour of motoring west before I'd clear the island's sprawling shoals and could turn east in search of shelter for the night. The winds had calmed, and the water reflected a fat, full moon rising just ahead of me. As twilight fell, faint ribbons of green aurora borealis flashed against the dimming sky.

This was my last night in Nunavut Territory, north of the sixtieth parallel. I skipped dinner and rowed to shore with my tripod and camera and, to be on the safe side, the shotgun. The sky seemed to open up, beckoning me with all its celestial charms. Still, I spent as much time looking over my shoulder for approaching bears as I did admiring the heavens above. As the sky darkened to full night, the aurora took on form and color, green curtains fluttering on the wind, fringed now in purple, then in crimson red. The full moon turned the landscape ghostly pale. Toward eleven p.m., clouds began to roll in, and by midnight the curtain fell and the show was over.

In the morning, I measured the next day's journey out on the charts. I took my calipers, set the points five minutes of latitude apart, then put one point down at my morning's position. I flipped the legs end over end, ticking off intervals of five nautical miles. By staying out at Sentry Island, I had made a very long day for myself. Eighty miles to the south, the abandoned Hudson's Bay Company outpost at Nunalla, tucked by the mouth of Egg River, had offered me at least some protection against the sea three summers

ago. Everywhere else, drying tidal flats and rocky shoals extended for miles, exposed constantly to the Bay's fickle moods.

When I crossed the sixtieth parallel, I reached to switch out the small GPS data card that stored my topographical maps for Nunavut with another for Manitoba. I dug around. The card was missing, and I realized it was likely among that stolen gear from the previous summer. Years of hard experience had taught me that my Garmin GPS's outdated marine charting for this coast was dangerously vague, sometimes as much as a half mile off the mark. My large-scale paper charts had proven more decorative than practical by this point. While those topographical maps showed nothing of the water's depth, they did provide an accurate rendering of the coastline's indistinct contours between here and Churchill.

I told myself it wasn't essential. I could have turned around and made my way hours back to Arviat and then tried to buy or download the map. Or, I could just push on, if not blindly then at least shortsightedly. In the spirit of Sir John Franklin and Henry Hudson and all the other ill-prepared and ill-fated explorers of that bygone heroic era, I kept right on going with the full knowledge that I was, sooner or later, going to regret it.

The hours unwound as I guided *C-Sick* through our final miles. I imagined that, with a little help from the full moon, I might even run through the night all the way to Hubbard Point. Maybe I'd get there in time for the polar bears to all get together at sunrise and bid me a fond farewell.

I was so happy in the warm sunshine that I paid no heed to a line of clouds building over the horizon, and cheerfully ignored the first breeze stirring from the east. All my life, I have been that way, closing my eyes to trouble brewing until the hard slap of reality startles me awake, too late to dodge a disaster that might have easily been avoided. As the easterlies compounded, a dark wall of clouds slowly blotted out the sky. I counted down the miles, still thinking, then hoping, and finally praying that I might somehow make landfall before dark.

But the numbers didn't lie. Egg Island was still ten miles out when the sun slipped beneath the horizon, just ahead of the storm front. As darkness fell, a northeast wind quickly built to twenty knots and rain began bucketing

down. I pushed on for two more hours until the GPS told me I'd arrived. But outside the cold glow of my screen, I could make out nothing but the dark shadows of an angry sea. I stuck my head out the cabin's sliding portal, closed my eyes, and listened. I heard breakers, much too close. When I looked again, through the darkness I could make out the ghostly white outlines of breaking waves. The depth-sounder's shallow water alarm beeped continuously, and neither the radar nor my GPS gave me any confidence about where the narrow entrance to shelter might lie.

I had been at the helm for fourteen hours straight, and my nerves were frayed. I could try to bluff my way through this, reading the shallow bottom and hoping to blindly pick my way through to shelter. But odds were just as good, probably better, that I'd find myself dropped onto some unseen rocks, leading to the dubious pleasure of standing by helplessly as *C-Sick* splintered beneath me. She deserved a better fate than that, even if I might not. I turned away from shore and motored off into the storm to put a few miles between me and calamity, then hunkered down to wait for the night to end.

Lumpy seas in daylight are a discomfort. But in the darkness, when you can't see what's coming, it's like being beaten with a sack over your head. You never know when or from which direction the next blow will come. I could only sit there and endure the pummeling. Hours past midnight, I finally crawled into my bunk, braced my knees under the lip of the gunwale, and fell into a fitful half sleep. I roused to the insistent beeping of the shallow water alarm: the wind had blown me to within a hundred yards of the rocks. The starter clicked once, then turned my single outboard over with a ragged growl. I dropped the engine into gear and motored away from one more disaster.

Finally, sometime around five a.m., the skies cleared just long enough to reveal the first light of dawn and, on the opposite horizon, a setting full moon. I rubbed my stubbled face and bleary eyes, slapped myself awake, and pointed *C-Sick* back toward the sheltering cove's narrow entrance. Once there, I took one look at the crashing waves and knew there was no shelter for me here. I turned the wheel hard over and continued south.

Hubbard Point was roughly halfway between me and my destination in Churchill. On the way north three summers ago, I had exulted in my first

polar bear encounters on those rocky islands. Right now, I'd be happy just to get a couple hours of undisturbed sleep.

As I pushed thirty-five miles farther south, the tide was running against me, and it took nearly seven hours of continuous pounding to reach the small knot of islands at the Caribou River's mouth. When I finally arrived, it was nearly low tide, and long, treacherous rock shelves reached more than a mile from the shore. I struggled to remember where I had safely anchored years before. I motored down the island's south side until my depth-sounder showed barely five feet of water, and even there we still sat exposed to rolling seas. To the north I found nothing but open coastline. The wind began to catch my Zodiac at the top of each wave and flipped it over again and again.

Janet sent me the weather forecast for Churchill. Winds northeast at twenty-five, building to gale force tonight. My brain buzzed with static and I felt like I'd been thrown down a flight of stairs. It was still seven, probably eight more hours to Churchill, but I was fresh out of ideas. I was hanging on by the thinnest of threads, and I could feel it unraveling in my hands.

I jolted myself to jittery wakefulness with still more coffee, then zipped the cockpit's torn canopy down against the storm. I turned on the bilge pumps to empty out the accumulated seawater. Nothing happened. I start dicking around with the wiring, but in the end, I just grabbed a small manual pump, the size you'd use in a canoe to clean up a spilled beer, and hoovered up bucket after bucket of gray water to dump overboard. I picked out a GPS waypoint at the mouth of Churchill River and pointed *C-Sick* on a straight-line course across forty more miles of angry ocean.

In truth, I had half wanted a proper final send-off from the Bay, a final, life-threatening, suitably terrifying adventure to cap off this journey. I've said it many times before: Be careful what you ask for. I had set up a camera to record the final miles of my journey, and in the pictures, I looked ten years older, my shoulders slouched, eyes drooping, face ashen and sunken and unshaved. I was a wreck.

Big rolling seas came across the beam, rocking *C-Sick* over on her side and kicking up massive waves of spray. Water exploded into the air, over the bow, and against my windows. Big sheets slashed against the hull, drenching

the roof, and half collapsing my canvas canopy. There was no land in sight, nothing around me but fast-moving, confused water. It didn't much matter whether it was five miles to shore, fifty, or five hundred. I was in my own small world, completely at the mercy of the elements. One careless moment or a rogue bit of hydrology could spell the end of our ride.

It wasn't long before another foot of water was sloshing back and forth in the cockpit, with odd bits of muck and junk swirling around in it. I was reluctant to stop and bail it out, but the stern began to sit low and heavy in the water, so I dashed back and pumped out bucket after bucket, throwing it over the side as the boat rolled beneath me.

The wind lashed at each passing wave, but my little *C-Sick* rallied, bobbing almost regally indifferent to the raging turmoil all around.

It was *C-Sick*'s calm bearing, amidst so much wind and storm, that finally settled my nerves.

I flattered myself more than a little when I remembered Sir Ernest Shackleton's family motto, "By Endurance We Conquer." But I wasn't there to conquer anything. I was just trying to get home. So, I braced myself against the wheel, steered to face each wave, and concentrated on nothing more than keeping the boat moving in a straight line. Endure. As I stared at the GPS screen, hour after hour, the miles wound down. I started counting them off, one by one. As darkness fell, I could see the flashing red light atop Churchill's only landmark, that big white elephant grain terminal complex. I ignored the glowing instruments and simply followed my eyes those final miles to shore.

As I rounded Eskimo Point, the waves turned steep and squirrelly. I wondered how disappointing it would be to sink the boat within sight of town. But I rode the last of the incoming tide under the cliffs at Cape Merry, beyond four-century-old Prince of Wales Fort and past the lost bones of Jens Munk's men, and finally up into the Churchill River. It seemed like overkill, but I followed the enormous channel markers that marked deep water for the grain ships. In my absence, someone had put up brand-new security

Young Beluga whale calf with mother and pod, Churchill

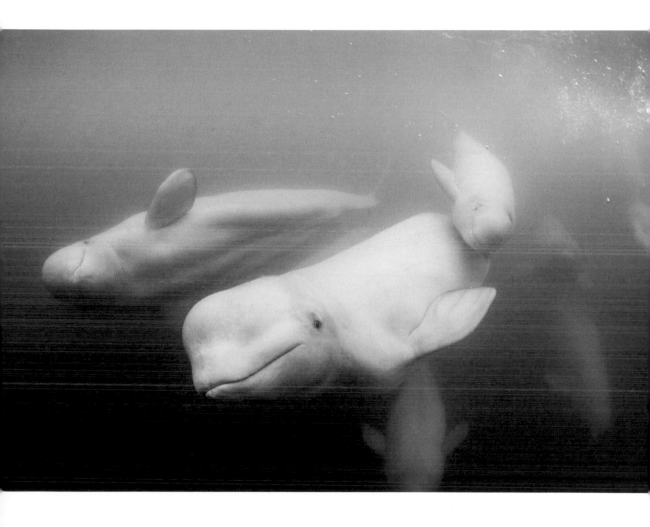

lighting at the port's cargo dock. The place now glowed under a blinding sodium vapor glare, and when I finally dropped anchor, the water was lit up like a rest stop along the New Jersey Turnpike.

My old buddy Remi was bringing in the last beluga whale-watching tour of the season aboard his double-decker aluminum boat. He blasted the ship's horn and hollered down an excited greeting. "Welcome back, man. We never thought we'd see you here again!"

I reluctantly declined his offer of a ride into town and to my old room at the Polar Inn. My whole body was shaking with fatigue, and I couldn't quite face being around people yet, not even old friends. I needed to change out of my fetid clothes, wash up, put something in my stomach, then surrender to fatigue.

I stood on deck, trying to take it all in, and I realized I was surrounded. I could just make out the shapes of the welcoming committee. A pod of a dozen or more beluga whales swarmed around *C-Sick*, swimming beneath her and letting out excited bursts of bubbles. Through the hull, I heard a chorus of ecstatic *clicks* and whistles from the whales' singing.

I was so tired, I imagined I could understand what they were saying.

"We heard you're with Greenpeace. Dude, you've got to help us . . ."

CHAPTER 29

LOOSE ENDS

In the days that followed my arrival in Churchill, a strange weariness over-took me. I chalked it up to simple exhaustion. After a thirty-six-hour pas-sage across the final 160 miles of storm-tossed Hudson Bay, I had taken an ass-beating like no other. But it also felt like a vast weight was finally, slowly lifting. I had lived in a constant state of alertness, worry, and fear for so long it had come to seem like my natural state of being. With its departure came a feeling of absence—a release, to be sure, but also a longing for that sense of purpose.

These last three summers, I felt like an explorer upon the sea. Now I was just one more old man with a crappy boat, in need of a hot shower and a strong drink.

Remi helped me out with both. September is usually a slow time in Chur-chill, the tail end of beluga season and before the polar bear tourist rush, so I got my old room back at the Polar Inn on the cheap. I stood under a scalding stream of hot water until my feet began to shrivel and prune. Then I stood there a good while longer, as the room filled up with steam. When I wiped my hand across the bathroom mirror, I barely recognized the haggard face staring back at me.

I told my stories over a string of double Jamesons over at The Pier, a dive bar just up the street. Shitty weather. Bear attacks. Hostile natives. The end-less journey home. The long, disjointed narrative was already forming itself

into neat chapters in my head. Nothing amused Remi more than the sorry state of repair aboard *C-Sick*. He recognized and admired all manner of recklessness and foolish adventure out on the water. "You had two bilge pumps, and you couldn't get either of them working?" he laughed, shaking his head at the depths of my ineptitude.

I had kept Janet semi-apprised of the long journey home and my safe arrival. But on the hotel phone, we were able to carry on what passed for normal conversation.

"You know, I was thinking about what to do with *C-Sick*," I started.

"That's funny," Janet said, "I was thinking about what to do about getting the lawn mowed. Think the Arctic explorer could squeeze that into his busy schedule?"

Before we hung up for the night, she filled me in on all I'd missed. "We have dinner plans in two weeks with Scott and Lisa. And we're dog-sitting Georgia next week. I've been thinking, maybe it's time we got a puppy. . ."

Back onboard *C-Sick*, I tried to clean and organize, but I felt at loose ends. Disappointment hung in the air like one more bad smell. I had come up here with a simple mission: make the best polar bear images ever shot in the 150-year history of photography. Okay, that was always a fool's errand, I knew that. But I had worked as hard as I knew how, and I had still come up short. Bearing witness to beauty should have been its own reward, yet so much remained that I was never able to put a frame around and call my own.

I was left to wonder, "What more could I have done? Broken all my promises, blown up my life, stayed up North and keep going and going until . . . what?" For decades, I had justified acts of surpassing selfishness in the name of Art, my career, the demon bitch goddess of Photography—as all-consuming as any other addiction or vice, just with more expensive gear. But wasn't there a limit, some point on the journey, or on the globe, where you had to either turn back, or push on and risk vanishing beyond the far horizon? I had fancied myself the man who would chase these pictures to the edge of the world, then over it if need be.

But I wasn't that guy any more. Maybe I never was. In the fog of exhaustion, I couldn't even say for sure what I had been chasing up there in the Arctic. I only knew I hadn't found it.

Most days, I couldn't keep track of my car keys, and I was long past the point of imagining I might change the world. But I tried to console myself with knowing I had done my best to tell the story of one of the last wild places on Earth, a difficult land that I had grown to love. Maybe I'd even made one or two decent snapshots along the way. For now, at least, that would have to be enough.

I consoled myself with the lines of an old Robert Browning poem: "A man's reach should exceed his grasp, Or what's a heaven for?"

For now, I felt an almost physical pull southwards, toward the life I'd left behind. While out on the water, I had placed my memories of all life's small pleasures into a box, then closed the lid down tight. Now I allowed myself to unpack them, one by one, and I could feel my heart start to unfold itself from the tight knot it had become.

My last night, I stood on *C-Sick*'s back deck, fresh bottle of whiskey in hand, and once again toasted absent friends. I named them off, out loud, one by one. It wasn't like the list was all that long, but I wanted to see the faces of the people in my life, wanted to make them real. And I thought of those who had passed on, but whose memory I carried with me all the same.

Even through the pier's spotlit glare, I could make out the stars above. Looking north, I clearly saw the stars of Ursa Major, the great bear. I remembered summer nights from childhood, when my father showed me how to follow the pointer stars to Polaris, the North Star. He told me that so long as I could find that star, I would never be lost. All these years later, he's still showing me the way. North.

I poured a second glass, began to take a sip, then stopped and slowly poured out a small offering into the water below, a gesture of thanks for safe, if sometimes shaky, passage.

In the morning, feeling a little foggy, I motored a few hundred yards to the dock, where I scrambled to sling two heavy straps beneath *C-Sick*'s hull, then looped them onto steel chains that the Port's cargo crew had maneuvered overhead. Suddenly, *C-Sick* was flying through the air, and I started laughing like an idiot. The hundred-ton crane plucked my boat effortlessly out of the water and deposited her gently on a railroad flat car. I hurried up the steep bank and helped shove old truck tires beneath her hull to soften the

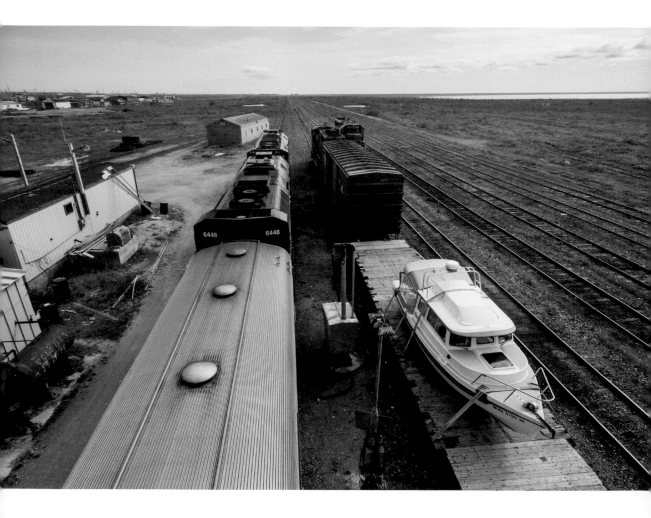

ride. She left town facing backwards, her bow still pointed north, on a long line of freight cars heading south.

I followed a few hours later in the relative comfort of a Hudson Bay Railroad sleeper car, in a berth no bigger than my bunk aboard *C-Sick*. The clean cotton sheets felt cool and sleek after six weeks in the same damp sleeping bag.

The passenger cars bucked and rolled on uneven tracks, and it felt like I was still at sea. I lay awake for a long time, staring out my window at the darkening night sky. We traveled south across tundra, slowly rolling back into the land of toothpick spruce. Sometime in the night, I woke to see faint bands of aurora shimmering overhead. They flickered across the sky, like pale ghosts dancing. I watched as they faded, then disappeared.

When I opened my eyes again, it was full daylight, and we were traveling through the boreal forest. Trees blocked out the horizon. I'd done what I could do; there was no going back now. I still had 1,800 miles of driving ahead of me to tow *C-Sick* back across the continent to the shores of the Pacific.

It began, finally, to sink in.

I was going home.

C-Sick on southbound Hudson Bay Railroad flat car, Churchill

ACKNOWLEDGMENTS

For all my talk of solitary adventures, I relied upon the generous help of dozens of people during my travels across Northern waters.

I must thank Page Burt and John Hickes for their kindness, generosity, and hospitality during my repeated visits to Rankin Inlet. I could not have completed my journeys without their help and support. And I owe a debt of gratitude to Dwight, Louise, and Remi Allen in Churchill, for the warm welcome they offered to a stranger wandering in off the cold water. To Royal Canadian Mounted Police Constable Michael Fortier, who was stationed in Repulse Bay, I offer my thanks as well; he not only helped to keep me on the right side of the law, he also checked in on my progress during that eventful final summer in the North. My thanks go to Clint Sawchuck for both his confidence and encouragement when I set out from Gillam, Manitoba, and for making sure I made it back home in one piece.

Above all, I would like to thank the kind people of the Kivalliq Region of Nunavut Territory. You greeted a stranger with kindness and allowed me to travel through your land and experience the wonder of a place that you have called home for thousands of years.

I owe a huge debt to my old boss at the *Anchorage Daily News*, Richard Murphy. He threw me a lifeline and introduced me to a strange and wonderful new world up in Alaska, and he worked against long odds to turn me into a better photographer. A big thanks to fellow *Daily News* staff photographer Bob Hallinen for introducing me to the wildlife of the North during our long road trips together in Denali National Park. Thanks as well to my friend and fellow photographer Rebecca Jackrel. I will always remember how she showed me that it's not enough to care about photography, you need to care about your subjects as well. My picture editors Carl Gronquist and Jane Perovich have been invaluable friends and supporters. Thanks to their hard work and guidance, I've been able to keep the lights on and my bills paid for more than twenty-five years.

This book would never have come to pass without Mountaineers Books publisher Helen Cherullo and editor in chief Kate Rogers. They must have seen something promising in my strange missives and random blog posts. I could not have seen the book through to completion without the help and encouragement of Mary Metz, my project editor. She guided this leaking vessel away from the shoals and back on course when hope was nearly lost. The editing work done by Kirsten Colton and Alyssa Barrett shaped an unwieldy mass of scrawled notes into coherent paragraphs on a page, and I am in their debt. Thanks as well to my friends Charles Mason and Wendy Walker for reading through early drafts and reminding me of the many lessons I missed in freshman English.

Though I'm sure there were days they wished they'd packed me off to reform school, I owe my parents, Bill and Louise Souders, everything. They created a home for the four of us kids where we always felt safe and loved, and they encouraged us all to find our own paths. I credit my grandmother, Irma Zug, with helping to instill my love of photography and travel.

And finally, I could not have done any of this without the love and support of my wife, Janet. She is the light that guides me home.

ABOUT THE AUTHOR

For more than thirty years, Paul Souders has traveled around the world and across all seven continents working as a professional photographer. His images have appeared in a wide variety of publications, including *National Geographic*, *Time*, and *Life* magazines in the United States and *Geo* in France and Germany, as well as hundreds of other publishing and advertising projects.

Traveling solo in a 22-foot powerboat, he covered thousands of miles of remote coastline to photograph polar bears in the Canadian arctic. The resulting images have drawn wide acclaim: first place awards at the BBC Wildlife Photographer of the Year competition in 2011 and 2013, the *National Geographic* Photography Contest in 2013, and Grand Prize in the 2014 Big Picture Competition.

Paul has been slapped by penguins, kissed by dolphins, head-butted by walrus, terrorized by lions, and menaced by vertebrates large and small. He once spent twenty-seven hours digging a safari truck out of the Seregenti mud using only a saucepan. He still thinks he has the best job in the world.

He lives in a 1905 farmhouse in Seattle's Ballard neighborhood with his wife, Janet, and their dog, Lulu. His images and writing appear on his website: www.worldfoto.com

Arctic Solitaire is his first book.

recreation • lifestyle • conservation

MOUNTAINEERS BOOKS is a leading publisher of mountaineering literature and guides—including our flagship title, Mountaineering: The Freedom of the Hills—as well as adventure narratives, natural history, and general outdoor recreation. Through our two imprints, Skipstone and Braided River, we also publish titles on sustainability and conservation. We are committed to supporting the environmental and educational goals of our organization by providing expert information on human-powered adventure, sustainable practices at home and on the trail, and preservation of wilderness.

The Mountaineers, founded in 1906, is a 501(c)(3) nonprofit outdoor activity and conservation organization whose mission is "to explore, study, preserve, and enjoy the natural beauty of the outdoors." One of the largest such organizations in the United States, it sponsors classes and year-round outdoor activities throughout the Pacific Northwest, including climbing, hiking, backcountry skiing, snowshoeing, bicycling, camping, paddling, and more. The Mountaineers also supports its mission through its publishing division, Mountaineers Books, and promotes environmental education and citizen engagement. For more information, visit The Mountaineers Program Center, 7700 Sand Point Way NE, Seattle, WA 98115-3996; phone 206-521-6001; www.mountaineers.org; or email info@mountaineers.org.

Our publications are made possible through the generosity of donors and through sales of more than 500 titles on outdoor recreation, sustainable lifestyle, and conservation. To donate, purchase books, or learn more, visit us online:

MOUNTAINEERS BOOKS

1001 SW Klickitat Way, Suite 201 • Seattle, WA 98134

800-553-4453 • mbooks@mountaineersbooks.org • www.mountaineersbooks.org

Also available:

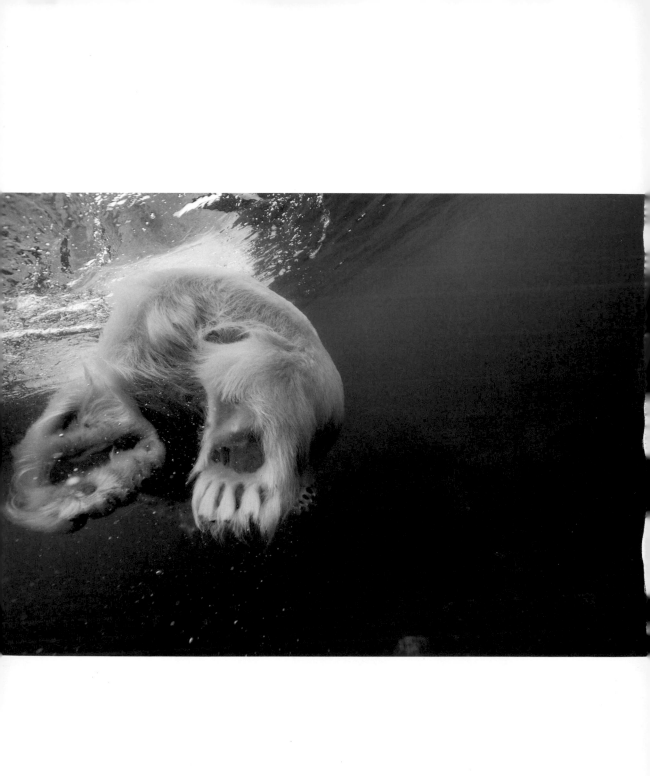